D1327556

7000000025764

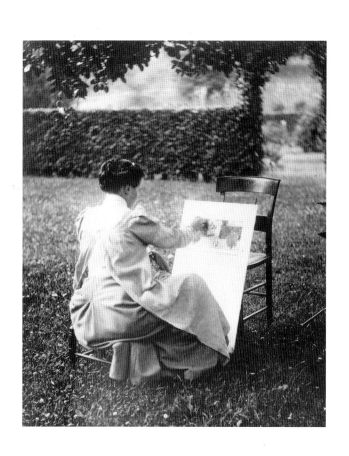

The **Red Rose Girls**

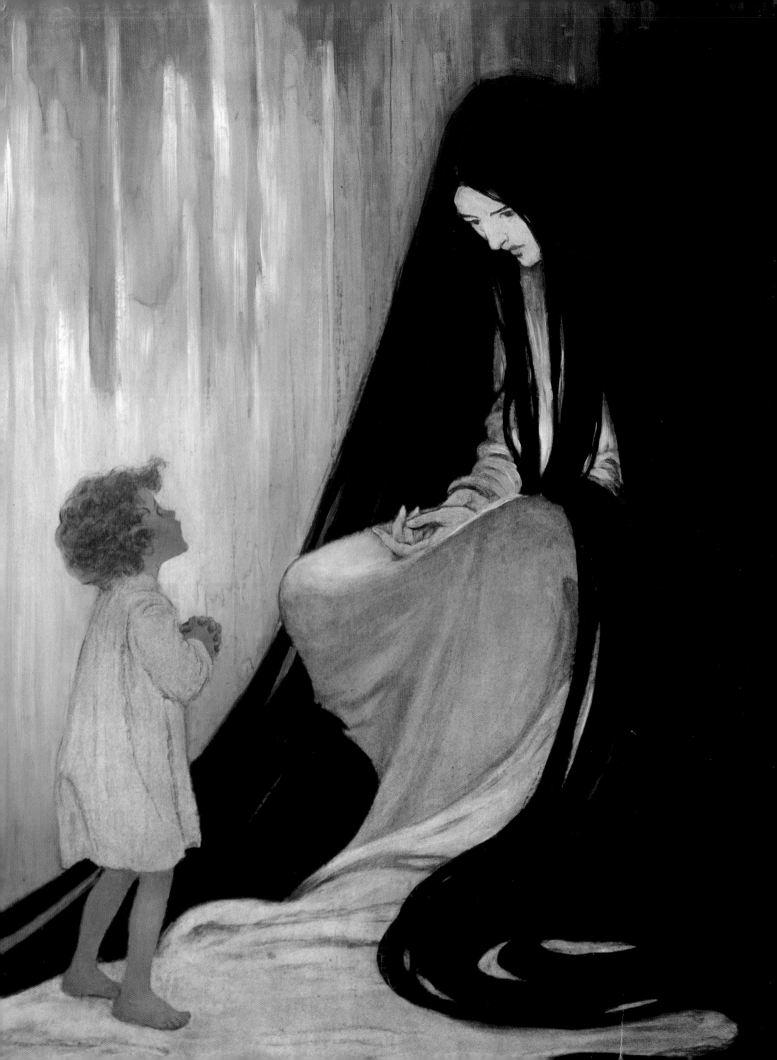

By Alice A. Carter

The Red Rose Girls

An Uncommon Story of Art and Love

HARRY N. ABRAMS, INC., PUBLISHERS

EDITOR: Elisa Urbanelli
DESIGNER: Darilyn Lowe Carnes
EDITORIAL DEVELOPMENT: John Campbell

Library of Congress Cataloging-in-Publication Data

Carter, Alice A.
 The Red Rose girls : art and love on Philadelphia's Main Line / by Alice A. Carter.
 p. cm.
 Includes bibliographical references and index.
 ISBN 0–8109–4437–5 (hc.)
 1. Women artists—United States Biography. 2. Lesbian artists—United States
Biography. 3. Artists—United States Biography. 4. Artists' studios—Pennsylvania—
Philadelphia Region. 5. Smith, Jessie Willcox, 1863–1935. 6. Elliott, Elizabeth Shippen
Green. 7. Oakley, Violet, 1874– . I. Title.
 N6536.C37 2000
 759.13—dc21
 [B] 99–39866

Page 1: Elizabeth Shippen Green working on an illustration in the Red Rose Inn garden, 1905. Archives of American Art

Page 2: Jessie Willcox Smith. *Are You Ill, Dear North Wind?* From *At the Back of the North Wind* by George MacDonald (David McKay Company, 1919). Photograph courtesy of the Archives of the American Illustrators Gallery, New York. © Copyright 1999, ASaP of Holderness, N.H.

Copyright © 2000 The Wonderland Press

Published in 2000 by Harry N. Abrams, Incorporated, New York
All rights reserved. No part of the contents of this book may be reproduced without the written permission of the publisher.

Printed and bound in Japan

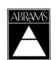

Harry N. Abrams, Inc.
100 Fifth Avenue
New York, N.Y. 10011
www.abramsbooks.com

Contents

I. The Academy Centennial 6

II. Jessie Willcox Smith 10

III. Elizabeth Shippen Green 22

IV. Violet Oakley 30

V. Howard Pyle 38

VI. The Love Building 46

VII. The Romance of the Red Rose 56

VIII. Halcyon Days 76

IX. Cogslea 120

X. "The Interstices between the Intersections" 136

XI. Declaration of Independence 160

XII. Old Friends and True Blue 182

Notes 208

Bibliography 211

Index 213

Acknowledgments 216

I.
The Academy Centennial

THE DATE IS THURSDAY, FEBRUARY 23, 1905. TEDDY Roosevelt is about to be inaugurated for a second term. Anheuser Busch has proclaimed Budweiser "king of bottled beers." It costs $150 a year to attend Harvard University. You can buy a standard Oldsmobile Runabout for $650 or a house for $2,000. Women will not vote in national elections for another fifteen years.

On this particular night Jessie Willcox Smith, Elizabeth Shippen Green, and Violet Oakley leave their communal residence for a banquet celebrating the centennial exhibition of the nation's oldest art institution, the Pennsylvania Academy of the Fine Arts. Forty-one-year-old Jessie Smith, the oldest of the trio, approaches the evening with her status at the Academy already assured. At the 1903 exhibition she had garnered the institution's prestigious Mary Smith Prize for the best painting by a woman and is firmly established as one of the nation's foremost illustrators. Elizabeth Shippen Green, thirty-three, is also at the top of her career. The only woman under contract with *Harper's* magazine, she will be awarded the 1905 Mary Smith Prize within the week. The youngest, thirty-year-old Violet Oakley, enjoys a national reputation as an illustrator and muralist.

The local press anticipate the occasion with enthusiasm. "Distinguished men and women to assemble this evening at Academy of Fine Arts amid rare decorations," gushes the *Evening Bulletin*.[1] Florists decorate the Academy's great stairway with palms, azaleas, and evergreens. Tables are set for the three hundred guests that the *Bulletin* describes as "the greatest gathering in this country's history of men and women distinguished, either as patrons or through actual achievement in the field of American art."

Now open for a month, the exhibition has received national attention and favorable reviews. John Singer Sargent, Thomas Eakins, Winslow Homer, Childe Hassam, and Robert Henri have all sent canvases. Also represented are illustrators Howard Pyle, Maxfield Parrish, and the three women, Jessie Willcox Smith, Elizabeth Shippen Green, and Violet Oakley.

The guests arrive at seven o'clock and file into the main gallery, which is reported to resemble a Florentine banquet scene from the days of the Medici. Seating assignments have been carefully arranged. Diners are meant to social-

Opposite:
Elizabeth Shippen Green. *Toasting.* From the 1902 Bryn Mawr College calendar. Photograph courtesy of the Bryn Mawr College Archives

The Pennsylvania Academy of the Fine Arts, 1876–77. Photograph by Frederick Gutekunst. The Pennsylvania Academy of the Fine Arts, Philadelphia

ize. Husbands and wives are separated and so are the three friends. Jessie Smith, who is assigned a place opposite the head table, is facing away from Elizabeth Green and Violet Oakley, who sit at opposite ends of the second row. The guests dine sumptuously and apparently without alimentary concern on a multicourse dinner that includes deep-sea oysters, terrapin (Philadelphia style), fillet of beef, quail on toast, Virginia ham, mushrooms, spinach, new potatoes, hominy points, Waldorf salad, two kinds of cheese, Nesselrode pudding, and fancy cakes. An orchestra fills the hall with classical music.

The artists are a conservative group. The reporter from the *Philadelphia Press* is gratified to find no "long-haired freaks accentuating in extraordinary personality what they lack in genius." As for Smith, Green, and Oakley, the *Press* notes that they looked like "lovely echoes of their clever and beautiful work."[2]

Speeches are made, toasts given. The mayor arrives late, but in time to catch the tributes to the venerable Academy given by artist William Merritt Chase, and by Caspar Clarke, director of the Metropolitan Museum in New York. The prizes are last, after coffee and cigars. Sculptor Alexander Calder is awarded the Lippincott Prize. The Temple Gold Medal goes to marine painter William T. Richards. Then a surprise announcement: a special gold medal in honor of the Academy's centennial is awarded to the illustrator Violet Oakley. She is the youngest person ever to receive the award. The hall erupts in

applause, and Violet, stunned by this unexpected honor, is pelted with rose petals and carnation blossoms. Jessie and Elizabeth join the standing ovation but are unable to catch a glimpse of their friend in the crowded hall.

After the banquet, the three women return in triumph to their leased estate in Villanova: the beautiful and elegant Red Rose Inn. Awaiting their arrival is the woman behind the women: the fourth member of the household, Henrietta Cozens. Henrietta is not a working artist and contributes little to the household finances. Yet her assistance proves invaluable. She manages the estate, tends the gardens, even knits the nightcaps. The other three are properly grateful. They call her their "darling little Heddy," and make sure she wants for nothing.

In her 1929 essay *A Room of One's Own*, Virginia Woolf discussed why women authors failed to excel and devised a formula to rectify the situation. Women could achieve eminence, she contended, if given equal educational opportunity, financial independence, and privacy. Had Virginia Woolf known about these three intrepid American illustrators, she might have revised her specifications to include the opportunity to collaborate. For it was their unconventional living arrangement that freed Smith, Green, and Oakley simultaneously from both the domestic responsibilities and the artistic isolation that still inhibit many capable artists.

(Caption written by Violet Oakley) "The Red Roses: Elizabeth Shippen Green, Violet Oakley, Jessie Willcox Smith and Henrietta Cozens. Poster for first exhibition at the Plastic Club taken at 1523 Chestnut Street when they planned to move to 'The Red Rose' Villanova." Archives of American Art

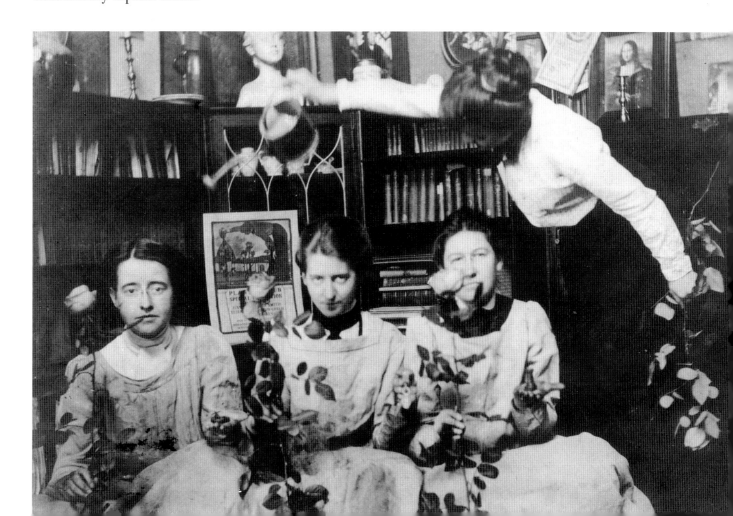

II.
Jessie Willcox Smith

J ESSIE WILLCOX SMITH WAS BORN IN PHILADELPHIA at a time when the city still retained much of its original charm, typified by tree-lined cobblestone streets and brick-walled gardens fragrant with the scent of the clematis flower. Jessie liked to tell her friends that she was not born in the month of September, but in the month of Clematis, on the sixth day, in the year 1863. She was the fourth of four children and enjoyed a childhood of comfort, if not privilege. Her middle-class family managed to make ends meet but was never part of Philadelphia society, a closed circle that included only the descendants of the Colonial founders and the very wealthy. The Smiths were neither longtime residents nor heirs to

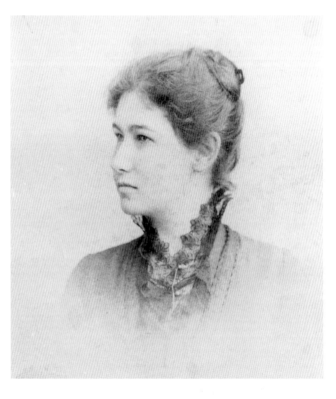

Jessie Willcox Smith posed for this photograph in April 1889, when she was twenty-five years old. Archives of American Art

money and property. The family hailed from New York and moved to Philadelphia just prior to the birth of their youngest daughter. Nevertheless, Jessie's parents had social aspirations. They proudly traced their lineage back to an old New England ancestry, claiming a long line of descent from the New Haven branch of the large and prolific Smith clan.

In keeping with this heritage, Jessie Smith and her siblings were schooled in the conventional social graces necessary for advancement in Victorian society. Once, when she was asked in an interview what counted for beauty in a child, Jessie answered, "good manners."[3] By her own standards Smith must have been an exceptionally attractive child. Throughout her life she

remained irreproachably polite, personally answering every fan letter and request for advice, photographs, or even money, in her large, easy longhand. She was a healthy, athletic girl, big-boned and long-limbed, with a graceful carriage and expressive blue eyes that frequently drew comment. Still, she often revealed a certain amount of insecurity about her appearance that belied her contention that conventional good looks were unimportant.

Judging from her idyllic paintings of children and from her generosity and lifelong devotion to family, those formative years must have been happy ones. The Smith home at 210 South 41st Street was a commodious, solidly built twin edifice that hugged the street behind a low stone wall in West Philadelphia, near the newly relocated campus of the University of Pennsylvania. The household was managed by Jessie's mother, Katherine DeWitt Willcox, and funded by her father, Charles Henry Smith. Although Jessie left no biography of her mother, she kept this poem for years, the following passage bracketed with a heavy black line.

> Delicate, fragile, weak she is not,
> Mother who has loved me long:
> Her strong back's bowed by bending o'er cot
> As child after child there fell to her lot;
> And she thanked the good God for the children she got,
> And burdens she bore with a song.[4]

Most accounts of Jessie Smith's family describe her father as an investment broker, a misconception she never bothered to correct. Although there was an investment brokerage firm in Philadelphia called Charles H. Smith and Sons, this business does not seem to have been run by anyone in Jessie's immediate family. In 1880, when Jessie Smith was sixteen, her father, who was sixty-one years old, listed his occupation in the city census as "machinery salesman." Her thirty-year-old brother, Dewitt, listed the same occupation and was obviously engaged in helping his father. There were no artists in Jessie's family. As a child she acquired a love of music and of reading but showed no interest in art at all, never "drawing on her cuffs" or adorning the margins of her school work.[5]

Jessie Smith loved to walk, and the city was an ideal place to explore. In spite of its unprecedented growth as a metropolitan center of publishing and manufacturing, the City of Brotherly Love took pride in its provincial atmosphere. Skyscrapers did not narrow the streets or block the vistas. William Penn's green squares were still protected by their high wrought-iron railings,

and the heart of the town was not yet dominated by the imposing tower of City Hall but remained as the founder had intended, a bucolic park in the middle of urban bustle.

The Smiths were supportive of both their daughters. By mid-century the writings of Emerson and others subscribing to the transcendental philosophical movement had infiltrated the public consciousness, as well as the conversations in middle-class homes. Philadelphia, a city historically progressive on issues of social reform, embraced these ideas concerning the worth of the individual and provided a sympathetic environment for families willing to educate their daughters as well as their sons. Jessie Smith was sent to the Quaker Friends Central School in Philadelphia and then to Cincinnati, Ohio, to attend high school with her cousins.

After graduation, she remained in Cincinnati. The Smith family had no investments or savings to support their youngest daughter, so Jessie knew that she would be obliged to make her own living. Because she had always loved children, she secured a job as a kindergarten teacher, trusting that a career in education would prove to be rewarding as well as somewhat profitable. It did not take her long to realize that she had no aptitude for her new vocation. When she found her charges disarmingly active, frequently obstreperous, and ill-mannered, she began to look for some other means of support.

One of her friends developed an interest in art and made some sketches that Jessie admired. A young man who wanted drawing lessons (or maybe just wanted to know Jessie's friend better) requested instruction. Permission was granted, but this was an age of chaperones, so the young women were properly cautious. Jessie Smith went along to guard her friend's virtue and, tiring of the novel she brought to amuse herself, joined in the lesson. It immediately became apparent that she had considerable talent. When her friend's mother, who was an artist, commented favorably on Jessie's drawings, she abruptly changed her plans. Many years later she wrote about the accidental beginning of her auspicious career.

> I knew I wanted to do something with children, but never thought of painting them, until an artist friend saw a sketch I had made and insisted I should stop teaching (at which I was an utter failure) and go to art school—which I did.[6]

Because Jessie Willcox Smith was to become famous as a painter of children, biographers have always been a bit uncomfortable with her inadequacy as a teacher. A persistent story is that because she was tall, the rigors of

bending down to care for her small charges caused her back to ache. Her years spent at the easel, however, evidently caused her no such problems. In her many letters in which she complained of various ailments over the years, the problem that supposedly cut short her teaching career at twenty never recurred.

So Smith returned to Philadelphia to try her hand at art. Initially she thought of becoming a sculptor and began by copying a popular style of table-top genre work called a "Rogers Group," named for sculptor John Rogers (1829–1904), who made an industry of these inexpensive parlor ornaments, the three-dimensional equivalents of Currier & Ives prints. Her first production was a small fired clay model of a black boy eating a watermelon. Although today the subject matter seems insensitive, even provocatively offensive, times were different then, and ethnic stereotypes regularly appeared in painting, sculpture, and illustration. She sold this first creation to a Philadelphia art-supply store's gallery for fifteen dollars and walked home feeling like a millionaire. However, her experience working in three dimensions was short-lived. Later she explained, "My career as a sculptor was brief, for my clay had bubbles in it and burst when it was being fired. 'Heavens,' I decided, 'being a sculptor is too expensive! I'll be a painter!'"[7] Smith knew she needed professional training, but in 1884 it was still difficult for a woman to acquire a quality education in art.

For men working toward a career in art, academies and teachers were available to support them in their studies, but women's institutions were scarce. Until the middle of the nineteenth century, it was considered needless and inadvisable for a woman to prepare for any professional career. The expectation was that a girl brought up like Jessie Smith would marry, so the sum of her higher education usually consisted of the acquisition of certain accomplishments that would help her to attract a suitable husband. Education for women began in the home, where it was a mother's duty to instruct her daughter to be a scrupulous housekeeper and capable seamstress. If a family had sufficient means, proper penmanship, English, arithmetic, a few phrases of French, piano, and drawing were added to the curriculum. This instruction comprised what was known as a "fashionable education."[8]

For middle- and upper-class women interested in art and fortunate enough to be provided with a "fashionable education," lessons were taught by private tutors. The curriculum, known as drawing from the "flat," consisted of copying the tutor's own drawings or replicating engravings of works by well-known artists. Although amateur accomplishment in art was considered an advantageous social refinement, professional studies in life-drawing classes

were feared to compromise a woman's virtue by inflaming her passions and making her unfit as a wife and mother. It was even considered improper for women artists to draw undraped statuary in mixed company; although segregated classes were permitted. By 1844 the Pennsylvania Academy, acknowledging the artistic interests of many of the city's female residents, set aside an hour on Monday, Wednesday, and Friday mornings when the sculpture gallery would open to women artists who wished to copy the antique casts. These special hours were abolished in 1856 when the Academy board conjured up a more imaginative solution.

> Although the presence of what is usually termed nude statuary, in domestic Society, is not inconsistent with the purest and most refined intercourse, especially when habit has produced its inevitable effect; yet in a Public Exhibition, the circumstances are dissimilar, too much so, to need any remark; be it therefore resolved, that a close fitting, but inconspicuous fig-leaf be attached to the Apollo Belvedere, Laocoon, Fighting Gladiator, and other figures as are similarly in need of it.[9]

With the modesty of the *Apollo Belvedere*, *Laocoön*, and *Fighting Gladiators* thus preserved, the school was able to accommodate aspiring artists of both sexes without compromising moral standards. However, once given the chance to sketch the statuary and, consequently, to gain proficiency in drawing, women students were no longer content with a curriculum that denied them the opportunity to attend life-drawing classes. In 1860, a group of female

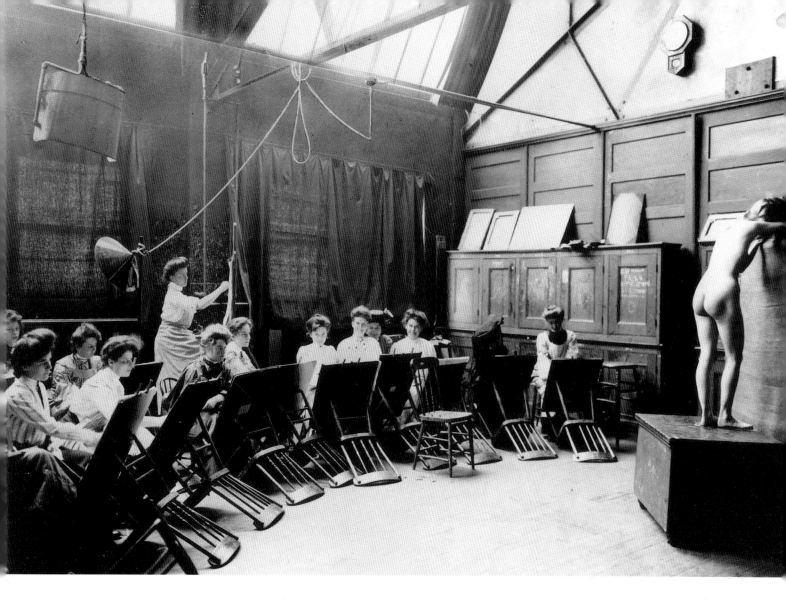

students at the Pennsylvania Academy, upset by their exclusion from life drawing, started their own classes outside the campus, posing for each other sometimes clothed, sometimes half-draped. Although word of the renegade courses embarrassed the Academy, Ladies' Life classes were not added to the curriculum until 1868, and they remained segregated for many years. In 1886, when Thomas Eakins lifted the loincloth of a male model to reveal a little too much anatomy to his female students, he was fired.

European study was possible for aspiring female artists but required courage as well as cash—two commodities in short supply at Jessie Smith's household. The École des Beaux-Arts, which welcomed American men, did not admit women. Mary Cassatt, always noted as one of the few women who succeeded against these odds, was fluent in French and skilled enough in art to be accepted for private instruction in the studio of Jean-Léon Gérôme, so her inability to attend the famous Parisian academy did not inhibit her studies as much as isolate her from the company of the American men in her group. Her

Women's life-drawing class, 1905. Archives of American Art

Opposite:
Violet Oakley. *Portrait of Jessie Willcox Smith*. From "Representative Women Illustrators: The Decorative Workers" by Regina Armstrong, *The Critic* (June 1900). Collection of Jane and Ben Eisenstat

parents were hardly typical. Wealthy and sophisticated, they had raised their children in Europe as well as the United States; even so, they were still apprehensive about sending their daughter to Paris to study. In 1865, when Mary Cassatt made her intentions to go abroad known to her father, he told her he would almost rather see her dead.[10] Nathaniel Hawthorne's *The Marble Faun* had recently been published and must have fanned Mr. Cassatt's paternal concerns. The book, which tells a dark tale of the misadventures of two women artists in Rome, could hardly have offered much comfort.

In spite of these obstacles, Philadelphia produced several talented women painters during the nineteenth century. In general they were intelligent, ambitious women whose careers began auspiciously, promising distinction until domestic responsibilities interrupted their artistic production. Unlike Jessie Smith, who had no family connections to the art world, the women who did succeed were often daughters or wives of artists with the opportunity for private instruction and access to studio space. Thomas Sully's daughter, Jane Cooper Darley, was an accomplished portrait painter whose reputation did not survive the century. The dynastic Peale family produced seven talented women painters, all of whom failed to achieve the eminence enjoyed by their grandfathers, fathers, and brothers. For even in the most enlightened, artistic families, the role of women was well defined. The greatest handicap facing every woman artist was exclusion from the fraternity of male artists, where ideas and philosophies were exchanged and the camaraderie and energetic synergy necessary to sustain a lifetime of creative production was fostered.

Nevertheless, as the century progressed, professional opportunities for ambitious women began to increase. This change of events coincided with social transformations that made it apparent that a suitable marriage would not define the future of all young women. By mid-century the departure of legions of young men to the Western Territories thwarted the marital prospects of many girls. Later, the staggering loss of lives in the Civil War contributed further to the shortage of eligible bachelors. As a result, middle-class men who did not relish the thought of supporting indigent female relatives indefinitely began to look for solutions to the problem of "surplus" women.

In 1870, when Smith was seven years old, a national census revealed that one half of all women employed in the United States were servants or housekeepers.[11] This throng of female workers made up one twelfth of the country's total labor force. However, domestic service was not considered a viable option for the daughters of families clinging (however desperately) to any social pretensions. It was a vocation crowded with ambitious immigrants

struggling to get a foothold in their new country. The hired girl, often of Irish descent and the butt of many jokes, was customarily ridiculed as a hopeless yokel, unfit to enter a proper household.[12] Other vocational opportunities failed to offer a better answer. Although a career as a seamstress was considered a more genteel solution to the embarrassment of poverty than domestic service, it was a field in which the number of willing workers far exceeded the demand for labor. Teaching offered an alternative, yet paid so poorly as to make self-sufficiency difficult.

In Philadelphia, an art career offered a more viable path for women seeking financial autonomy. By the 1840s the city had emerged as an important manufacturing center for textiles, wallpapers, floor coverings, upholstered furniture, and publications. Decorative artists were in great demand to embellish these products. The propensity for lavish ornament was a hallmark of Victorian taste, and it required many artists to satiate so big an appetite. In response to the need to supply these growing industries with artisans and to find a means of support for impoverished women, a new art academy was opened in Philadelphia.

The Philadelphia School of Design for Women was founded by Sarah Peter in 1844. The daughter of a senator, wife of the British consul, and mother of two grown sons, Mrs. Peter had the requisite time and money to devote to philanthropy, as well as a deep concern for the plight of the many women with no jobs and no training. She hired a teacher and started the school in a bedroom of her home. Mrs. Peter told an early visitor to her institution that "as the world now went on, the best service one could do to any new-born female child was to drown it."[13] These were tough times for women. Sarah Peter had the vision and the resources to make some changes.

Her enterprise was immediately successful. When it quickly outgrew the room that she had set aside for it in her own home, Mrs. Peter appealed to the president of the Franklin Institute for help. The Institute, founded at the beginning of the Industrial Revolution to provide vocational training, was sympathetic to the needs of the fledgling institution. In 1850 a committee under the guidance of the Institute's director took over the management of the school, moved it to larger quarters, and in an emotional pamphlet appealed for public support.

> Poverty sometimes comes unexpectedly upon those who by previous education, habit and taste will make the best designers. At present they—and we refer particularly to our female population—are thrown

upon the employment of their needles for a livelihood, and a walk of life already crowded to a heart-sickening extent is still more thronged. Our school of design places at the command of such persons a new means of support.[14]

The School of Design for Women did not provide an education equal to that of the Pennsylvania Academy, as the emphasis was on decorative pattern and ornament, and the curriculum assiduously avoided contentious life-drawing classes until 1886. However, the institution prospered by staying clear of controversy and providing a well-chaperoned, restricted environment that would keep a young women's chances for matrimony intact. For no matter how bleak her prospects, most families encouraged their daughters to choose marriage over career if the opportunity ever presented itself.

It was to this institution that Jessie Willcox Smith was sent on October 2, 1884. She was twenty-one years old, and presumably her parents' hopes for their youngest daughter's future were still undiminished. The tuition was inexpensive, $100 for a term of five months, and the school was elegant. By 1884, it was housed in its sixth location, an impressive mansion that had been the home of the actor Edwin Forrest. Situated in a fashionable neighborhood at Broad and Master streets, surrounded by gracious homes on large, well-tended lots, it was a beautiful setting for an inferior education.

The school was poised on the brink of dramatic changes that would revamp the character of the institution and keep it strong in the coming century. Emily Sartain, an award-winning portrait and genre painter, would return to her native Philadelphia in 1886, take over as principal, hire a distinguished faculty, and institute life-drawing classes. But these changes would come too late for Jessie Smith. Her patience with the structured and outdated method of teaching drawing from the flat did not last long. The only new innovation at the School of Design for Women in

The Forrest Mansion, Philadelphia School of Design for Women. Moore College of Art Archives

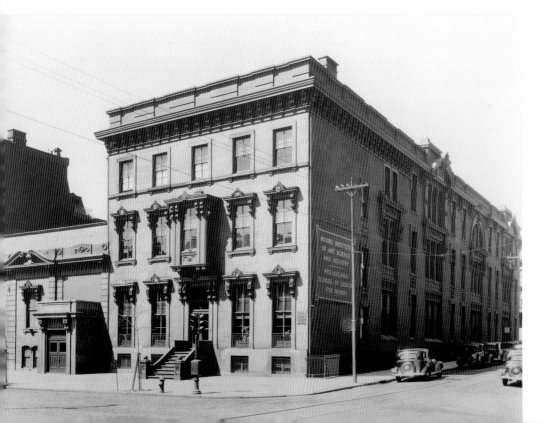

1884 was the hiring of a professor to teach a class in carpet and upholstery design. Jessie wanted more.

The hesitant and apathetic kindergarten teacher had become an ardent young artist with an enthusiasm for the creative process that would last a lifetime. In 1885, there was only one school that offered rigorous training for serious women art students in Philadelphia. The sheltered Miss Smith somehow convinced her family to allow her to enroll at the Pennsylvania Academy of the Fine Arts, where she came under the tutelage of the school's director, the notorious and volatile Thomas Eakins. If the women's school was too inflexible for the ambitious young woman, the radical Eakins represented a scandalous departure from the social conventions that regulated Smith's life. She shared her family's desire to advance their social status and was determined to be both an artist and a gentlewoman.

Smith enrolled in the Academy just one year before Eakins's ignominious departure, at a time when

Thomas Eakins at about thirty-five, c. 1880. Photograph attributed to Susan Macdowell Eakins. The Pennsylvania Academy of the Fine Arts, Philadelphia. Charles Bregler's Thomas Eakins Collection. Purchased with the partial support of the Pew Memorial Trust

the institution was rife with scandal. Complaints about Eakins's teaching methods, specifically his methods of teaching female students, circulated throughout the school. Although the loincloth episode is most often cited as the official reason for Eakins's eventual banishment, there were many other incidents that contributed to his removal as director. In an era when it was considered immodest for a woman to show her ankles, there were rumors that Eakins invited female students to his studio for free private instruction, and that in the absence of a professional model he encouraged the women to take turns posing nude for the impromptu class. Ordinarily a believer in cooperative education (letting the students help each other with only sporadic appearances by the instructor), Eakins was alleged never to have missed a moment of these private sessions. On at least one occasion he stripped off his own clothes, purportedly to make an anatomical distinction to a female student. In a letter of explanation to Academy officials he attempted to justify the incident with characteristic hubris.

> Once in the dissecting room she [a female student] asked me the explanation of a movement of the pelvis in relationship to the axis of movement of the whole body, so I told her to come around to my own studio

where I was shortly going. There, stripping myself, I gave her the explanation as I could not have done by words only. There was not the slightest embarrassment or cause for embarrassment.[15]

Eakins's defense against the charges confronting him was to argue that "if women are to be taught at all, I think they should have good teaching."[16] The realistic portrayal of the human figure was central to his instructional methods, and he was convinced that precise understanding of anatomy was essential to artistic success. He objected to the Academy's grotesque policy of castrating cadavers in the dissection room, a procedure intended to protect the virtue of female students while affording them the opportunity for serious study. Eakins kept the corpses intact and was reprimanded for it.

Although it may have proved possible to defend Eakins's wisdom concerning the procedures in the dissecting room, the motivations for his other indiscretions were less clear. His attempt to exonerate his behavior under the guise of providing enhanced instruction to women would have been more convincing had he not doubted the results. In a letter to Edward Coates, the Academy's chairman of the Committee on Instruction, he wrote,

> I do not believe that great painting or sculpture or surgery will ever be done by women, yet good enough work is continually done by them to be well worth their doing, and as the population increases, and marriages are later and fewer, and the risks of losing fortunes greater; so increases the number of women who are or may be compelled at some time to support themselves, and figure painting is not now so dishonorable to them.[17]

One can only wonder what Eakins thought of the conservative Jessie Willcox Smith, a formal, determined young woman, tall enough to look the five-foot-nine-inch Eakins in the eye and not given to eccentricity in manner or dress. No longer an awkward teenager, she was still no Victorian belle, resembling neither the fashion drawings admired in magazines, nor the statuesque beauties in the popular paintings of Edward Burne-Jones and John William Waterhouse. Later her quiet dignity would serve her well, but in her youth at the bohemian Academy it kept her apart from her colleagues. It is impossible to imagine Jessie Smith at one of Eakins's private classes. But it is equally unlikely in that tempestuous year, when the trouble at the Academy was extensively covered by the local press, that she could emerge from the institution as naïve as she had entered.

Although Smith confided in her friends that she thought Eakins was a "madman," his classes improved her work. Under his tutelage she studied anatomy, perspective, and photography, yet she objected to his approach. Her own artistic vision, which was more romantic than realistic, never meshed with Eakins's insistence on rigorous confrontation with nature. "I always wished there were children in the life classes," she once remarked, "the men and women were so flabby and fat!"[18]

Following Eakins's expulsion some Academy students went to his studio for private instruction. Jessie never considered that option and persisted in her studies at the Academy, working with Thomas Anshuntz and James B. Kelly, two of Eakins's former students who carried on the intent of the curriculum but eliminated the controversy. Jessie graduated in 1888 but was critical of the institution. She had enrolled in the Academy seeking the collaboration and artistic community lacking in her immediate family. She found instead dissension, scandal, and, in the wake of Eakins's dismissal, institutionalized isolation. Years later, with wry humor, she described her classmates.

> There was prevalent in those days at the Academy a superstition which was known by the elegant term of the "Academy Slump." . . . It used to take a victim periodically, and it was considered a most important thing. One had to go through this to develop, to amount to anything afterward. If you did not have this period in your time there, you could not be a great artist. It was necessary for your future success in life. It came, as I say, periodically, about every three months or so, and the victim would give up his work and study, and pace up and down the corridors outside—those cold, clammy corridors—with his head down, never speaking to anyone, or else he would go out and sit on the back stairs, and the other students would regard him with a feeling of awe and a little envy, because this is a state we had to go through. We had to have this or we would never amount to anything.[19]

Jessie Willcox Smith never did succumb to the opprobrious "Academy slump" and she also never publicly discussed her presence at the school during the most turbulent time in the institution's distinguished history. Conflict of any kind caused her to feel profoundly uncomfortable. Her penchant for avoiding acrimony ruled her personal and professional life and manifested itself in her idealistic and often joyous paintings.

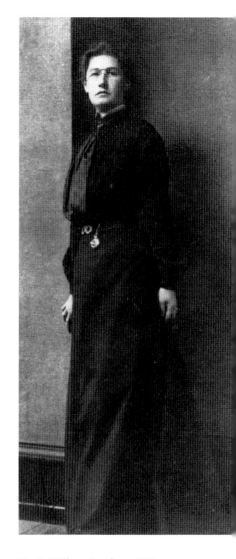

Jessie Willcox Smith, c. 1902. Photograph courtesy of the Bryn Mawr College Archives

III.
Elizabeth Shippen Green

ELIZABETH SHIPPEN GREEN WAS ALSO A GRADUATE of the Pennsylvania Academy. Although she too complained about the general gloom that seemed to permeate the atmosphere, it is doubtful that the cold corridors and victims of "Academy slump" dampened her high spirits. Bessie, as she was known, was the complete antithesis of the dignified Jessie Smith. Formality was decidedly not her hallmark, and a steadfast friend aptly described her as "a delightful person, and full of fun, who didn't mind making herself look ridiculous."[20] Small, slim, dark-haired, and bright-eyed behind her spectacles, she was Smith's junior by eight years. The two just missed being classmates at the Academy. Elizabeth began her studies in 1889 and completed them in 1893.

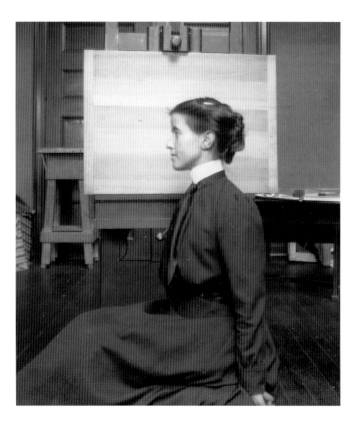

Elizabeth Shippen Green, 1903. Collection of Jane and Ben Eisenstat

Elizabeth Green, the third child of Jasper and Elizabeth Boude Green, was also born in September (Jessie's month of "Clematis"), on the first day, in 1871. Her sister Katherine was just a year older. The Greens' first child had died in 1866 at the age of two. The family home was near the heart of Philadelphia at 1320 Spruce Street. The Greens were not wealthy but they had impeccable old Philadelphia connections through both the Green and the Shippen families, which provided Elizabeth with entrée into the best social circles

throughout her life. The position that Jessie Willcox Smith had to struggle to achieve was Elizabeth Shippen Green's birthright and probably contributed to her easygoing temperament and self-confidence. The Shippens were among the first families to populate William Penn's "Greene Country Towne." The Green family were early Quaker settlers in Upper Bucks County. Jasper Green's brother Amos was a member of the Pennsylvania State Legislature from 1858 to 1859. Elizabeth also counted among her ancestors Matthew Clarkson, the mayor of Philadelphia from 1792 to 1795.[21]

Like most Victorian parents, it was important to Jasper and Elizabeth Boude Green that their daughters have every possible social advantage. Elizabeth was sent to private Philadelphia schools, beginning her elementary education at Miss Mary Hough's School and continuing on at Miss Gordon's School. Her interest in art began at a very young age. Encouraged by her father, a former Academy student, woodcarver, and artist-correspondent for *Harper's Weekly* during the Civil War, she began illustrating her school notebooks at the age of eight. In 1884, when Elizabeth was thirteen years old, Jasper Green had a painting accepted in a show at the Pennsylvania Academy of the Fine Arts. It was a modest landscape entitled *Red Run Ralston*. Nevertheless, it received a favorable review, and Mr. Green's talents were compared to Hudson River

Above left:
Jasper Green, Elizabeth's father, at the Red Rose Inn, 1904. Photograph by Elizabeth Shippen Green. Collection of Jane and Ben Eisenstat

Above right:
Elizabeth's mother, Elizabeth Shippen Boude, poses for a photographic portrait by her daughter, 1903. Collection of Jane and Ben Eisenstat

School painter George Hetzel. This honor from the Academy enhanced the family's already high opinion of the institution, and Elizabeth's parents allowed their talented young daughter to enroll at her father's alma mater when she was just eighteen.

Unlike Jessie Smith, Elizabeth Green never thought of pursuing a career in the fine arts. Her focus was always on illustration. Most likely it was her father's influence. In fact, artists like Jasper Green were in large part responsible for the public demand for the kind of illustrative images that would drive his daughter's career. When the nation was anticipating the start of the Civil War, two of the country's most influential publications stationed artists in spots where armed conflict was most likely to occur—both certain that circulation would be greatly enhanced if they published pictures of the unfolding drama. *Frank Leslie's Illustrated Newspaper* sent English illustrator William Waud to Charleston harbor. *Harper's Weekly* found several artists among the officers at Fort Sumter and commissioned drawings.

Once the war began, the tremendous demand for pictures affirmed the foresight of the editors at *Leslie's* and *Harper's*. During the most intense periods of conflict, *Harper's Weekly* printed and sold a million copies each month. Recognizing the popularity of illustrated editions, other major publications were quick to capitalize on the new trend and began hiring artists of their own. Drawings were tucked in leather bags and rushed by mounted messengers from the battlefield to the engravers, where craftsmen quickly traced the artists' designs on the end of blocks of fine-grained boxwood. Often when the sketches arrived at the engravers, they were cut into four pieces—a process that ruined the original artwork but allowed four different craftsmen to incise the design onto separate blocks, thereby expediting the printing. Finished blocks were then bound together, permitting a master engraver to smooth out the junctures so that the final print appeared to be seamless. Even with the employment of these cooperative methods, the process was time-consuming—ten to twelve hours to engrave a single 4-by-5-inch block was not unusual. Typically the nation had to wait many days for pictures from the battlefield.

Due to time constraints and a shortage of skilled engravers, illustrations that appeared in newspapers and magazines often bore scant resemblance to the original drawings and were customarily published without a byline. Not surprisingly, most of the Civil War illustrators remained anonymous, although a few did gain recognition in related fields. The renowned painter Winslow Homer was at Yorktown in 1862, and Thomas Nast, who was to become famous for his political cartoons, sketched military operations in Washington,

D.C. But generally, the destiny of most American illustrators was similar to Jasper Green's. Their work remained unsigned and unsung.

The only Civil War artist of Jasper Green's generation who did establish an international reputation for his subsequent illustrative work was another Philadelphian, Felix Octavius Carr Darley. Darley did not work in the field as a war correspondent but stayed at home rendering precise monochromatic paintings of important battles and engagements that were then reproduced carefully as steel engravings. Always cognizant of the engraver's essential role in his success, Darley was extremely vigilant about how his work was produced and whenever possible engaged the services of master engraver Thomas Sinclair, who specialized in stone lithography. Darley's attention to the engraving process paid off in commissions to illustrate books for celebrated authors such as Washington Irving, James Fenimore Cooper, Nathaniel Hawthorne, and Henry Wadsworth Longfellow. However, when he worked for periodicals and had no input into the preparation of his drawings for reproduction, Darley too was at the mercy of the wood engraver. Sometimes the damage done by an unskilled artisan was cause for an apology. The *Aristedian* magazine published the following disclaimer along with Darley's illustrations: "In favor of Mr. Darley, it is scarcely necessary to speak; but we must add, in justice to him, that the engraver of the designs, in four or five instances, have spoiled his ideas and gave a representation quite different from the drawing on the block."[22]

During the war the public became accustomed to newspapers and magazines embellished with pictures, and after hostilities ended, the call for illustrated articles did not diminish. Instead, demand skyrocketed. Contributing to

Pencil drawing by Felix Octavius Carr Darley (1822–1888), America's first important illustrator. Collection of Jane and Ben Eisenstat

this change was the eventual implementation of the American Copyright Act, which put a stop to the custom of re-engraving drawings by foreign artists and using them in American publications, a practice that saved money but discouraged the use of local talent. Postwar improvements in the rail systems and a marked rise in the literacy rate also contributed to the soaring circulation of many publications and ensured artists a nationwide audience. In addition, the gradual introduction of photographic engraving greatly advanced the profession. For the first time, illustrators were able to work in fluid pen or pencil lines with the assurance that their drawings would be accurately reproduced. In 1880 *Harper's* magazine published its first edition in England and editorialized that "The delicacy and beauty of the illustrations found nothing comparable in Europe; and it was the English edition of *Harper's* which made Europe acknowledge our superior work in rapid fine art printing."[23] No longer fearful of being embarrassed by poor engraving, American illustrators began to sign their work, and subscribers looked forward to the publication of drawings by their favorite artists: Edwin Austin Abbey, A. B. Frost, Charles Dana Gibson, and Howard Pyle.

In an era of electronic communication, it is often forgotten that in the last quarter of the nineteenth century illustrated books and periodicals were the only vehicle for bringing images of the world into American homes—that weekly magazines with serialized stories generated the same anticipation as a favorite weekly television program. Books by important authors were greeted with the same excitement as major motion pictures. New productions were enthusiastically reviewed, and illustrations hung next to paintings in the nation's most prestigious exhibitions. In the years following the Civil War it was not unusual for illustrators to enjoy financial success, widespread fame, and a lifestyle of luxury that had evaded Jasper Green, for whom these changes came too late.

For youngsters poring over the books and magazines that inundated Victorian homes in the postwar years, a career in art must have seemed like an exciting opportunity. Editors promoted their artists and published numerous articles displaying their opulent studios and homes. Girls as well as boys hoped for success as they copied pictures from magazines or created their own illustrations to accompany favorite stories. However, very few publications featured paintings by women. Although a study completed in 1890 revealed that 88 percent of all the subscribers to American periodicals were women, and magazine editors actively sought out qualified artists who could delineate a feminine point of view, there were few female artists skilled enough to com-

plete the assignments. Jasper Green could see that his daughter had talent and that the commercial climate favored her success—so it was not surprising that he had high hopes for her future. Certainly, he was a proud father. When he died, among his treasured possessions was a scrapbook containing a complete record of his daughter's published illustrations.

The Academy's policy toward students like Elizabeth who wished to pursue any of the applied arts was well defined. Although they would be afforded the same opportunities as their classmates pursuing the disciplines of painting or sculpture, they would not be given any instruction on the "mechanical" requirements of their profession. As stated in the Academy's *Circular of the Committee on Instruction*, that order of preparation was decidedly not the mission of the institution and was best left to the trade schools.

Elizabeth Green was an unusually ambitious and resourceful young woman. She learned the technical aspects of the illustration field from her father. At the age of seventeen she set up a studio in the corner of her bedroom, produced a series of drawings, and sold them to the *Philadelphia Times*. These first published illustrations appeared in the *Times* on her eighteenth birthday (one month before she began taking classes at the Academy), as an accompaniment for her own charmingly naïve rhyme about a child and her doll, "Naughty Lady Jane."

My Lady Jane's been bad to-day
She really is a fright,
And all because I've done my best
To do the thing that's right!

You see she has such lovely curls,
So long and smooth and fair;
But oh! She made me comb them till
I'd pulled out every hair!

Her eyes will open or will shut
So she can sleep or wake—
She made me stick them with a pin
Until they had to break!

By pressing on a little knob,
She would quite loudly cry—
Until she made me break it off
To find the reason why!

I never yet have seen a doll
So bad as Lady Jane;
It's very wrong in her, I think,
To give her mother pain!

But never mind, my Lady Jane.
I love you, don't I, dear?
Although I have to do the things
That make you look so queer!

The verses marked both the beginning and the end of Elizabeth's professional literary aspirations—although she continued to compose poetry to

amuse herself and her friends—but her illustrations heralded the start of a long and distinguished career. The *Philadelphia Times* editors, who recognized talent when they saw it, were suitably proud of their young prodigy and gave Elizabeth an extended byline.

> You will see in another column today some very pretty verses called "Naughty Lady Jane," accompanied by six exquisite illustrations. They are the work of Miss Bessie S. Green of Philadelphia who is only eighteen years old. The lines are unpretending, of course, yet admirably suited to their purpose; but the illustrations show wonderful talent. Indeed they would do credit to an artist much older and more experienced than Miss Green.[24]

The pen-and-ink drawings of a child with her doll were skillful yet derivative, bearing a striking resemblance to British artist John Everett Millais's illustrations of children. At the age of seventeen, it would have been most unusual if Green had perfected a distinctive personal style, and it would not be surprising if she admired Millais. One of the founders of the Pre-Raphaelite movement, Millais enjoyed unprecedented critical and financial success. Both his paintings and his illustrations were widely admired. Like Elizabeth, he was a child prodigy, although his talents became apparent at an earlier age. He won a silver medal from the Royal Society of the Arts when he was nine, and he began his training at the Royal Academy Schools when he was only eleven.

The remuneration for the *Times* illustrations was hardly enough to earn Bessie Green financial independence (fifty cents for a one-column drawing, a dollar for two columns, and occasionally three dollars for a very large drawing), but the success of these illustrations led to other commissions for the publication, and the modest fees were enough to pay the $8-per-month tuition at the Academy. The young artist was so anxious to see her work in print that she willingly tested the stamina that would sustain her long professional life. While working diligently in the Academy's Antique class, seeking to gain her instructor's recommendation for promotion to the Women's Life class, she also produced a series of illustrations each week for the *Philadelphia Times*. It is easy to imagine her that first cold winter—a slight girl in sensible clothes holding tight to her portfolio as the winds swept her up cobbled Broad Street, past the onion dome of Kiralfy's Alhambra Palace theater and the Academy of Music, through the courtyard of the new city hall, and on down to Cherry Street and the imposing Academy facade.

Green's success was commendable for someone so young, but it was limited. For it was impossible for any illustrator to gain distinction creating small line drawings. Most artists sought larger commissions, such as book illustrations or magazine covers. Despite her youth, Elizabeth would not deny herself that goal. She began to solicit new clients who would give her the opportunity to showcase more impressive drawings. Her first magazine cover was published in December 1890, two months into her second year at the Academy. She was nineteen years old. The drawing, executed in a sure and fluid line, appeared on the December cover of the humor magazine *Jester* and depicted a young couple in evening dress at a holiday party. Elizabeth, who was eclectic in her literary tastes and always loved a pun, must have laughed when she was sent the copy for her assignment. Her drawing, entitled *Every Bud Has Its Thorn*, was captioned:

> HE: (utterly blasé and bent on being witheringly sarcastic.) I assure you, Miss Jacqueminot, I get thoroughly battled when I talk to a *debutante*, just lose my head completely y'know.
> SHE: Indeed? what a pity. Well, Christmas is not far off, and perhaps Santa Claus will bring you some presents of mind.

Showing a great deal of presence of mind, Elizabeth worked her way through the rigorous Academy curriculum while continuing to publish her illustrations.

In 1893, the year Elizabeth graduated from the Academy, the Green family endured a crushing loss, one that Elizabeth would be reminded of every year for the rest of her life. The Green's eldest daughter, Katherine, died on Elizabeth's twenty-second birthday. The tragedy must have upset Elizabeth a great deal, yet it did not stop her from working on her drawings and paintings, which she continued to produce and sell. Perhaps she thought her professional success could somehow ease her parents' loss. She was now their only child. So she worked diligently to established herself as a regular contributor to the *Philadelphia Public Ledger*—a newspaper so successful that it became a favorite local pastime to try and calculate the income per second of its editor, George W. Childs. Elizabeth's assignments for the *Public Ledger* were all fashion illustrations: a corseted woman in a broad-shouldered gown that emphasized her tiny waist, a straw hat trimmed with Mercury wings. Although her drawings were competent, they were prosaic and virtually indistinguishable from those of the many other fashion illustrators plying their trade for the eight major local newspapers and numerous local magazines. She had yet to hit her stride.

IV.

Violet Oakley

VIOLET OAKLEY, THE YOUNGEST OF THE TRIO, WAS born in New York on June 10, 1874, into an artistic dynasty. Twelve of her ancestors were artists. She once described her own interest in the field as "hereditary and chronic" and with rare humor remarked that she was born with a paintbrush in her mouth instead of a silver spoon.[25] Her grandfather, George Oakley, was a businessman who emigrated to the United States from London after the Battle of Waterloo, when a depression in the wool business reversed his financial fortunes. Throughout his life he maintained a keen interest in art and returned to Europe many times to copy the works of the Old Masters. He eventually taught himself to paint well enough to be elected an Associate of the National Academy of Design. He encouraged Violet's father, Arthur, to pursue a career in art, and although Arthur eventually established a career in business he maintained an interest in painting.

Violet's maternal grandfather, William Swain, enjoyed a long, successful career as a professional artist and made his living as a portrait painter in Massachusetts, where he gained fame as "The Gainsborough of Nantucket." He was elected to the National Academy in 1836. Swain passed his ability on to his daughter Cornelia, Violet's mother. Cornelia Swain studied in Boston with William Morris Hunt, a well-known painter of the Barbizon school whose murals for the New York State Capitol building gained him public acclaim. Before her marriage, Cornelia Oakley lived for a short time in San Francisco. According to family legend, she set up the first painting studio in that city and occupied herself painting portraits and quaint genre pictures. Two of Violet's aunts, Juliana and Isabel Oakley, also had artis-

Violet Oakley with her oldest sister Cornelia, December 1874. Cornelia died of diphtheria two months after this photograph was taken.
Archives of American Art

tic ambitions and studied in Europe. Juliana married an expatriate Russian aristocrat, Count Michel de Tarnowski, and settled in Nice with her five children. Family responsibilities must have hampered her career. Yet, according to Violet, her aunts continued their studies in Munich with the American painter Frank Duveneck, although both would have been in their forties when Duveneck opened his school in 1878 and years older than their teacher.[26] Violet was justifiably proud of her talented family. In her later years she made several starts at an autobiography but unfortunately never got past the table of contents and a few brief pages. Her first chapter, "Goodly Heritage," began with a quote from the Psalms of David. "The lines are fallen unto me in Pleasant Places: Yea, I have a goodly heritage."[27]

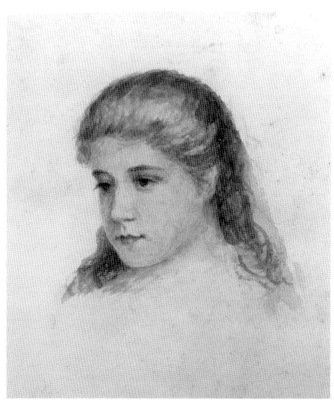

Cornelia Swain Oakley, watercolor portrait of Violet Oakley, c. 1880. Archives of American Art

Violet grew up in Bergen Heights, New Jersey, the youngest of three sisters. Her mother had cast aside her own professional ambitions when she married Arthur Oakley in 1866, yet she was anxious for her children to reap the benefits of a good education. She encouraged all three of her daughters in art, and they spent many hours sketching. The young Violet had an eye for detail and was careful with her drawings; although she always remembered to accessorize the little girls in her pictures properly—attaching bows to the hair and furbelows to the garments—she invariably forgot the noses. When she finally discovered her error, she was mortified and tried to correct her previous omissions by drawing several noses on each portrait.[28] She brightened every picture with flowers and sunshine.[29]

Although Violet's early drawings were cheerful and unconstrained, her childhood was not entirely free from care. She suffered from both asthma and extreme shyness. The Oakleys' first child, Cornelia, died of diphtheria at the age of six after only five days of illness. Violet was eight months old when little Nellie died, and presumably it was the untimely loss of their eldest child that led Violet's parents to become overly protective of their frail baby daughter. Understandably, Violet's mother never recovered from the death of her firstborn. She saved little Nellie's baby teeth, carefully wrapped in paper, for the rest of her life. After her mother's death, Violet apparently did not have the heart to dispose of this last memento of the sister she never knew. The tiny

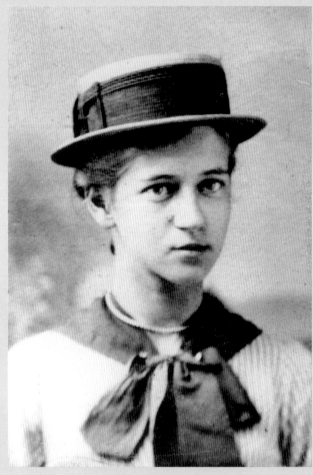

Above left:
Violet (seated) and Hester Oakley. Violet is holding her
favorite rubber doll. Archives of American Art

Above right:
Violet at about age twelve. Archives of American Art

worn teeth still remain with Violet's treasures—now filed carefully in a folder at the Archives of American Art in Washington, D.C.

When her older sister, Hester, was sent to Vassar College, Violet hoped to follow her, but her cautious parents would not permit it. Instead of going off to school, she stayed home, studiously copying the Old Master engravings that both her grandfathers had collected on their numerous trips to Europe. In 1894, when she was twenty years old, her parents finally felt secure enough about their daughter's health to permit her to begin her formal art education. She was allowed to accompany her father on the early train to New York City and attend classes at the Art Student's League, where she studied with Irving R. Wiles and Carroll Beckwith.

In the winter of 1895 Violet's family went to Europe to visit her Aunt Juliana's family in France. Violet and Hester seized the opportunity to travel to Paris for art instruction. The sisters were admitted to the Académie Montparnasse to study with Edmond Aman-Jean and Raphael Nevin. Violet's biographers have made this Parisian experience into a grand event, but in actuality the atelier was the typical all-female class: a mixture of the serious student and the dilettante, the ambitious and the merely bored. Violet plunged into her studies and was captivated by the Parisian aesthetic and the graceful paintings and posters of the Art Nouveau movement. Hester, ambivalent about whether to pursue a career in painting or writing, worked at her easel but also became a keen observer with an ear for dialogue. Later she would incorporate the studio and the clique of eccentric female students who gathered from around the world to study in Paris into her novel, *As Having Nothing*. In her book Hester described the German girl who wore "atrocious" hats and was so talented that the others nicknamed her Holbein, the lonely young woman from Poland with the fiery temper, the sympathetic Americans, and the antipathetic English. She wrote of a daily battle in the studio between a "tall, irritating American and a small irritated Armenian who daily treated the studio to alternating chills and fevers, in defense of their clashing theories of ventilation."[30] That summer the sisters traveled to Rye, England, to take a class with Charles Lazar, the artist Violet credited for helping her conceptualize her paintings. "Work it out alone," Lazar told her. "Work it out with yourself and Nature."[31]

When Arthur Oakley's health began to fail, the European idyll was cut short and the family returned home. Although the exact nature of Arthur's condition remains unclear, in later years Violet described his malady as a nervous breakdown brought on by financial reverses, anxiety, and overwork.[32] A discouraging prognosis concerning his chance of making a full recovery and

Violet (seated closest to the camera on the carriage) with her Tarnowsky cousins in Nice, France, 1895. Archives of American Art

mounting medical expenses compounded the family's financial woes. So Violet and Hester began to think seriously about practical careers. Hester focused her ambitions on writing. Her first attempts at romantic fiction proved successful immediately. Her work was charmingly naïve and decidedly autobiographical; an artistic young heroine finds love when she least expects it and is delivered from poverty to riches in the process. When one of her stories was accepted for publication in the popular magazine *Woman's Home Companion* shortly after the Oakley family returned to the United States, Hester was elated and began working on her novel.

Violet, still unsure of how she could translate her artistic ability into economic independence, took the train to Philadelphia to study with Cecilia Beaux, the first female instructor ever hired to teach at the Pennsylvania Academy of the Fine Arts. She enrolled in two courses at the Academy. The portrait course taught by Beaux, "Drawing and Painting from Head," was the Academy's most expensive offering at $25 per term. Violet also entered the slightly less expensive $20-per-term "Day Life Drawing Class" with Joseph De Camp.[33] Still, with the cost of the matriculation fee, supplies, and her commute, Violet needed a substantial sum to sustain her education.

During her brief tenure at the Academy, Violet's family moved to Philadelphia in search of medical attention for her ailing father from the famous Philadelphia physician S. Weir Mitchell. By this time the family was experiencing serious financial difficulties that both daughters felt an obligation to alleviate. Hester's novel, *As Having Nothing*, was progressing well but would not be published until 1898. In the interim she enrolled in Howard Pyle's 1897 illustration class at the Drexel Institute. Pyle was a writer as well as an illustrator, and Hester Oakley thought she might follow in his footsteps. She loved the class and raced home to her sister exclaiming, "Violet, you must come too. He is simply wonderful!"[34] Violet, who was struggling with the financial burdens of the Academy tuition as well as uncertainty concerning the viability of a career in fine arts, heeded Hester's advice and left the Academy after one semester. Although her reduced circumstances abbreviated her time at the famous institution, she was proud of having studied there, however briefly. She was a lifelong member of the Academy Fellowship and the only artist who attended both the 100th and the 150th anniversary celebrations. Friends remember that she graced the receiving line at Academy functions in her flowing Victorian dresses well into the twentieth century.

Violet Oakley was a passionate, intense young woman, proud of her artistic family and determined to succeed. Hester based the heroine of her novel on her sister and described her protagonist—an aspiring illustrator who, but for circumstances, would have pursued a painting career—as having at the bottom of her soul "a perfect dragon of ambition." Because admission to Pyle's school was competitive, Violet prepared her portfolio carefully. She was elated when the famous artist looked at her work and told her, "I think I can help you."[35] Anxious to secure a space where they could begin working in earnest, the two sisters rented a studio at 1523 Chestnut Street on the third floor of the so-called Love Building, named for its owner. In spite of the family's desperate financial problems, Cornelia Oakley sacrificed her own comfort and loaned her daughters enough family furniture to make the place livable. Aunt Deci's cabinet, two carved chairs, two mahogany tables, Cornelia's own cane armchair, two reception chairs, Violet's desk, two mirrors, curtains, screens, drawings, prints, and a cast of the Madonna completed the eclectic decor.

Violet was twenty-two when she moved into the new studio and began her training at Drexel. She was a slender young woman with voluminous dark hair, hazel eyes, and an inclination to dress in shades of violet whenever possible. Although she was not tall, her perfect posture gave that impression. She was undeniably clever, but very shy and unsure of herself. Hester was the out-

Violet Oakley. *"Well Bless the Boy, He Don't Even Know How to Plant Potatoes!"* From *The Princess and Joe Potter* by James Otis (Dana Estes & Co., 1898)

going one. A Vassar graduate, in a day when most women did not even dream of attending college, she was full of confidence and gaiety. Violet was different. She was never able to conquer her shyness, and even her closest friends admitted that she was a person with strong emotions, "even volcanic at times."[36] As for gaiety, one friend recalled that her personality was "completely opaque," and that she had no sense of humor at all.[37]

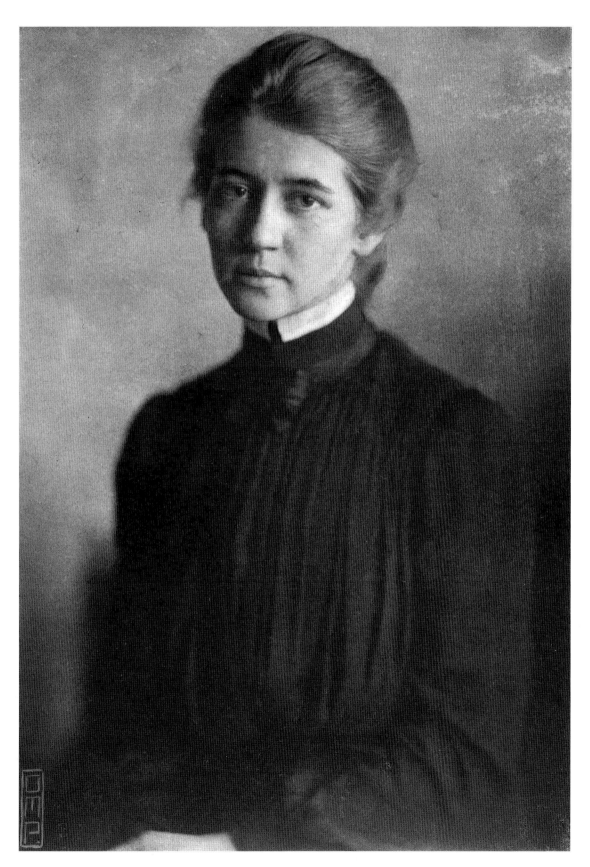

Violet Oakley. Archives of American Art

V.
Howard Pyle

WHEN VIOLET OAKLEY WALKED INTO HOWARD Pyle's illustration class in 1897, she noticed Jessie Smith immediately and was intimidated by her skill and confidence. "Still a little afraid of you—as that first day in Howard Pyle's class!" she wrote to her friend thirty-three years later.[38] Tall, serene Jessie, who was eleven years older than Violet, had not been idle in the seven years since her graduation from the Academy. In 1894, when Pyle selected her to join thirty-nine other promising students in his first class, she was already a competent working professional employed in the advertising department of the *Ladies' Home Journal,* where she produced product drawings of everything from stoves to soap. She earned extra income doing freelance work. Fifteen of her illustrations were included in a book of poetry for children published in 1892, and her drawings had already appeared in some of the nation's leading periodicals: *Harper's Round Table, Harper's Young People, Ladies' Home Journal,* and *Saint Nicholas Magazine.*

Elizabeth Green was also in the group, although she made no immediate impression on Oakley. Like Smith, Green was a charter member of Pyle's first class and an established professional illustrator. Shortly after her graduation from the Academy she was offered a job drawing fashion illustrations for the Strawbridge and Clothier department store, although it was her confidence as much as her ability that secured her the position. When she arrived for her job interview an editor showed her a drawing by an experienced illustrator and asked if she could duplicate it. When—without a moment's hesitation—she declared that she could, she was hired on the spot. The young artist worked diligently at Strawbridge's until 1895 when she was offered a more lucrative situation and joined her friend Jessie Smith at *Ladies' Home Journal.* The editors at the *Journal* made good use of Green's previous experience and put her to work illustrating a series of fashion articles. The job was steady although not challenging. For two years she supplied drawings for articles offering advice on diverse fashion concerns—everything from "Suitable Mourning Costumes" to "Dainty Fashions in Lingerie."

It is not surprising that when the Drexel Institute announced that Pyle would teach an illustration class, the course was immediately oversubscribed, and working professionals like Jessie Smith and Elizabeth Green were anxious

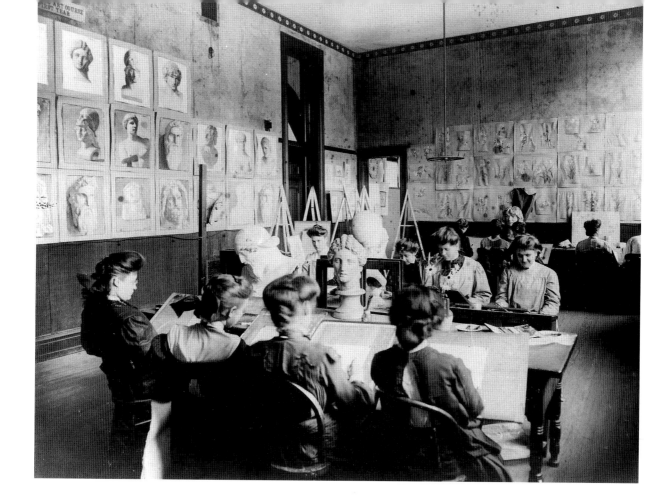

Drawing class at the Philadelphia School of Design for Women. Moore College of Art Archives

to be admitted. Howard Pyle began his teaching career at the age of forty-one, at a time when the high demand for magazine illustrations coincided with a decisive drop in their quality. Because illustrated books and periodicals were the main source of news and information, Pyle felt it was especially important that the artists who worked for publication have the most rigorous training possible. Initially he offered his services to the Academy, but they were not interested in any course in practical art. Pyle took the rejection personally; several years later, when the Academy reconsidered and offered him a position, he declined, remarking: "He who will not when he may, when he will, he shall have nay."[39]

A prolific talent and a patriotic "missionary of Americanism," Pyle and his illustrations were admired on both sides of the Atlantic. He surpassed his own definition of fame, "to have people talk about your work outside your own town," when he was still a young man.[40] In the 1880s he produced a steady flow of work, countless illustrations for magazines and drawings for the books that he wrote as well as illustrated. The *Merry Adventures of Robin Hood* was published in 1883 and garnered rave reviews in England and the United States. Critics admired Pyle's prose as well as his elegant pen-and-ink drawings, which were inspired by the work of Albrecht Dürer. The success of *Robin*

Howard Pyle. *The Little Officer Bending to the Saddle.* From *The Two Cornets of Monmouth* by A. E. Watrous, *Harper's Weekly* (September 12, 1891). The Kelly Collection of American Art

Hood was immediately followed by the publication of two more acclaimed books. Within a few short years his reputation as a writer and illustrator was so extensive that his fourth book, *The Wonder Clock*, was released simultaneously by Harper's in New York and Osgood McIlvane & Co. in London. In five years he had written and illustrated six books: two for adults and four for children. In the next eight years he produced more than one thousand illustrations for books and periodicals.

Although Pyle was committed to teaching, his own career kept him so busy that initially he was able to offer instruction only on Saturdays at 2:00 P.M., a convenient schedule for professionals like Smith and Green. However, during the first two years, Pyle's weekend class was so successful that the president of Drexel was able to persuade him to extend his commitment and teach two days a week in a new School of Illustration. Pyle scheduled classes on Monday and Friday. The rest of the week his students worked on their paintings at home. On the days when they did attend class, instruction began at nine o'clock in the morning with consultation and criticism, followed by life drawing. After lunch, courses in composition and practical illustration augmented the curriculum. In spite of this somewhat irregular schedule, Howard Pyle proved to be a charismatic, innovative instructor who treated everyone with patience and impartiality. He was an unselfish man, proud of his students' accomplishments. When any of them began to show professional promise, he was quick to recommend their work to the many distinguished art editors who trusted his judgment implicitly. Many of his best students began working professionally while still enrolled in his classes. After his first class with Pyle in 1902, N. C. Wyeth was inspired and wrote home to his mother, "The composition lecture lasted two hours and it opened my eyes more than any I have ever heard."[41] Pyle's per-

sonality was so strong that students were captivated by the powerful momentum of his teaching and found that it was impossible not to imitate him, at least for a few weeks. Jessie Smith recalled that "the class was filled with rows of temporary Howard Pyles."[42]

In the illustration class at Drexel, male and female students were given the same opportunities, although life-drawing classes were still segregated. There are no records of what Smith thought when her former teacher, Eakins, was hired at Drexel to teach a series of twelve classes. Undaunted by his previous problems at the Academy, he once again posed a nude male model in front of a women's class and was fired. However, this time the public reaction was much more tempered. The *Philadelphia News* defended the illustrious painter.

> We are inclined to think that there is a great deal of puerile and morbid nonsense about this matter. We are sure that no artist, male or female, would raise it, and that schools which are run on this restricted and hopelessly narrow line have little in common with real art or artistic impulse.[43]

Eakins must have had a good idea of the outcome of his decision to defy Drexel's rules for decorum in the life class. Perhaps his intentions were honorable, but it is difficult not to be skeptical given his outspoken opinions on the limitations of women painters. Pyle, on the other hand, believed that women artists could create work comparable to the productions of their male colleagues. His own philosophy ran contrary to the popular Victorian notion of a woman's true vocation as "the angel in the house." He supported a woman's right to a professional career yet sustained the idea that a

Howard Pyle. *Why Don't You Just End It?* From *To Have and to Hold* by Mary Johnston (Houghton Mifflin, 1900). The Kelly Collection of American Art

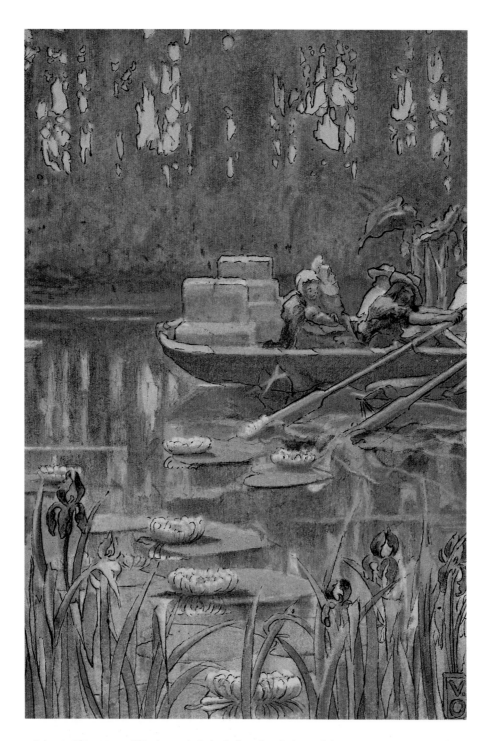

Violet Oakley. *Water-lilies in Myriads Rocked on the Slight Undulations.* From *Evangeline* by Henry Wadsworth Longfellow (Houghton Mifflin and Company, 1897)

Howard Pyle recommended Jessie Willcox Smith and Violet Oakley for this commission while they were still his students. Proud of both his protégées, he wrote: "I may hardly compare one with another, but I like the image of Evangeline standing in the hot radiance of the yellow fields gathered of their harvests, and I like the image of the boat floating out into the glassy level of the great river, mirroring a reflection of the prismatic light that one may easily fancy illuminated the soul of the poet himself when he wrote his lines, so long ago, to us of a younger generation."

Jessie Willcox Smith. *Fair in Sooth Was the Maiden*. From *Evangeline* by Henry Wadsworth Longfellow (Houghton Mifflin and Company, 1897)

successful female artist could not easily combine the role of wife with the demands of professional illustration. When a woman married, Pyle once said, "that was the end of her." Smith, Green, and Oakley did not mimic their teacher's technique, but Pyle's opinions had a profound effect on their personal lives as well as their artwork. "In my own experience, it seems to me he did not so much teach me how to draw but how to interpret life," Green remembered many years later. "He taught me, I might say, what philosophy of life I may possess."[44]

Pyle's instructions on how to approach an assignment were specific and inflexible. All students were to draw a minimum of fifty sketches for each illustration. Even if the first one seemed perfect, Pyle urged each of them to make the other forty-nine in order to simplify the compositional elements. "They will never shoot you," Pyle once noted, "for what you take out of a picture."[45] Under Pyle's tutelage all three women improved their work, refining their concepts and designs under the discipline of revision. As Smith later recalled, "He put himself right down on the plane with ourselves and was just one of us, and said 'I have twenty years of practical experience in illustration, and I may know a few things that will be helpful to those of you who are just beginning,' and then he would proceed to pour into us a fund of inspiration, knowledge and experience. We would hear more in one afternoon than we could assimilate in a year."[46] Green had similar memories.

> His wide human sympathy was the thing that impressed us, I think, most. There seemed no situation in life that he did not understand and did not know how to convey to you, and although he was a very great man and a very learned man, and a very, very, very great artist, it is perfectly amazing how much of a comrade he immediately made himself to us. He was never didactic. He was the most courteous person in conveying information that I have ever known.[47]

Although their teacher was encouraging, Smith, Green, and Oakley were not the stars of the class. That honor was reserved for Stanley Arthurs and Frank Schoonover.

Schoonover was a special favorite of Pyle's, and the two men often met for lunch when the one-hour break from class offered a brief hiatus in the long day. On one such occasion, Pyle seemed uncharacteristically irritated and angry. Finally he vented his frustration to his student and shouted, "I can't stand those damned women in the front row who placidly knit while I try to strike sparks from an imagination they don't have."[48] Presumably he was not

referring to Smith, Green, or Oakley. He counted them among his top students and recommended Smith and Oakley for their first important commission, a series of illustrations for Longfellow's *Evangeline,* which was published in 1897.

Pyle had noticed a similarity between the paintings of the two women that caused him to believe that a collaborative project would be successful. However, this equivalence in style was not unique to Jessie and Violet. Many of Pyle's women students worked together on their assignments and came to approach their paintings in a similar way, beginning with a strong linear drawing and then filling in the composition with areas of flat decorative color. Their work was heavily influenced by the influx of Japanese decorative art and prints that flooded Western markets in the last half of the nineteenth century, when Japan, after almost two hundred years of isolation, again opened its borders for trade. They also admired French Art Nouveau design and illustration with its obvious Japanese influence, flowing feminine lines, floral ornamentation, and unexpected asymmetry. It has been noted that the work of Pyle's female students is much more consistent in style than the work of their male colleagues, a testament to the spirit of camaraderie that developed among the serious women students in the class. Henry Pitz, Pyle's biographer, commented on these alliances, noting that it should not be forgotten that even in the presence of the most gifted of teachers, "students educate each other."[49]

The *Evangeline* project began a friendship between Jessie and Violet that was to last a lifetime. They could not have been a more unlikely pair—unpretentious, self-effacing Jessie and fiercely determined Violet—but the commission bound them together. As they worked, Violet gained respect for Jessie's competence and experience as an illustrator, as well as her technical facility in painting acquired during her tenure at the Academy. Jessie was impressed with Violet too. The younger artist was sophisticated and urbane, with family connections in the art world and in European society—contacts that dazzled Jessie, whose own background was much less illustrious. They were both aware that the *Evangeline* commission was an extraordinary professional opportunity for them. A book with color illustrations by a major author from a top publishing house could launch their careers. When they began their project in earnest, they spent as much time together as possible and showed each new production to their teacher. The process of working as a team was something new to them, but they found the collaboration helpful. Both of them felt that they were producing their best work, and they began to discuss sharing studio space.

VI.
The Love Building

JESSIE SMITH'S SMALL STUDIO AT 1334 CHESTNUT Street in downtown Philadelphia was close to her job at the *Ladies' Home Journal* but barely large enough for one artist. The Oakley sisters' quarters at 1523 Chestnut Street were much larger. The three-room skylit space on the third floor where the sisters lived and worked could easily accommodate another artist, so Jessie was invited to move in. Hester Oakley did not stay long. Writing had become the central focus of her career, so perhaps she felt she had no more need for studio space. When she left, her space was filled, first by Ellen Wetherald Ahrens, a former Academy student who was also studying with Pyle, and later by Elizabeth Shippen Green and another of Pyle's students, Jessie Dodd. It is possible, since Jessie Smith had cousins with the sur-

name Dodd, that Jessie Dodd was a relative, perhaps the cousin with whom she attended high school in Cincinnati.

Elizabeth Green, who still produced all her illustrations in the same corner of her childhood bedroom where she had worked for the previous eight years, was especially happy with the new accommodations. The building had high ceilings and good light, and their sympathetic landlord, Clement C. Love, who Violet described as a "sensitive and very amiable little man," charged them only $18 each per month for the combined studio and living space. Because he was patient when they occasionally fell behind on the rent, they dubbed him "Clemency Love" in honor of his benevolence.[50]

Smith, Green, and Dodd added to the Oakley collection of furniture and decorated their quarters in the manner popular with the famous artists of the day. William Merritt Chase's vast showplace studio in New York set the standard with its eclectic mix of paintings, sculpture, and antiquities. Accounts in the popular periodicals featured photographs of the famous atelier, which may have convinced the four women to attempt to reproduce it on a smaller scale. Photographs of the Chestnut Street studio reveal somewhat shabby rooms brightened with ornate fabric, wicker chairs, cloth-draped tables, posters, and paintings; a print of the Mona Lisa shared wall space with a poster by Edward Penfield and work by the four women. A cast of a Roman sculpture from the British Museum, purported to be a portrait of Mark Antony's daughter Antonia, and a large Japanese vase—both inherited by Violet from her grandfather George Oakley—added distinction to the mix.

Outfitting their new accommodations did not interfere with the energy and enthusiasm the tenants at 1523 Chestnut Street devoted to their illustrations. Jessie Smith and Violet Oakley worked faithfully on the *Evangeline* illustrations, soliciting help and advice from their famous teacher. It was not unusual for Pyle to catch an early train to Philadelphia, climb the stairs to their third-floor studio, and critique their work before rushing off to teach at Drexel. His time was evidently well spent. He was delighted with the finished paintings. When *Evangeline* was published in 1897, he wrote a suitably proud "Note on the Illustrations" to accompany the text. Smith and Oakley must have been pleased to have earned such praise from Pyle.

> There is a singular delight in beholding the lucid thoughts of a pupil growing into form and color; the teacher enjoys a singular pleasure in beholding his instruction growing into definite shape. Nevertheless, I venture to think that the drawings possess both grace and beauty.[51]

Opposite:
Violet Oakley in her studio at 1523 Chestnut Street, c. 1897.
Archives of American Art

47

Violet Oakley. *June.*
Cover illustration from
Everybody's Magazine
(June 1902). The Penn-
sylvania Academy of
the Fine Arts, Philadel-
phia. Henry D. Gilpin
Fund

The *Evangeline* project was a critical success and led to more assign-
ments for Smith and Oakley. Among Smith's commissions in 1897 were sever-
al illustrations published in a novel by Maud Wilder, and two cover illustrations
for *Woman's Home Companion*. Violet garnered covers for *The Century* maga-
zine and *Collier's Illustrated Weekly*. Elizabeth Green made enough money to
take a trip to Europe; at the end of the year she boarded the S.S. *Noordland* and,
chaperoned by her mother, visited London, Brussels, Paris, Antwerp, and
Amsterdam.

Green returned to Philadelphia inspired by the great museums of
Europe and determined to keep that enthusiasm directed. When she joined her

friends in their downtown studio, her energy proved contagious. The four young artists were anxious to expand their focus, to collaborate, and to continue their education, even though they had completed their schooling. In 1897 they had been presented with an opportunity to be part of a vibrant artistic community, becoming devoted charter members of the Plastic Club. The Plastic Club was the first successful woman's art organization in the country. At that time the word *plastic* did not carry its current meaning but referred to the fact that an unfinished work of art is always in a malleable, or plastic, state. The club was conceived by a group of women artists who met at the Philadelphia studio of sculptor John Boyle to discuss common professional concerns. Their gathering fostered a determination among the city's female artists to form a supportive organization through which women could combine artistic and social interests. Since

Violet Oakley. *Lenten Cover.* From *Collier's Illustrated Weekly* (February 1899). Collection of Jane and Ben Eisenstat

1860, the Philadelphia Sketch Club, an organization restricted to men, had provided male artists with a place to share information, discuss and debate current issues in art, hold drawing classes, and invite visiting artists and writers to lecture. Smith, Green, Oakley, and Dodd wanted no less for themselves.

The Plastic Club members elected officers, solicited membership limited to "women engaged in the pursuit of art in any of its branches," and selected a motto from a poem by Théophile Gautier.

> All passes—art alone
> Enduring, stays to us.
> The bust outlasts the throne
> The coin—Tiberius.[52]

Housed in a room at the Fuller building at 10 South 18th Street, the club membership roster included most of the best-known women artists in the city—local celebrities very much admired by the four young illustrators. The noted painter Blanche Dillaye served as the first president. Emily Sartain,

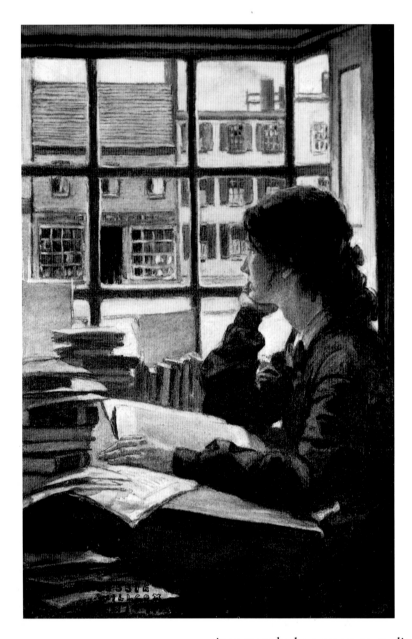

Jessie Willcox Smith. *She Read One of the Annuals, or Gazed through the Window*. From "The Emigrant East" by Arthur Colton, *Scribner's* (December 1900). Photograph courtesy of Illustration House

Opposite:
Violet Oakley. *Elizabeth Shippen Green*. c. 1900. Collection of Jane and Ben Eisenstat

president of the Philadelphia School of Design for Women, and illustrator and painter Alice Barber Stephens shared the vice presidential duties. Other members included the illustrator Charlotte Harding and Violet's eminent teacher, Cecilia Beaux.

The club was not without its skeptics and critics among both the press and the community of male artists, but the women were determined. "We had the anticipation, not the fulfillment of success," wrote president Blanche Dillaye.[53] "We had prejudices to meet and overcome, we had the belittling prejudice against women's art clubs, and we had, to justify that, a history of many mediocre organizations against us."[54] Nevertheless the members persevered, so that by 1898 the club was able to offer a full schedule of speakers, classes, and social opportunities.

The first Tuesday of every month was reserved for an informative lecture selected to keep members apprised of developments in their profession. The weekly drawing classes the club sponsored were a godsend for many of the women, since most had no access to studio space large enough to pose a model. Social events and parties were also on the calendar, but most significantly a series of shows of the members' artwork gave many of the women their first opportunity for a public exhibition. Jessie Smith, Elizabeth Green, and Violet Oakley were active participants in the club, lending their expertise where they could. Smith and Oakley served on the Committee on Designs and illustrated and designed club flyers, reports, and exhibition posters. Green was elected to the Exhibition Committee.

Although Jessie Dodd joined the organization with her housemates, she was not an active member. The easy camaraderie the other three artists shared eluded her. Their many successes seemed to emphasize her failures, and

perhaps she felt excluded from their increasingly intimate circle. Lacking the skill and self-assurance of her friends, she had a difficult time gaining commissions. When she did find work, the pressures of the deadlines and her lack of confidence in the final results caused her to suffer debilitating headaches that sometimes lasted all day. In 1899 she gave up and returned home to Ohio. Jessie Smith was especially saddened by her defection. As a farewell gift, the three women made Jessie Dodd a friendship calendar for the coming year and illustrated each page to accompany a quotation or personal message. Jessie Smith wrote, "After all, say what we will, the one supreme luxury of life is sympathetic companionship."[55]

Sympathetic companionship is one term that could be used to describe the intense feelings that were developing between Jessie, Elizabeth, and Violet. A more common name at the time was *romantic friendship*. In the nineteenth century, romantic friendships were accepted as a normal part of a woman's life. Even an intense relationship that included effusive love letters and tender embraces was looked upon as a common and harmless diversion, a natural result of women's sympathetic, sentimental natures.

At the new women's colleges that proliferated in the last half of the century, the officially sanctioned social activities encouraged the formation of strong emotional ties among the students. Parents did not want their daughters to fraternize with the opposite sex while they were away at school, so, although dances were organized, men were not invited. Even though there were no male guests, these events were meant to be romantic occasions, and the infatuations that developed as a result evidently displeased neither the young women, the college administrators, nor the general public.[56] An article in the January 1895 issue of *The Century*, entitled "Festivals in American Colleges for Women," described the procedure for one such event at Smith College without a hint of censure.

> Looking down from the running-track on seven or eight hundred girls dancing together, one is struck by the almost theatrical effect of the swaying forms and bright colors against the background of lavish decoration with which the second class has tried to outdo the class above. Men are not missed, so well are their places filled by the assiduous sophomores. Each new girl is escorted to the gymnasium by her partner, who in addition to filling her dancing-card and sending her flowers, provides her with a "memrobil," sees that she meets the right person for each dance, entertains her during refreshments and escorts her home.[57]

In the nineteenth century it was a widely held view that a close roman-
tic friendship between two young women could keep a girl out of trouble while
she waited for the right young man to introduce her to what Henry James
called "her sterner fate."[58] Such intense romantic relationships between women
were considered benign, partly because women were thought to be essentially
uninterested in a physical relationship unless aroused by a man. Even when
thus brought around, experts suspected that while women were often attentive
to their marital duties, they took little pleasure in the process. In *The Physiolo-
gy of Women*, written in 1869, the author noted: "There can be no doubt that
the sexual feeling in the female is, in the majority of cases, in abeyance, and that
it requires positive and considerable excitement to be roused at all; and, even if
roused (which in many instances it can never be), is very moderate compared
with that of the male."[59]

As Jessie, Elizabeth, and Violet shared their triumphs and failures and
the everyday pressures of meeting editors' demands and deadlines, their rela-
tionship with one another grew stronger. Their success forced them to make a
decision about their lives. Howard Pyle had already made it clear to them that
combining a career with marriage was not an option in an age when a woman
was expected to manage a household, function as a hostess, and bear children
from matrimony till menopause—and Pyle's opinions were sacrosanct. The
three friends chose to continue their careers in art. In a rare interview, Jessie
once stated her opinion on the subject: "A woman's sphere is as sharply defined
as a man's," she noted. "If she elects to be a housewife and mother—that is her
sphere, and no other. Circumstance may, but volition should not, lead her from
it. If on the other hand she elects to go into business or the arts, she must sac-
rifice motherhood in order to fill successfully her chosen sphere."[60]

Secure with their decision to dedicate their life to their art and free from
worry over the health and happiness of Jessie Dodd, the three women soared
in their careers. Smith and Green, who were both still working for the *Ladies'
Home Journal*, soon had enough freelance work to enable them to quit their
staff jobs. Green's pen-and-ink drawings appeared on covers for *The Scholar's
Magazine* and *St. Nicholas*, and accompanied short fiction in the Curtis Pub-
lishing Company's *Saturday Evening Post*. One of her drawings for the Curtis
Publishing Company was reproduced in a beautiful volume published in Lon-
don: *The Studio*'s 1900–1901 special winter number, "Modern Pen Drawings:
European and American." She must have been thrilled not only to have her
work featured with renowned illustrators Edwin Austin Abbey, Maxfield Par-
rish, and her teacher Howard Pyle but also to receive her first encouraging

international review from editor Charles Holme: "Miss Elizabeth Shippen Green though a newcomer, draws with force and has a nice regard for the decorative effect of lines and black masses."[61] Jessie Smith illustrated several books, among them Nathaniel Hawthorne's *Tales and Sketches* and *Mosses from an Old Manse*, as well as numerous stories for *Harper's Weekly, Scribner's,* and *Harper's Bazaar.*

Violet Oakley's professional life also flourished. In addition to her illustration work, she experimented with designs for murals and stained glass. Caryle Coleman, one of her former teachers at the Art Students' League, saw her illustrations for *Evangeline* and thought her decorative, circumscribed paintings would translate well to stained glass. Coleman, who at the time was the head of the Church Glass and Decorating Company, suggested that Violet design an "Epiphany" window for his firm. If the design proved workable his craftsmen would translate it to glass, and it would be displayed in the company's New York office. Violet put her heart into the drawings and was pleased when they were accepted. Although there was to be no remuneration for designing the window, she hoped someone might notice her work and trust her with a similar commission. Passionate and dramatic by nature she sought some portent to assure her that her new venture might prove successful. So after she delivered her designs, she went alone to the Church of the Ascension on lower Fifth Avenue in New York and prayed, in front of the imposing altarpiece by the famous mural painter John La Farge, that one day she too would be worthy of such an assignment.

Oakley's first stained-glass window design, sketched as a sample for the Church Glass and Decorating Company of New York City, 1900. Archives of American Art

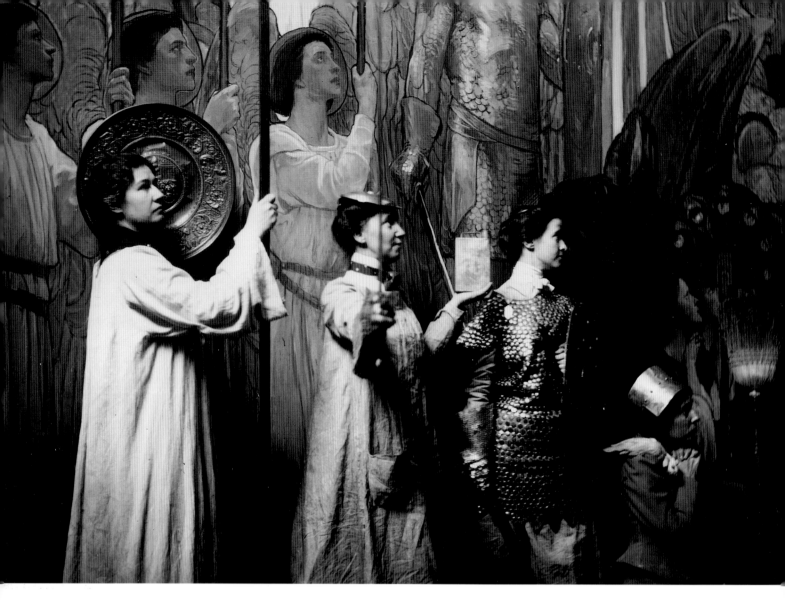

Jessie Smith, Henrietta Cozens, Elizabeth Green, and an unidentified friend pose in front of Violet Oakley's mural for All Angels' Church in New York City. Archives of American Art

In 1900 her prayers were answered. One of Coleman's clients admired her work, and she was chosen to paint two murals and create five stained-glass windows and an altarpiece in mosaic for All Angels' Church on 81st Street and West End Avenue on New York City's Upper West Side. To prepare herself for the assignment, Violet made numerous sketches. Even after they were approved, she continued to make more detailed drawings, beginning a pattern of perfectionism that would enrich her work but diminish her bank account. She was only twenty-six years old and intimidated by the task ahead of her.

The commission was a personal triumph for Violet, and it came at a time when her life was changing in a number of ways. In the summer of 1900 Violet's parents left Philadelphia temporarily for Fort Washington, Pennsylvania, to avoid the oppressive heat that threatened Arthur Oakley's fragile health. Hester, who had fallen in love with her longtime friend Stanley Ward and abandoned her career as a novelist, decided to accompany her parents on their vacation. Increasingly worried about her father's failing physical and emotional

condition, Violet took a well-deserved break from her work to join the family reunion. It was during this brief interlude that she came upon an edition of *Science and Health with Key to the Scriptures* by Mary Baker Eddy, the founder of the Church of Christ, Scientist. She read the volume avidly, hoping it would offer a formula for the restoration of her father's health.

Hester Oakley and Stanley Ward were married on December 14 at St. Thomas Episcopal Church in Whitemarsh, Pennsylvania, at high noon. Because of the Oakleys' reduced circumstances, the wedding was a modest affair. Arthur Oakley summoned the strength to walk his daughter down the aisle, and Violet, the maid of honor, was her sister's only attendant. Family friends hosted the wedding breakfast. The new couple set up a residence in Orange, New Jersey, and the rest of the family returned to Philadelphia.

Despite warnings from the Oakley family's Episcopal clergyman and vehement opposition from Hester, Violet began taking a course taught by one of Mary Baker Eddy's students. Still intent

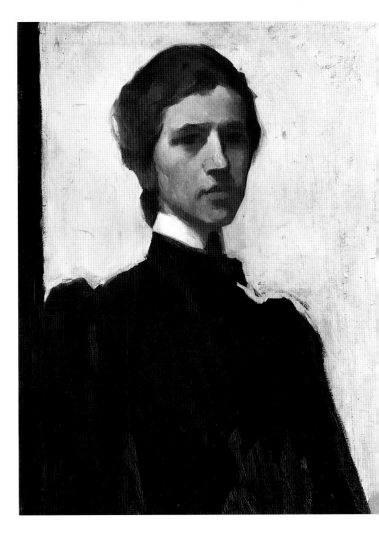

Violet Oakley. *Self-Portrait: The Artist in Mourning for Her Father.* c. 1900. The Pennsylvania Academy of the Fine Arts, Philadelphia. Gift of the Violet Oakley Memorial Foundation

upon finding a cure for her father, she could not reconcile herself to the fact that he was beyond any help. He died soon after Hester's wedding, leaving the family bereaved and in serious financial difficulties. In her grief, Violet did not lose her religious conviction or believe that her father's death in any way repudiated the uplifting message of *Science and Health*. On the contrary, she found spiritual guidance and comfort during this difficult time in Eddy's teachings and became a devout lifelong Christian Scientist. She credited her new faith with the complete remission of her asthma and a general feeling of good health and well being. Her religious beliefs also affected her philosophy on the purpose of art. She began to see her career not only as a way to earn a living but as a way to teach moral values and elevate the human spirit. The All Angels' project gave her the opportunity to create artwork that was more in tune with her emerging social conscience. Art, she wrote, could be a "stimulus to civic righteousness." The "elevating influence of beautiful images" could have a positive effect on the community.[62]

VII.
The Romance of the
Red Rose

ALTHOUGH JESSIE SMITH, ELIZABETH GREEN, AND Violet Oakley must have been delighted that their work was gaining so much recognition, fame had a price. A sign posted on the staircase wall at the Chestnut Street studio stating emphatically, "Match-boys, Peddlers, and Beggars not allowed in this building," failed to shelter the young women from all sorts of intrusions.[63] Match-boys, peddlers, and beggars were the least of their problems. Art students seeking advice and reporters curious about their unprecedented success came calling. Edith Emerson, Oakley's friend and companion in later years, blamed some of the disruptions on Green. Flirtatious and witty Elizabeth, Emerson wrote, "kept everyone amused with her repartee and various young architects, art editors, sculptors and family friends dropped into the studios—or rather climbed the many stairs to the top floor."[64]

In the cold weather intrusions on their privacy were tolerable. But when the summer heat rose through the building to the top-floor studios, and the sun shone through the skylights, their productivity diminished even without the unwelcome interruptions. In the days before air-conditioning, Philadel-

The Low buildings at Bryn Mawr College, c. 1900, around the time that Smith, Green, and Oakley spent the summer there. Courtesy of the Bryn Mawr College Archives

The Red Rose Inn.
Archives of American Art

phia summers were notoriously unpleasant. The weather occasioned much misery, causing more than one resident to recall with irony William Penn's proud boast that his city lay "six hundred miles nearer the sun" than England.[65] Frustrated and hot, the women escaped to the country. They rented apartments in the Low dormitory on the Bryn Mawr College campus where the humidity was tempered by suburban breezes and young men were not likely to distract Miss Green. Invariably quick-witted, Elizabeth amused her friends by claiming that she obtained her whole education that summer, sitting on the college lawn breathing in all the knowledge left unabsorbed by the coeds.[66] The three young artists stayed at Bryn Mawr through the worst days of summer heat. Jessie and Elizabeth made good use of their time by garnering a commission to illustrate the 1901 calendar for the college. Characteristically, they were unable to enjoy their well-deserved vacation without productive work, and they designed an impressive labor-intensive piece. Smith painted five full-page illustrations for

Jessie Willcox Smith and Elizabeth Shippen Green. Illustrations from the 1901 Bryn Mawr College calendar. Photographs courtesy of the Bryn Mawr College Archives

During the summer of 1900, while they were living in the Low building on the campus of Bryn Mawr College, Smith and Green produced this calendar. Their friend Ellen W. Ahrens also worked on the project, contributing decorative floral panels and collaborating on one of the main illustrations with Smith.

Jessie Willcox Smith. *Maypole*

Jessie Willcox Smith. *Graduation* Jessie Willcox Smith. *Soccer*

Above:
Elizabeth Shippen
Green. *Sleigh Ride*

Below:
Elizabeth Shippen
Green. *Graduation
Hats*

the calendar, and Green contributed twenty-four colored illustrations for headers and footers on each page.

It was at the end of this vacation, in the early autumn of 1900, that the three friends first visited the Red Rose Inn in the suburb of Villanova. The summer in Bryn Mawr had done nothing to hone their enthusiasm for returning to the city. Considerable time spent browsing through a collection of *English Country Life* only added to their dissatisfaction. They dreamed of the lifestyle they saw delineated in the pages of the magazine. "We became enamoured of the idea of living in the midst of the beauty and order of such Gardens as those of England: of having a country estate; of escaping from work in city studios," Violet wrote.[67]

It had been the ambition of all three women from the beginning of their collaboration not only to achieve artistic success but also to advance to the inner circle of Philadelphia's social elite. Jessie brought only industry and aspiration to their alliance. Violet brought her "dragon of ambition" and her impressive European connections, and Elizabeth brought her certified entrée into Philadelphia society through her distinguished ancestors. Yet all three lacked an essential ingredient necessary for acceptance in the best circles: inherited wealth. Although Americans like to think that a democratic society pre-

Jessie Willcox Smith and Elizabeth Shippen Green. Illustrations from the 1902 Bryn Mawr College calendar. Photographs courtesy of the Bryn Mawr College Archives

These illustrations are from the second calendar Smith, Green, and their friend Ellen Ahrens produced for the Bryn Mawr College Student Association.

Jessie Willcox Smith. *Students on a Street Car*

Elizabeth Shippen Green. *Student and Teacher on Horseback*

Elizabeth Shippen Green. *Girl on Sailboat*

cludes the rise of aristocracy, in his book *The Perennial Philadelphians*, Nathaniel Burt disputes the point and contends, "There can or should be no doubt that Philadelphia is one of many American communities where an hereditary upper class has existed from the beginning—as soon as it got a chance to get started—and where it proposes to keep right on going whether anyone believes in its existence or not."[68]

In William Penn's municipality, hereditary wealth did not often manifest itself in lavish spending or ostentatious attire, but rather in the family estate. Although Philadelphia is a flat, industrial town, it boasts beautiful rolling suburbs. In the last half of the nineteenth century, many of the city's elite fled from the center of the city out along the Pennsylvania Railroad's westward "Main Line" to aristocratic English-style country homes. Bryn Mawr College sat squarely in the middle of these Arcadian fields, and the three friends toured the neighboring countryside that summer, admiring the imposing homes of Philadelphia's leading families.

One day, as summer was waning and their return to the city imminent, they drove out to Villanova from Radnor, where Elizabeth's parents were staying, to see the famous Red Rose Inn. The estate had been in the news for several years—the subject of numerous newspaper articles centering around the plans of the owner, Frederick Phillips, to turn the property into an artists' colony. After a visit to William Penn's ancestral home, Stoke Pogis, in England, Phillips was inspired to christen his holdings with the same name and to formulate a scheme to subdivide the more than eight-hundred-acre property into a number of building lots. It was his dream to supervise the building of new homes on these lots and to lease these residences to creative people with few resources but refined taste who might then "develop their talents amid the graceful surroundings of country life."[69] Unfortunately, his siblings (who shared an interest in the property) filed numerous lawsuits to prevent him from spending their inheritance on what they viewed as a foolhardy venture. Neighbors, who called the plan "Phillips's Whim," were opposed to the undertaking and concerned about the proximity of potentially eccentric artist-tenants. The legal battles stalled Phillips's grand scheme for a number of years, but he was not completely thwarted. Inspired by the old hostelries in the area, he opened the farmhouse to the public as an inn. He called it the Red Rose, in keeping with the Stoke Pogis theme. It was the custom of Penn's leasehold tenants to present him with a red rose in lieu of quitrents. Phillips planted a garden full of red roses and presented one to each of his visitors when they signed the guest book.

Eventually, Frederick Phillips won his legal battles and was proceeding toward the establishment of his American Stoke Pogis when his death halted all plans. His litigious relatives, anxious to finally liquidate the assets, immediately put the Red Rose Inn, along with 205 acres of the property, up for sale. The Inn was to be closed to the public shortly, so the three friends who had heard so much about the beautiful farmhouse and spectacular gardens made plans to tour the grounds before it was too late. Violet, who claimed to have lived her entire life in the "consciousness of a perfect place," believed she had found it.

> Never shall I forget that drive along the Spring-Mill Road, through loveliest, pure country: the sharp turn into the quarter-of-a-mile of private drive-way between clipped hedges; over the little bridge across the Arrowmink Creek; past the two weeping willow-trees which swept our faces quietly as we drove through the stone posts of the second gateway and up the last long slope to the long, low stone house with its line of barns, stables and other out-lying buildings forming the happiest combination possible, and in that late autumn afternoon light of a mellowness and beauty, a fragrance and magic quite beyond the telling.[70]

Jessie and Elizabeth set out immediately to investigate the grounds. Violet, who was caught up in one of the intense, almost mystical experiences that would occur in her life with increasing frequency, stayed apart from her friends. She sat alone under the buttonwood tree by the spring house, looking out on what the trio would call the "Divine South Front," and claimed the property for herself. When she finally joined the other women on a tour of the residence, she had an eerie sense that the whole place was perfectly familiar to her and that she had lived there before. "I had lived in all those rooms, had gone up and down its winding staircase, sat by the great open fireplace in the hall. It was all more vividly real and actual and right and my own than anything in this world had ever been before. It was a very strange and intense experience," she later wrote. "I said nothing about it at the time but I shall never forget it."[71] Twenty-six years later, the memory of that initial visit was still fresh in Violet's mind: "It was in the year 1900 that I first found myself at the Red Rose, Villanova, and I knew at once that I had come home. This was it."[72]

Jessie and Elizabeth had no comparable cryptic feelings, yet they both fell in love with the property. They went back to the city and delved into their assignments with renewed ambition and energy, hoping eventually to save enough money to buy a house in the country. They harbored no illusions about

purchasing the beautiful Red Rose Inn, for although the women were flourishing financially, even their combined incomes could not begin to underwrite a two-hundred-acre estate. Later that year, they gave up all hope when the property was purchased for $200,000, by Anthony J. Drexel. Nevertheless, the inn became their archetype for gracious country living.

Although the Inn was closed to the public, it was vacant. With no owner on the premises to resent the intrusion, they took another trip out to the estate. The house was locked and silent; but the women peeked through the windows and saw that nothing had been changed or removed. The flowered wallpaper and quaint old furniture were still there, as Violet said, "simply waiting."[73] Violet's confidence that the house was destined to be theirs was contagious. The women checked their finances and formulated a plan to rent the estate. Brimming with excitement they went to their lawyer, Elizabeth's cousin, Joseph Green Lester. Lester, who was to help the women with a variety of legal matters over the years, was a generous man who never once charged them for his services. Initially the idea that the three illustrators might rent such a lavish estate must have seemed preposterous. Yet Lester's transactions with the agent for the property yielded some hope that an agreement might be possible.

Jessie, Elizabeth, and Violet returned to Chestnut Street so exhilarated about the prospect of renting the Inn that they were afraid someone else would snatch it from their grasp before the negotiations were complete. Reluctant to mention their scheme even to close friends, they developed a personal code based on the text of the Henry James story, "Covering End," so they could discuss their plans without revealing their secret. They called the Red Rose Inn "Covering End" and dubbed their lawyer, Lester, the "family solicitor." "Prodmore" was the real estate agent, and they christened themselves "The Lawful Heirs."[74] It took many months for the "lawful heirs" to realize their dream and secure the property, but in the spring of 1901, they informed their kind landlord that they would not be renewing their lease at 1523 Chestnut Street. He wrote them a affectionate note lamenting their departure "after six, may I say, short years."[75]

Their new neighbors in Villanova were less enthusiastic about the trio of illustrators and feared that, incredibly, Fred Phillips's utopian "whim" might posthumously become a reality. Violet took upon herself the task of assuring the nearby residents, "This is not going to be an artist's colony at all. We have grown tired of working in the midst of trolley cars, drays and heavy traffic, so we three are going out to where the green trees grow, where the cows roam and where the air is pure, and quietness prevails. We have a lease for a year and a

Above and opposite: Interior views of the Red Rose Inn, 1902. Photographs by Elizabeth Shippen Green. Collection of Jane and Ben Eisenstat

half but when the time is up, if our experience justifies us, we will try to extend the lease."[76]

The Red Rose Inn proved to be everything the women hoped for: romantic, charming, and very English. The house was commonly entered through the side entrance hall, a long thin room furnished with a bright green settle and decorated with coats of arms and old pewterware bearing the imprint of a rose. The comfortable library was furnished with antiques and wallpapered with a registered English ornithological pattern dating back to the seventeenth century. In the dining room the original farmhouse fireplace stretched across one entire wall. Blue-and-white china decorated the mantel and complemented cheerful chintz curtains. Fred Phillips had remodeled the front hall,

removing the original low staircase so that the entry foyer opened all the way up to the second floor, giving a bright, airy feeling to the adjacent rooms. Much of the old straight-backed wooden furniture was painted pale green and decorated with primary colors. Throughout the house heraldic devices embellished window seats and wood trim.

A little wicket gate led from the main house to the skylit barn that the women planned to convert to their studio. The spectacular gardens included a two-story smokehouse lately transformed into an enchanting tearoom, as well as a picturesque old stone skating house with an unusual interior that featured an open fireplace. An antique Dutch skating scene adorned the mantel. Many years later Violet could still remember the magnificent grounds in detail.

Here were such gardens as we had supposed existed only in "English Country-Life." There were inner and outer courts, a long and wide brick-paved terrace across the South front of the main house, shaded by pine and hemlock and a great feathery Coffee Tree many times taller than the building itself. Three more enclosed gardens, a long Pergola behind which lay the green-houses and a carefully planned Nursery, part of which formed a long Evergreen Walk leading down to the lake.

The hill mounted high above the buildings to the north, against whose protecting side they seemed to snuggle in complete security: but with sunny exposure—a formally trained Vineyard on the hill-side to the left—and on the right magnificent woods: beyond these the sweep of a great meadow, and beyond that—the thicket where the mystic haze moved its way puzzlingly in and out.[77]

By the time the women were ready to relocate, the household had expanded to include their friend Henrietta Cozens. Although not an artist, Henrietta had agreed to shoulder the responsibility of managing the property and overseeing all domestic chores. Perhaps the three artists considered the advice offered by their friend and fellow Plastic Club member Anna Lea Merritt when they asked Cozens to join them. In an article in *Lippincott's Monthly Magazine*, Merritt wrote,

The chief obstacle to a woman's success is that she can never have a wife. Just reflect what a wife does for an artist: Darns his stockings; Keeps his house; Writes his letters; Visits his benefit; Wards off intruders; Is personally suggestive of beautiful pictures; Always an encouraging and partial critic. It is exceedingly difficult to be an artist without this time-saving help. A husband would be quite useless. He would never do any of these disagreeable things.[78]

Henrietta's compelling interest was in gardening. She had no career ambitions other than to fulfill the traditional expectations of a proper Victorian housewife; since she had no intention to marry, she decided to commit her time and energy to managing the household for her three friends.

The move to the Red Rose Inn necessitated a stronger, more binding commitment among all four women. While they lived at the Chestnut Street studio, there was no need to be overly concerned about any potential defection from the group. The three artists were well compensated for their work. *Scrib-*

Right:
Reference photograph taken at 1523 Chestnut Street for a cover painted by Violet Oakley and published by *Collier's Illustrated Weekly*, June 21, 1902. From left to right: Elizabeth, Violet, Jessie, and Henrietta. Archives of American Art

Below:
Informal photograph taken moments later.

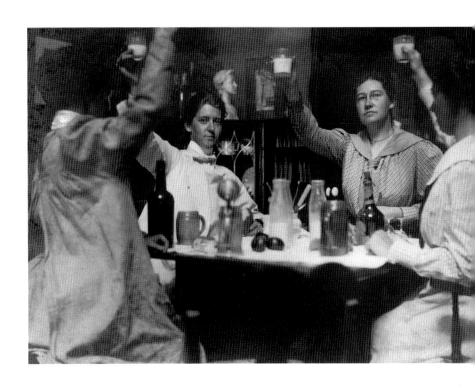

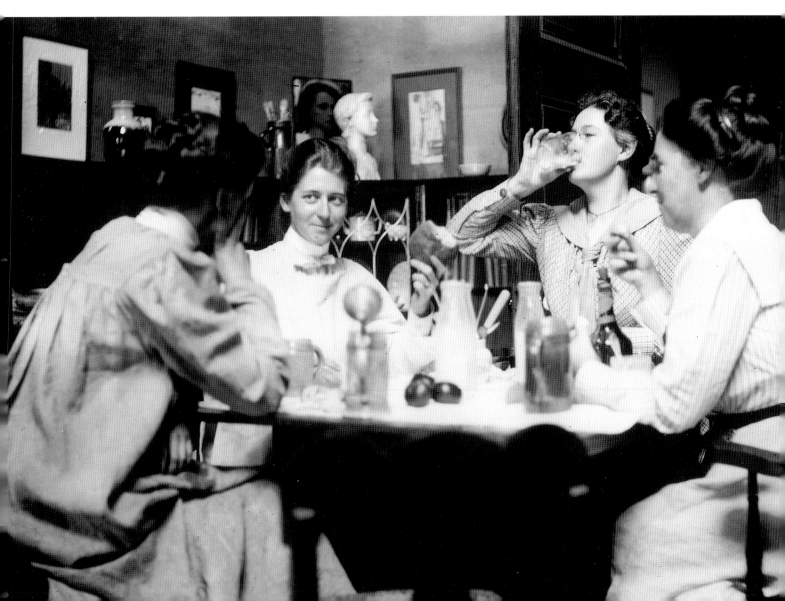

VIII.
Halcyon Days

THE FAVORABLE PRESS NOTICES PRAISING VIOLET Oakley's designs for All Angels' Church, exhibited at the Plastic Club, helped her to gain recognition as a muralist at a most auspicious time. In 1902, the state of Pennsylvania was engaged in building a new State Capitol building, to replace the previous edifice, destroyed in a disastrous fire. John Huston, the architect commissioned to design the new structure, had a grand vision for the building, which he saw not only as a place to conduct the business of the commonwealth but also as a museum to applaud the history and contributions of the citizenry. When Oakley's work was brought to his atten-

Right:
Violet Oakley at work in her studio at the Red Rose Inn, 1903. Archives of American Art

Opposite:
Elizabeth Shippen Green. *Life Was Made for Love and Cheer*. From "Inscriptions for a Friend's House" by Henry Van Dyke, *Harper's Monthly Magazine* (September 1904). Collection of the Library of Congress

When the logs are burning free,
Then the fire is full of glee;
When each heart gives out its best,
Then the talk is full of zest:
Light your life and never fear,
Life was made for love and cheer.

Inspired by the sentiments in this stanza of Henry Van Dyke's poem, Green painted herself and her housemates partying on the lawn in front of their beloved Red Rose Inn.

tion, he decided to take a chance on the talents of the young artist and commissioned her to paint eighteen murals for the Governor's Reception Room. Although the majority of the murals in the new State Capitol building were assigned to the well-known illustrator and muralist Edwin Austin Abbey, the eighteen paintings for the Reception Room constituted a sizable task. It was the first time an American woman artist had received such a prestigious assignment. Violet was offered $20,000 for the project, which would take her four years to complete. She accepted $5,000 immediately as an advance against expenses. Never judicious with her money or adept at making long-range financial plans, the sum seemed inexhaustible to her. In preparation for the job, she sailed for England in March 1903, inviting her mother to accompany her. The Oakleys traveled in style. Violet wrote to her friends that their cabin was a fine one, their deck chairs were sheltered yet sunny, and they were to be seated for dinner at the captain's table; quite a heady experience for someone so young. Nevertheless, she was homesick the day the steamer left the dock, and sitting in her stateroom she wrote to her "Dearest Red Roses."

> This isn't a bit funny—and I can't seem to make it so, for I must be feeling travel-bound and homesick in having to write you so far away. Don't let the Red Rose forget me and don't let any summer boarder take my place in your hearts at least. With love and good-by kisses from Mother and your absent sister.
>
> Violet Duchess of Oaks

She sealed up the envelope and addressed the letter to "Mr. and Mrs. Cogs and family."

When she arrived in England, Violet set to work exhaustively researching the life of William Penn. She also spent time in London's museums and galleries and gained artistic inspiration from Pre-Raphaelite painters Dante Gabriel Rossetti and Edward Burne-Jones. During the summer of 1903, she traveled to Rome, Florence, Venice, Assisi, Perugia, and Siena, studying mural-painting techniques and analyzing the works of the Italian masters. In Venice she discovered the mural paintings of Carpaccio in the Church of San Giorgio degli Schiavoni and found inspiration for her own project.[86]

The trip was Violet's first time away from her friends in five years. Although she was a diligent and serious researcher, as the weeks went on, she missed her companions and begged for some word from the Red Rose. From Italy she sent a postcard: "This is a picture of my retreat. How do you like it and why won't you write me?" From Florence, still waiting for an answer, she

simply scrawled, "*Why don't you write to me.*" By August she was back in England, out of money and late with her rent check for the previous month, which her friends had to cover. She wrote an apology to Henrietta, who managed the finances, promising the back rent for July and her share of the August expenses as soon as a check was forthcoming from *Collier's Magazine*. In September she concluded her studies and boarded the Royal Mail Steamship *Umbria* for the return voyage. Tired, lonely, and afraid she had been forgotten, she wrote,

> Dear Red Roses
> Please drop me a line of welcome . . . and also tell me if you all have engagements and if so what nights—for I won't come home to an empty house and a cold welcome. I want every single one of you to be there—so please let me know . . . I wish I could be surprised

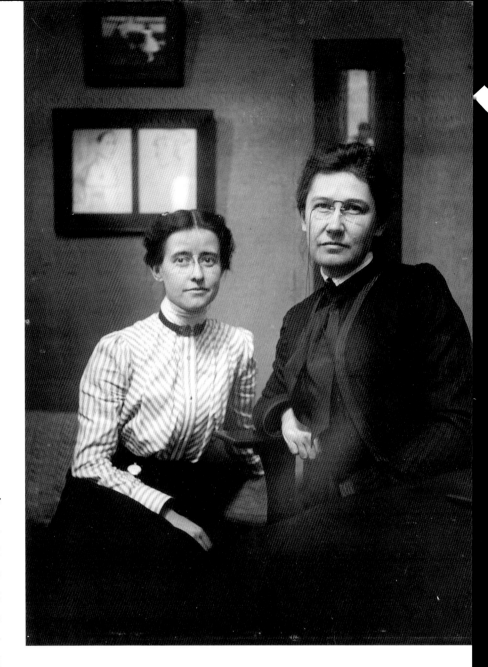

by a line of Red Roses on the dock—but I have a horrid way of wanting more than I have.[87]

Violet's fellow "Red Roses" had not forgotten her. They were occupied with their own work and with the management of their extensive property. Smith and Green were entering a period of astonishing productivity. During the next three years they illustrated countless magazine articles. They collaborated on the 1902 calendar for Bryn Mawr College and the critically acclaimed *Book of the Child*, a project they initiated on their own and first published as a series of illustrations for a calendar. Even though the work was speculative, the two artists carefully staged each picture, setting up props and choosing clothing for the children who came to the estate to pose for the illustrations. Elizabeth took photographs to use for visual reference and had prints

Portrait of Elizabeth and Jessie, probably photographed in 1903 in conjunction with the publication of *The Book of the Child*. Archives of American Art

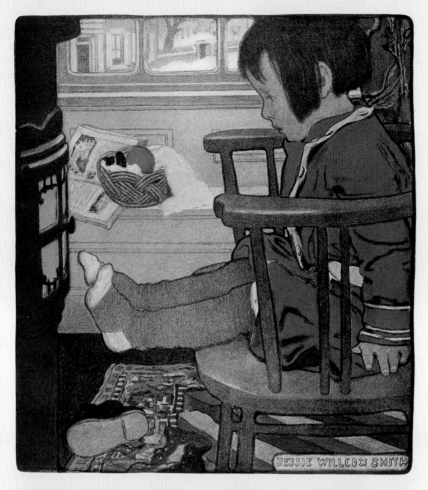

Pages 80–84:
Jessie Willcox Smith and Elizabeth
Shippen Green. Illustrations from
The Book of the Child by Mabel
Humphrey (Frederick A. Stokes
Company, 1903)

*In 1902 Smith and Green collaborat-
ed on a series of illustrations that
they self-published as a calendar.
The pictures delighted editors at
the New York publishing house of
Frederick A. Stokes who requested
permission to republish them as a
children's book. The finished project,
The Book of the Child, was aug-
mented with text and verses by pop-
ular author Mabel Humphrey.*

Left:
Jessie Willcox Smith. *Jingles*

Jessie Willcox Smith. *Dolly's Nap*

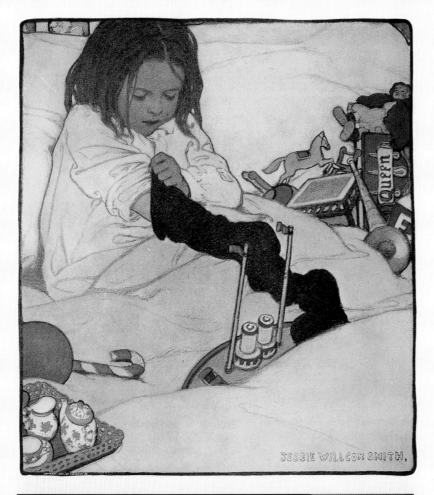

Jessie Willcox Smith. *A Real Santa Claus*

Jessie Willcox Smith used this photograph as reference for her illustration *A Real Santa Claus*, published first in 1903 in a calendar, and some months later in *The Book of the Child*. In published interviews, Smith, Green, and Oakley all denied using photographic references for their paintings and spoke eloquently about how they selected their models and drew only from life. Many artists of the period were reluctant to admit that rather than have models sit for hours—a process that dictated a passive pose— a much better result could be obtained by working from photographs. Archives of American Art

This is one of Green's reference photographs for *The Little Gardeners.* Collection of Jane and Ben Eisenstat

Elizabeth Shippen Green.
The Little Gardeners

Elizabeth Shippen Green. *A Rainy Day*

Elizabeth Shippen Green. *The Summer Sun*

COPYRIGHT, 1902, BY C. W. BECK, JR.

made from the glass negatives common at the time. The completed paintings were stunning. The styles of the women meshed seamlessly. Writing for the July 1905 issue of *Book News*, Norma K. Bright commented enthusiastically on the illustrations.

> Their calendar "The Child" gained hosts of friends with its lifelike presentation of the modern child in attitude of childish occupation. Here were the small boy and girl of the American home, and American mothers and fathers, sisters, and brothers, and all the rest of the entire group of relatives recognized them accordingly.[88]

Editors at the New York publishing house of Frederick A. Stokes were so impressed with the calendar illustrations that they requested permission to reprint them as a book. The popular children's author Mabel Humphrey was commissioned to write stories and verses to accompany the pictures. The book was an instant critical success, an uncontested classic. Smith and Green never again had to worry about obtaining prestigious assignments, working with unreasonable deadlines, or being adequately compensated for their work. In 1902, Smith had received a bronze medal for paintings she exhibited at an international exposition in Charleston, South Carolina. In 1903 she was awarded the Academy's prestigious Mary Smith Prize for the best painting by a woman.

Smith also illustrated *Rhymes for Real Children* and Frances Hodgson Burnett's *In the Closed Room*. In 1903, the publishing house Charles Scribner's and Sons selected her to produce designs for Robert Lewis Stevenson's *A Child's Garden of Verses*. It was a $3,600 project that originally included twelve full-page color illustrations, a cover design, a lining design, a title page, and one

Jessie Willcox Smith. *Come Play with Me*. From *In the Closed Room* by Frances Hodgson Burnett (McClure, Phillips & Company, 1904). Collection of Jane and Ben Eisenstat

Opposite:
Elizabeth Shippen Green. Frontispiece. *The Book of the Child*

Jessie Willcox Smith. Illustrations from *A Child's Garden of Verses* by Robert Louis
Stevenson (Charles Scribner's Sons, 1905). Photograph courtesy of the Archives of the
American Illustrators Gallery, New York. © Copyright 1999, ASaP of Holderness, N.H.

Above:
Looking Glass River

Opposite:
The Land of Counterpane

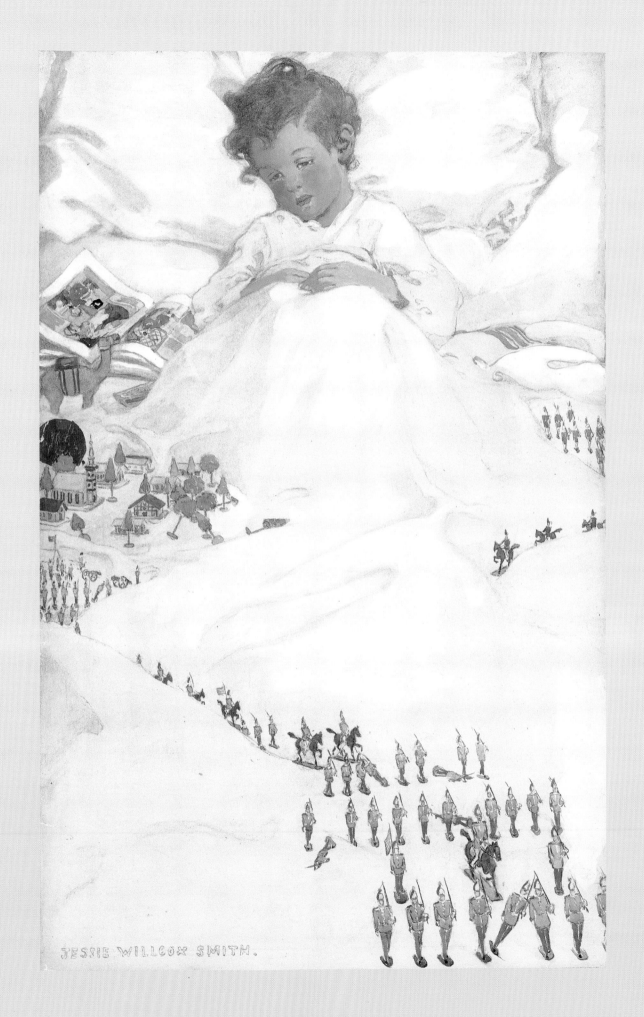

JESSIE WILLCOX SMITH.

Jessie Smith with her camera, 1905. Collection of Jane and Ben Eisenstat

Opposite above:
Elizabeth Green in her studio at the Red Rose Inn, c. 1903. Archives of American Art

Opposite below:
Jessie Smith painting at her easel in the Red Rose studio, 1903. Archives of American Art

hundred small drawings. The commission was a difficult one, as she was requested to complete six of the full-page illustrations in less than a year. Given her household and studio expenses it was quite clear that, in order to stay financially solvent, she would have to accept a number of other assignments as well. Nevertheless, she did an outstanding job, creating a volume that has become a treasured children's standard. Years later, looking back over thirty years of professional life, she counted these illustrations as the most successful of her early commissions. "The subject matter of these stories appealed tremendously to my imagination," she wrote. "I felt them very strongly—and that always makes for good work."[89]

Almost all of Smith's clients requested the poetic, idealized images of American childhood at which she excelled: charming children in picturesque surroundings. Her vision of childhood was so agreeable it could hardly have flowed from the brush of someone familiar with the daily trials of raising a child. In fact, her sympathy for children was more aesthetic than practical. While on vacation in Maine, she wrote to Henrietta about her inadvertent arrival at the home of friends during a child's party.

The house was alive with children and Mommies and candles and cake and etc. It is quite smart of people here I fear and a serious drawback—and heaven help me their nurseries are all papered with Jessie Willcox Smiths. What have I done to deserve this? What I want is a desert isle with a few people I could select. Well I'm hoping after they have all met me and seen what a disagreeable old thing I am they will return to their nurseries and take it out on the wall decoration.[90]

Analyzing her work without studying her correspondence has led many critics to assume that Smith's drawings of children reveal a deep longing

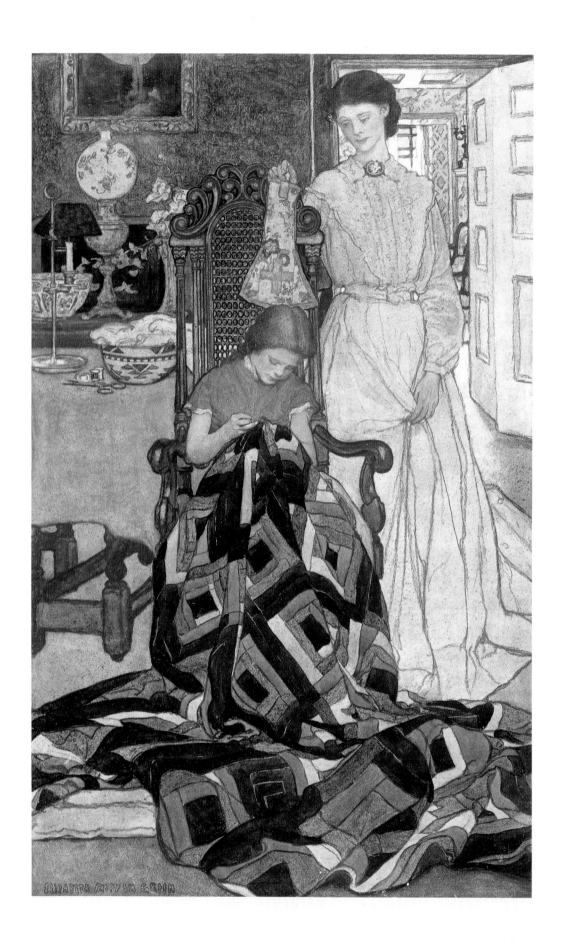

for a family of her own. Yet, although she was often quoted as saying that motherhood was as noble a calling as one could achieve, she never expressed any personal regret about her own choices.

While Jessie Smith's delineations of childhood were making her name familiar to a wide audience, Elizabeth Green was also gaining national recognition. In August of 1901 she was invited to join noted illustrator Edwin Austin Abbey and her teacher Howard Pyle as one of a select group of artists under exclusive contract to *Harper's Magazine*. The agreement would be renewed every year for the next twenty-three years. Elizabeth's drawings of romantic Victorian home life struck such a sympathetic chord with the magazine's readers that the editor told her she was one of the best things that ever happened to *Harper's*.[91] Her paintings were as

removed from domestic reality as Smith's, but she did not specialize in portraying a strictly Wordsworthian childhood and painted adults as often as she did children.

Henrietta kept busy with the household and vast gardens. She exchanged recipes with friends and clipped them from the newspaper: tomato rabbit, banana princess pudding, rich sauce for fish, potato soufflé—"If the family are 'fed up' on mashed potatoes, try this for a change." She took care of the household pets, a Persian cat with the patronymic Cogs, and a St. Bernard dog, officially Maximilian Prince of Neuwied, shortened to Prince—both housewarming gifts from their lawyer, Joseph Green Lester. Henrietta lovingly tended the great crimson climbing rose that gave the property its name, as well as the garden and stucco-walled pergola adorned with the fragrant white clematis variety "Traveler's Joy" planted by Frederick Phillips in honor of the inn's guests. A path flanked by evergreens led to a small lake and a hill planted as a vineyard. Beyond that, Henrietta's hoe and rake were not needed. In the tradition of the picturesque that the women all admired, the meadow and

Opposite:
Elizabeth Shippen Green. *The Thousand Quilt.* From *Harper's Monthly Magazine* (December 1904)

Above:
Reference photograph for Green's illustration *The Thousand Quilt.* Collection of Jane and Ben Eisenstat

woods were left uncultivated. Unaccustomed to such space, they all cherished the extensive grounds. Violet especially liked to walk the fields when she was at home, and measured distances at the Red Rose not in acres but in poetry. It was four sonnets from the house to the meadow on the far side of the lake.[92]

When Violet returned from Europe, she began to work in earnest on the murals for the Governor's Reception Room at the Pennsylvania State Capitol building in Harrisburg. She called the series, "The Founding of the State of Liberty Spiritual." There were to be eighteen horizontal panels, all six feet in height. The longest panel was to measure nineteen feet. Her plan for the paintings was to compose a narrative beginning with the events in Europe that led to William Penn's vision of religious freedom in a peaceful, unarmed state, and ending with his first sight of the shores of Pennsylvania. Violet was struck by the force of Penn's insight. She liked Victor Hugo's quotation: "There is one thing stronger than armies, and that is an idea whose time has come." Violet felt the realization of Penn's dream was imminent and would devote much of her life to pursuing his hope for international disarmament, harmony, and understanding.

Convinced that her artwork could become a valuable force for disseminating Penn's thesis to the waiting world, she worked with the tireless patience of a true believer. Oakley once said that she was quite sure she had been a monk in an earlier existence. When corrected by her interviewer who laughed and said certainly being female she must have been a nun, she answered, "No, the abbesses and sisters were too busy nursing the sick and doing fine needlework. I never heard of them illuminating manuscripts. I am quite sure I was a monk."[93] Her interviewer was perplexed and described Violet as fair, delicately feminine, graceful, and gracious. The idea of the young artist as a monk, he contended, was humorously incongruous. Her friends might have disagreed. They were increasingly dismayed by Violet's serious nature, her devotion to the Christian Science faith (which they did not even attempt to understand), and her pretentious view of herself as Penn's one true disciple.

They began to complain among themselves—with humor, but they complained nonetheless. When Henrietta went to Casco Bay, Maine, to vacation with her family, Jessie wrote that Violet was insufferable.

> Violet is looking over my shoulder to see to whom I am writing—but she will not find out! I get on very well during the day while I am buried in the work I love—but when the day is done and I wander around alone I feel as if the bottom has dropped out indeed, and life this side of Casco Bay was hardly worth the living. I think Violet's doll

Opposite:
Elizabeth Shippen Green. *A Gentle Shadow Had Fallen Upon Him*. From "The Man and the Boy" by Julie M. Lippman, *Harper's Monthly Magazine* (December 1902). Collection of the Library of Congress

ELIZABETH SHIPPEN GREEN

gentle shadow had fallen upon him

175

is stuffed with sawdust too. The letdown from the gay and varied life of the last four weeks is almost too much for "Science" to grapple with and a terrible boredom fills the air tempered with a general dissatisfaction and prudishness.[94]

Violet's tenacious ennui seemed to extend to any household chores, including (in Henrietta's absence) helping to care for the increasing family menagerie. Cogs and Prince had been joined by two more cats, Jackie and Finney. Violet ignored them all, but showed a special antipathy for poor Finney. "She is horrified and disgusted by his ugliness," Jessie complained to Henrietta, "and I had to remind her that she was the one who objected to his being given away in his youth, that now she owed it to him to take care of him and fatten him up—but so far I have not seen any movement in that direction."[95]

Elizabeth Shippen Green Elliott. *The Journey*. From "The Little Past" by Josephine Preston Peabody, *Harper's Monthly Magazine* (December 1903). Collection of the Library of Congress

When Henrietta came home the situation was defused. She managed the estate so effectively that the Red Rose Inn was serene, and quarrels faded into the background. All three women were happiest when they were engaged with their work, and they spent most of their waking hours at their easels. But although art was the central focus of the household, the busy schedules of all

four women did not preclude a social life. They loved the symphony, attended concerts in Philadelphia, and frequented lectures. Elizabeth, the only one of the three prone to procrastination or to feel confined at the Red Rose, liked to get away from her work and take the train into the city. She was part of what newspaper accounts called a "brilliant audience" the evening her favorite author, Henry James, made his debut as a public speaker at the Bellevue-Stratford Hotel. The subject was Balzac, but James's whimsical comments on other authors amused Elizabeth. Dickens's novels, James quipped, left the "effect of early morning in houses with unwashed window panes." Charlotte Brontë, he maintained "moved through an endless autumn," while Jane Austen "sat resignedly in an arrested spring."[96]

All three women remained active in the Plastic Club, participating in exhibitions and serving on committees. Jessie and Elizabeth were apparently welcome, but Violet's endless proselytizing about William Penn's "Holy Experiment" had become tiresome. One year Violet was one of four enthusiastic candidates for Plastic Club vice president. Pleased with the willingness of their members to serve in executive positions, the club named three vice presidents. Emma Sachse was to be first vice president, Alice Barber Stevens the second vice president, and third vice president was Mrs. Leland Harrison. Violet took her hat and went home.

In spite of Violet's difficult personality, the Red Rose was filled with affection. Elizabeth's good-natured humor and satiric wit enlivened every gathering. The household was the subject of numerous articles in nationally distributed periodicals. *The Century* ran an article by Harrison S. Morris, the managing director of the Pennsylvania Academy, titled, "Philadelphia's Contribution to American Art." How elated the Cogs family must have been to be mentioned as successors to the great Philadelphia painters Benjamin West, Thomas Sully, and Charles Wilson Peale—even though the praise was somewhat diminished by the characterization of female artists as women of leisure.

> At one, yet as widely separated in style and impulse as a group of young saplings, are the youngsters emerging from this venerable nursery of West, Peale and Sully; And not the least encouraging symptom of the times—one which, perhaps, those progenitors of art would have wagged their heads over— is the predominance of women in the field. Art is theirs by right of birth: they have instincts for color and native traits of taste; They belong to society and to the household, where these are most employed; and they bring leisure and reflection to the

study of the craft in a day when men are fast losing those needful attributes. What, for instance, could be more conducive to the growth of individual talent than retirement to such a retreat as the Red Rose Inn, where the gifted trio of latest fame have withdrawn from the inquietude of the city? There in the shade of embowering roses and well within deep screens of privet, they working out destinies which are sure to be as endearing as they are delightful.[97]

Other magazine articles showcased the Inn and its grounds as well as the talents of the tenants—the writers often noting with apparent relief that there was nothing eccentric about the household, as the trio was chaperoned by Mrs. Oakley, the elder Greens, and Henrietta Cozens. As one writer put it, "The Red Rose does not consist of the three artists alone. Miss Green's father and mother, Miss Oakley's mother, and Miss Couzens [sic] a friend of all three young ladies, combine to keep the household properly balanced—that is; with artists in the minority." The writer evidently was not aware that Jasper Green and Cornelia Oakley were also artists, although that knowledge would not have altered the respectability they lent to the household. Nevertheless, however much public concerns were alleviated by the presence of the older generation, it is unlikely that Elizabeth's elderly parents or Mrs. Oakley would have put a strain on the close ties between the four women or disapproved of a romantic friendship or what was often called a "Boston marriage."

Jessie and Henrietta had become increasingly devoted to one another. In fact, Jessie's letters to her friend show far more tenderness than the correspondence Henrietta received from her fiancé during their brief engagement in 1888. Henrietta was somewhat ashamed of her fiancé's letters, and although she kept them her entire life, she tore out the signature. Apparently she felt no similar embarrassment about any of the effusive notes she received from Jessie and saved them carefully with salutations and signatures intact, although the letters reveal that their friendship was not casual.

> I'm not going to send you any more of my absurd little notes. I am afraid that now that you are getting well they will bore you and come under the category of what you are pleased to call slush—but I can't keep the slush out—my heart is too full of it.[98]

> The reading class was taken in the library and I wandered in thinking I would try and listen. I soon realized I was not there at all. I was spending the evening in a dark flower decked room where a very precious lit-

tle person is with blue bows in her hair. . . . I trust I will not be called upon to pass an examination on the story. I could not tell whether it was tragedy or comedy—poetry or prose.[99]

I don't know how you take it but it has an awful effect upon me (my temperature has gone up and my appetite down) when I realize I shant see you ALL DAY TO DAY AND ALL DAY TOMORROW. It is a grand mistake to fancy each day has the same number of hours.[100]

The year 1905 began in triumph for the residents of the Red Rose, and they would look back on the beginning of that year as the best time of their lives. The Inn seemed to bring them nothing but luck. Readers waited impatiently for Jessie Willcox Smith's covers to appear on *Collier's Magazine*, where she was a regular contributor. Her magnificent book, *A Child's Garden of Verses*, was about to

Jessie Willcox Smith. *The Hayloft*. 1905

Jessie Smith originally created this illustration for A Child's Garden of Verses *by Robert Louis Stevenson, published by Charles Scribner's Sons in 1905. Collier's magazine reprinted the painting on the cover of its September 16, 1905, edition.*

be released by Scribner's in New York and by Longmans, Green and Company in London to rave reviews on both sides of the Atlantic. The book became so popular that it inspired a poem by Christopher Morley. While studying as a Rhodes Scholar at Oxford he published a volume of his work, *The Eighth Sin*. The title of the book—which shows the author's humility—came from the following line in the letters of John Keats: "There is no greater Sin after the seven deadly than to fatten oneself into the idea of being a great poet." Thus, acknowledging at the outset the quality of his efforts, Morley nevertheless published, "To Jessie Willcox Smith: In Graditude of her Illustrations of A Child's

Jessie Willcox Smith. *Picture Books in Winter*. 1905

*This cover illustration for Col-
lier's magazine is also a reprint
of a painting commissioned for
Scribner's 1905 publication of
A Child's Garden of Verses
by Robert Louis Stevenson.*

Garden of Verses." The results notwithstanding, it was heartfelt homage, and in later years Morley begged readers to consider his youthful volume "as a boy's straggling nosegay somewhat wilted in a hot eager hand, clumsily tied together with honest love."

> He would have said with radiant face:
> Dear Lady, in some fairy place
> Some garden where (without a nurse)
> You must have met my bairns alone
> And smiled and took them for your own.
>
> They were more ragged then perhaps,
> They did not know the joy of laps
> A very lonely life they led,
> They never had been tucked in bed
> In spite of all their messy laughter
> They badly needed looking after
>
> These children of my wistful dreams
> The magic of your brush now seems
> To bring to life—I recognize
> The golden heads. The dark brown eyes
> The dainty frock the slim bare legs
> And all that love-of-children begs.
>
> The bairns are yours as much as mine
> And so to you I now resign
> A half of all that fund of glee
> That they have always brought to me.
> But on one thing they will insist—
> They never sleep till they've been kissed
>
> P.S. I note with grateful joy
> You've made the oldest one a boy!

Jessie's contract awarded her a 10 percent royalty on all copies of the book sold in the United States and a 5 percent royalty on foreign sales. Her hopes for a good financial return on her work were validated in April when the last two drawings for the book were delivered to *Scribner's* and the art editor enthusiastically declared, "I have used up all my adjectives in acknowledging your various drawings for *The Child's Garden of Verses.*"

Title page

The Sewing Room

Pages 100–102:
Elizabeth Shippen Green. Illustrations from "The Mistress of
the House," *Harper's Monthly Magazine* (August 1905)

*No text accompanied this beautiful series of paintings romanticizing
the life of a housewife and mother. Although Green used the house
and garden at the Red Rose Inn as the setting for these illustrations,
her own hectic schedule built around difficult assignments and
demanding deadlines bore little resemblance to the routine of the
serene young mother she created for* Harper's *readers.*

The Rose Garden *The Library*

Afternoon Tea

The Five Little Pigs

Elizabeth Shippen Green's career was also proceeding splendidly. Her evocative illustrations were widely admired by the many readers of *Harper's* magazine. In 1905 more than forty of her illustrations appeared in the magazine. *Harper's* reserved expensive color printing for the work of their most respected artists, Howard Pyle and Green. The August issue of the magazine featured eight of Elizabeth's paintings in color in a series entitled, "The Mistress of the House." In an exceedingly unusual break from *Harper's* tradition, the pictures were published without any text. The illustrations showed a highly romantic and idealized vision of a woman's day and caught Elizabeth's protagonist—a beautiful young mother—in the sewing room, in the rose garden, in the library, at play with the children, quietly reading to a child, having afternoon tea with a friend, and descending the staircase dressed for dinner. It was the kind of life that hardworking Elizabeth could only imagine. The surroundings, however, were familiar. She used the gardens and interiors at the Red Rose Inn for inspiration, but the life she delineated—one of quiet leisure—was the stuff of dreams. The year 1905 also saw the completion of *Rebecca Mary*, perhaps Elizabeth's most beautifully illustrated volume. The book was serialized in *Harper's* beginning in December 1904 and continuing through 1905.

Violet Oakley seemed content both personally and professionally for the first time in many months. Her sister Hester had given birth to a beautiful baby girl, Margaret Ward. Violet was a doting aunt, and Cornelia Oakley saw in her newborn grandchild her own firstborn Nellie, at last returned. Amid this personal joy, Violet worked productively, completing six panels and a study for the seventh for the Governor's Reception Room at the State Capitol, which she submitted to the jury at the Pennsylvania Academy's 100th anniversary exhibition. She was proud of her paintings and evidently the judges at the centennial exhibition agreed. All her hard work, the long hours in the studio, and the cost-

Hester Oakley Ward and baby Margaret. Archives of American Art

Rebecca Mary Was Going Away

They Were in Each Other's Arms

Elizabeth Shippen Green. Illustrations from *Rebecca Mary* by Annie Hamilton Donnell (Harper & Brothers, 1903). Collection of Jane and Ben Eisenstat

Reference photograph taken by Green for *Rebecca Mary*. Collection of Jane and Ben Eisenstat

Violet Oakley. *The Founding of the State of Liberty Spiritual*, frieze cycle in the Governor's Reception Room, Pennsylvania State Capitol, Harrisburg, Pennsylvania. 1902–6. Photographs by Brian Hunt

Right:
(Left) *William Tyndale Printing His Translation of the Bible into English*, at Cologne, A.D. 1525; (Right) *Smuggling the New Testament into England, 1526.* 6' x 10' 4"

(Left) *Attempt to Stop the New Learning: The Burning of the Books at Oxford, 1526;* (Right) *"Lord Open the King of England's Eyes."* 6' x 11' 10"

Intolerance and Persecution Culminate in Civil War. 6' x 10' 4"

(Left) *The Complete Translation Set Forth with the King's Most Gracious License;* (Right) *"Rather Deathe Than False to Faythe. . . ."* 6' x 11' 10"

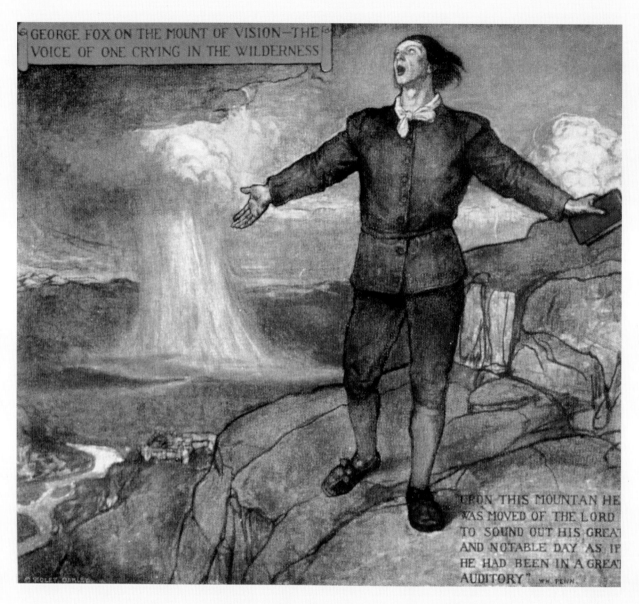

George Fox on the Mount of Vision: The Voice of One Crying in the Wilderness. 6' x 6' 6"

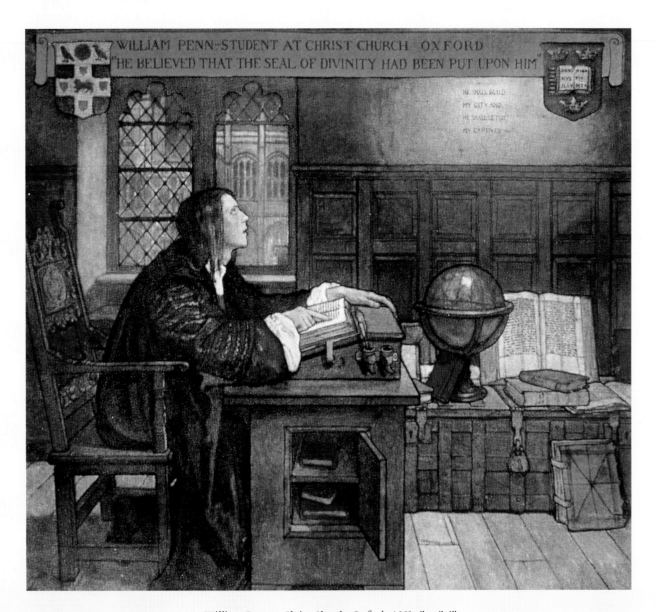

William Penn at Christ Church, Oxford, 1660. 6' x 6' 6"

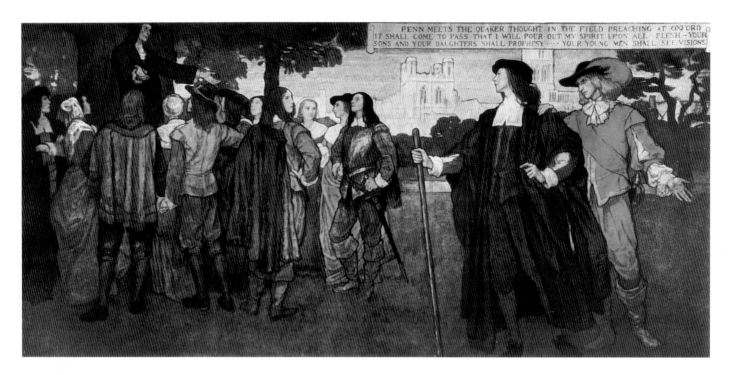

Penn Meets Quaker-thought in the Field—Preaching at Oxford. 6' x 13'

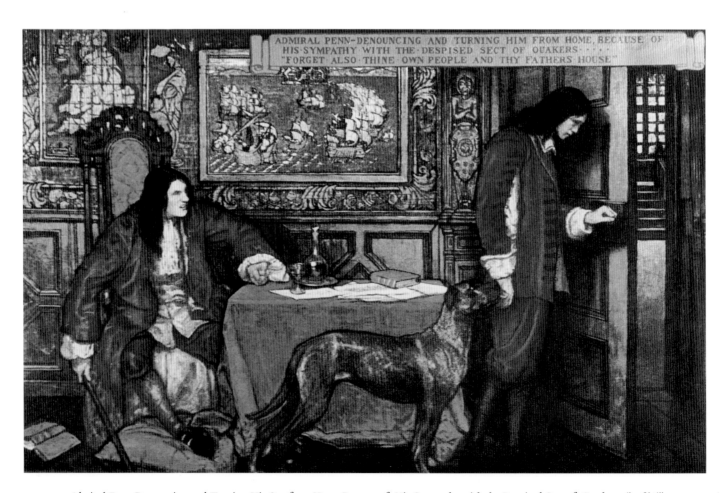

Admiral Penn Denouncing and Turning His Son from Home Because of His Sympathy with the Despised Sect of Quakers. 6' x 9' 6"

Penn Examined by the Lieutenant of the Tower of London, Condemned to Imprisonment in Newgate. Entire painting, of which this is the central panel, 6 x 19'

Having Been Liberated Through the Force of His Knowledge He Seeks to Free Other Friends Imprisoned. 6' x 9' 6"

Penn's Vision. 6' x 13'

Thy God Bringeth Thee into a Good Land. 6' x 6' 6"

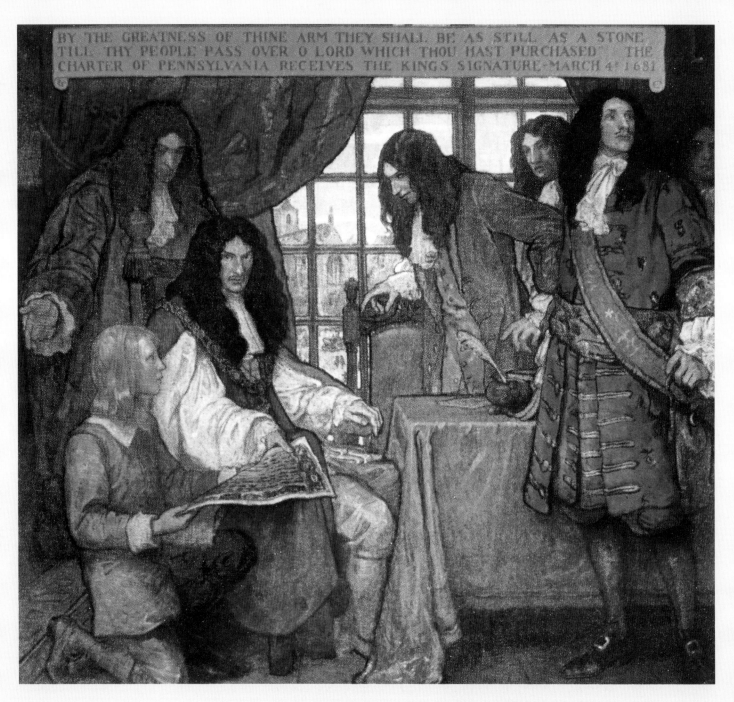

The Charter of Pennsylvania Receives the King's Signature. 6' x 6' 6"

ly research trip to Europe were rewarded as she stood proudly to receive the Academy's gold medal and was pelted with flowers like an opera star.

Five days later, Elizabeth's good news was delivered by mail from Harrison Morris, the managing director of the Pennsylvania Academy, to the Red Rose Inn.

> We are rejoiced to tell you that the committee on Exhibition of this Academy yesterday decided to award to you the Mary Smith prize for the One Hundredth Anniversary Exhibition. I enclose [for] you a circular which will give the terms of the prize and at a later date you will receive a check for $100 which it embodies. Thus you see your beautiful little group has met its deserts and you are promoted to a band which will be proud to receive you.

Edward Coates, the Academy president, added his own congratulations, noting that although the recompense was small, as the Greeks said of the olive wreath, it "should have been of pure gold had not Jupiter himself been poor."[101] The *Philadelphia Inquirer* missed the point when it reported, "The prize is a small one and cannot mean so much to Miss Green in the face of her firm financial status as one of the most successful of women illustrators as it might some years ago when she was struggling to get a foothold, and no doubt needed the money."[102] Elizabeth was delighted with the honor—proud to receive an award from the prestigious institution that had already put its stamp of approval on the work of her two friends. In a few short years, the Academy had completely reversed its policy on the importance of illustration. Having refused a teaching position to the celebrated Howard Pyle, they were now conferring accolades on his students.

It must have seemed that this good fortune was destined to hold—that perhaps the careers of all three women were even gaining momentum. In April, the Academy held its annual watercolor show. Many of the submissions were small in size, but critics agreed that although they lacked the impact of the large oils that dominated the acclaimed centennial exhibition, the work was noteworthy nonetheless. The press praised a pastel portrait of a mother and child by Mary Cassatt and a group of her color etchings, as well as a series of six watercolors by Winslow Homer. But it was the work of Jessie Willcox Smith, Elizabeth Shippen Green, and Violet Oakley that was reproduced in Sunday editions of the leading Philadelphia newspapers: Smith's *Century* magazine cover, "August"; Green's illustration for *Harper's*, "The Dissolving View"; and Oakley's painting of the Red Rose Inn.

Public and critical praise was gratifying, but the approval of colleagues still carried more weight. Smith was thrilled when fellow illustrator Maxfield Parrish saw one of her paintings at the watercolor show and offered to buy it. "My Dear Miss Smith," he wrote in May,

> She came today at last, and my! But we are glad to have her. We never knew such a long water color exhibition, and had almost given up hope. She is a perfect wonder, and I am proud as can be. It's the first hand made picture I ever owned, and to have gotten it so dirt cheap, nearly doesn't seem right. I hope you don't regret the deal very much. I think she is worthy of a better frame than the one she is in, and as soon as our living room is built I'm going to have her set in the wall. I thank you a thousand times for her.[103]

The halcyon days did not last. With the stunning swiftness so common in the era before effective antibiotics, Hester Oakley Ward's baby daughter contracted an infection and died. Violet and Cornelia were heartsick and tried to comfort Hester, who was inconsolable. Weakened by fatigue and grief, Hester herself became ill. Despite her husband's desperate efforts to obtain the best possible medical attention, she died of scarlet fever. The Oakley family was suddenly reduced to two. Too proud to seek either emotional support or financial assistance from Hester's husband, Violet and Cornelia felt truly alone. Cornelia picked an ivy leaf from Hester's new grave, wrapped it in paper, and put it in an envelope with baby Nellie's teeth—all that was left of her two lost daughters. Comforted by the active household and the presence of Violet's "sisters" she tried to develop a closer relationship with them and began to refer to herself as "Mother Cornelia." The moniker did not stick. Proper decorum and good manners characterized life at the Red Rose Inn. Despite Cornelia's attempts to establish more intimacy, Jessie, Elizabeth, and Henrietta resolutely called her Mrs. Oakley.

In the midst of the Oakleys' devastating personal tragedy, professional problems developed. Violet, a strong proponent of freedom of religion—a women who, having felt the sting of religious intolerance herself, would not even consider criticizing anyone's beliefs—came under fire for her designs for the Harrisburg murals. William McGrath, president of the American Catholic Historical Society wrote a long letter to Pennsylvania governor Samuel Pennypacker voicing his strong objections to three of the panels Oakley exhibited at the Academy. The paintings McGrath found unacceptable all depicted the vehement opposition of the Catholic Church to William Tyndal's translation of

the Bible into English in 1525. Fifty years later, Violet described the offending paintings.

> The first one . . . is the printing of the Bible in English by William Tyndal in Cologne. It was forbidden here. I mean, it was forbidden in England, which is almost the same thing. And they believed (the authorities) that Tyndal was a heretic or had heretical opinions, and his translation would not be trustworthy. For that reason, they forbade it. But he was a greater scholar than they were. He had studied the original Hebrew and Greek at Oxford. And he went to Germany, and at Cologne he started the translation beginning with the New Testament. The copies were smuggled in bales of merchandize into England and read eagerly by those who were waiting for it.
>
> And when they found that those volumes had gotten into the country they had a search made, especially at Oxford. They searched Christ Church, which was the college that had recently been established for the screening of the best students for the church. And there they found those best students had the forbidden book in their rooms. They made a search and brought them all out and forced the students to march in a procession and throw their precious volumes into the flames.
>
> And the next panel represents some years later, at Vilvorde in Belgium, the execution of William Tyndal. This was done under the authority of the Church of England. He was strangled at the stake and his body was burned. He was not burned alive. But his last words were, "Lord, open the King of England's eyes." And I think those are very Christlike words. Father forgive them.[104]

It was McGrath's contention that the historical events portrayed in the paintings were false and misleading—that even if they were true, the subject matter was "irrelevant" and "inappropriate" for the new State Capitol. Furthermore, even if they *were* relevant and appropriate, it would still be impolitic to install them, as they depicted theological issues instead of civic subjects and offended the Commonwealth's law-abiding Catholic citizens.

Oakley was upset and tried her best to answer the criticisms. She explained that because William Penn came to Pennsylvania seeking religious freedom, in order to understand the founder's motivations for leaving his native land, it was necessary to understand the magnitude of the religious intolerance that existed in England. Her explanation did nothing to quell the

gathering storm. Walter George Smith, the president of the Federation of Catholic Societies, jumped into the fray and mounted a campaign to prevent the paintings from being placed on the walls of the Governor's Reception Room. It was his contention that delving into the "partisan record of centuries long gone" did nothing to illuminate the life or the accomplishments of William Penn.[105]

Oakley again tried to justify her work, this time noting that although the first few panels dealt with Catholic oppression, other paintings in the series would tell a different story. When the sequence was concluded, she explained, the public would understand "the beauty of tolerance, versus the darkness of intolerance."[106] One of the panels not yet completed would show William Penn's prophetic vision—Penn leading the persecuted masses, Catholic monks and nuns among them, away from the tyranny of the Church of England and onto ships bound for the New World. In newspaper accounts Violet sounded confident, well-informed, and mature beyond her thirty-one years. Still, she must have been terribly worried. She had only a year left on the project, which had already consumed the greater part of her professional life. Most of the money due for the paintings was already spent. Violet desperately needed this assignment to be a triumph. She needed critical acclaim to secure her next commission. The capitol architect, John Huston, took a very public, high profile chance when he hired a woman for such a prestigious job and would not be likely to jump to her defense if her ideas proved too controversial. The press reported that Governor Pennypacker sustained "the historic accuracy of the paintings and their fitness for decorations in Pennsylvania's Capitol." However, he made no public statement on the subject at all, and his support for Oakley was alleged to be contained in a memorandum written to a protestant minister who refused to release the contents to the press.

The controversy over Oakley's murals was only one of the problems upsetting the tranquillity of the Red Rose Inn. In August, after several months of secret negotiations, H. S. Kerbaugh, the owner of Philadelphia's Kerbaugh construction company, purchased the Red Rose Inn and the two hundred surrounding acres from A. J. Drexel for $200,000. The residents of the inn were relieved to hear that Mr. Kerbaugh had no plans to demolish their home. However, he did intend to build a summer house nearby. In November, an army of workmen descended on the property to build an estate for Kerbaugh that, although large, was reported to be a "modern and artistic mansion whose design has brought great satisfaction to those of the vicinity who are romantically inclined and to all lovers of the picturesque who were interested in the

original art colony conception."[107] Although the interruptions rankled the nerves of the residents of the Inn, as the weeks went on, they became reconciled to the necessity of sharing the property and were not overly concerned. After all, Kerbaugh was constructing a summer home that would presumably be occupied for a few short months at a time. The rest of the year they would have the estate to themselves.

They went back to their work, Jessie finishing several assignments for *Collier's*, Elizabeth hard at work on a series of paintings for *Harper's*. Violet was painting large, almost life-size figures on the remaining panels for "The Founding of the State of Liberty Spiritual." Jasper Green read his evening paper comfortably ensconced in the library. Elizabeth's mother kept busy with needlepoint and knitting, and Cornelia Oakley occupied herself helping Henrietta with the household chores. By Christmas, when the fragrant pine, decorated with bright paper cones, was installed in the entry hall, life seemed back to normal.

Elizabeth reads to her parents, Jasper Green and Elizabeth Boude Green, at the Red Rose Inn.
Photograph courtesy of the Bryn Mawr College Archives

IX.
Cogslea

A KNOCK AT THE FRONT DOOR ON JANUARY 25, 1906, was the first indication that the "Romance of the Red Rose" was about to end. Henrietta answered the door expecting a tradesman and was stunned to be served with the following eviction notice:

To Violet Oakley, Jessie Wilcox [sic] Smith, Elizabeth Shippen Green and Henrietta Cozens, Lessees

Anthony J. Drexel having leased to you the premises in Lower Merion Township, Montgomery County, Pennsylvania, known as the Red Rose Inn, by lease the term of which expires on May 1, 1906, subject to three months notice, and the said Anthony J. Drexel and Margarita, his wife, having granted, assigned and conveyed to me the said premises, with the lease, you and each of you are hereby notified and required to

The house and studio at Cogslea, 1907. Photograph by Elizabeth Shippen Green. Collection of Jane and Ben Eisenstat

quit and deliver up to me possession of the said premises, which you now hold as tenant under me, at the expiration of the said lease, namely, the first day of May, A.D. 1906, as I desire to have such possession.

[signed] Henry S. Kerbaugh

The eviction notice caught the Red Rose Girls completely off guard. Later, friends would tell them that so many people advised Henry Kerbaugh not to disturb his famous tenants, that he lost his temper and shouted, "I don't want any beggarly artists on the place!"[108] His decision to turn them out put the household in turmoil. What were they to do? They had only three months to find an affordable property large enough to accommodate seven adults, four cats, and a St. Bernard dog. Studio space was essential. Although Jessie Smith had considerable savings and investments and could afford to turn down work during any move, Elizabeth Green and Violet Oakley could not. Elizabeth was worried about her aging parents. Jasper Green was due to celebrate his seventy-seventh birthday in six days, and, although he had been blessed with robust health for much of his life, he was not as strong as he used to be. Violet had financial worries. She was under an inflexible deadline with the Harrisburg murals and was obliged to finish them on time in order to be paid in full. She could not afford to be away from her work but could not imagine where she would find a working space in three short months. There was not a vacant studio anywhere in the Philadelphia area large enough to serve her needs.

Faced with an impending move under very difficult circumstances, the artists again appealed to Green's well-connected relatives. Help came from one of Philadelphia's wealthiest citizens, Dr. George Woodward. Between 1879 and 1880 Woodward's father-in-law, Pennsylvania Railroad executive Henry Howard Houston, had purchased three hundred acres of land in suburban Chestnut Hill. Located on the highest point of a series of hills that began in northern New Jersey and ended on Philadelphia's Main Line, Chestnut Hill was choice property, purported to be one of the coolest spots in the Philadelphia area and well known as a popular summer resort. When Woodward married Houston's daughter Gertrude, his affluent father-in-law built them a house on this favored site located between the picturesque Wissahickon and Cresheim creeks. After Houston's death in 1895, Dr. Woodward inherited the entire property.

Even before his marriage into the prominent Houston family, George Woodward was a well-connected, respected young man known for his involvement in both art and science. He had attended the medical school at the Uni-

versity of Pennsylvania and posed for Thomas Eakins's famous painting *Agnew Clinic* while serving his internship. After completing his training, he opened a private practice only to find that his interest in medicine was more philanthropic than practical. After two brief attempts to establish himself as a family physician, he quit his practice and dedicated his life to working toward social improvement. His medical knowledge led him to believe that many of the ills of society stemmed from the unhealthy living conditions in crowded cities. Like many men of his age, he had a nostalgic longing for a rural preindustrial lifestyle, and he began to devote his time and vast financial resources to building affordable suburban communities for middle-class families. He shared the sentiment espoused by William Morris, John Ruskin, and the Pre-Raphaelite painters that beauty in art and architecture could elevate the spirit and cure all manner of societal ills from crime to indolence.

He built his new suburban dwellings with care, using natural materials and locally quarried stone. Woodward did not sell his houses but instead chose to rent them out for 6 percent of his original investment. The tenants paid all taxes and were responsible for interior repairs. Woodward once wrote that he was motivated to rent his property rather than to sell it because he did "not wish to lose control of the personnel."[109] He was particular about his philanthropy, always inquiring into the tenants' "antecedents" and actively seeking a mix of young families, middle-aged couples, and interesting, creative people. The antecedents of Smith, Green, and Oakley apparently satisfied Dr. Woodward, and the three artists certainly fell under the category of interesting, creative people.

After much discussion, Woodward agreed to renovate the Hill Farm, a partially burnt-out house located on his property near the picturesque Cresheim Creek in Mt. Airy, just opposite his Chestnut Hill holdings. The old house had thick stone walls and an adjacent barn and carriage house that could serve as studio space. Woodward hired the noted architect Frank Miles Day to make the necessary improvements. George Walter Dawson was engaged to lay out the gardens, which the artists stipulated should, as closely as possible,

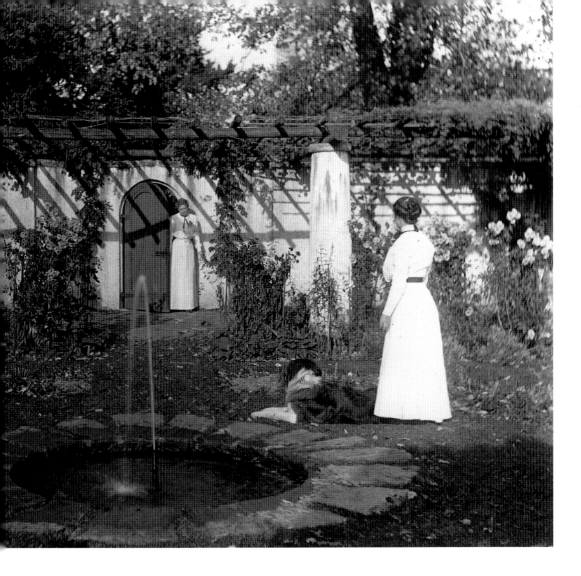

duplicate the grounds at their beloved Red Rose Inn—complete with the fountain, distinctive pergola, clematis, and red roses. The extraordinary generosity of the Woodward family mitigated the artists' distress over leaving their home, and the four companions were able to relocate to Mt. Airy with minimal interruption of their busy schedules. But their exodus was still painful, and it must have been agonizing to travel one last time down the Red Rose's quarter-mile private drive, over the bridge, and out the gate onto Spring Mill Road, the arching weeping willows brushing their flushed cheeks one last time.

The new property was quaint and charming, and, although it was not as impressive as the Red Rose, the women felt very lucky. They named their new home Cogslea, keeping the acronym they devised for their eccentric family and adding "lea" for the sloping land of the new estate. They were forever grateful for the generosity of the Woodward family and affectionately called their benefactor St. George. The name stuck, and although the original address for Cogslea was Allen's Lane, the present address of the home (now a national historic site) is St. George's Road. The Cogs family—two generations plus the pets—settled comfortably into their new life. The property, although

Jessie entering the garden at Cogslea through the door in the pergola while Elizabeth stands by the fountain with the family dog, Maximilian Prince of Neuwied, or "Prince" for short. The dog was named after Alexander Philip Maximilian Prince of Weid-Neuweid, the nobleman who financed Swiss illustrator Carl Bodmer's journey through the American West in 1833. Photographed October 31, 1909. Archives of American Art

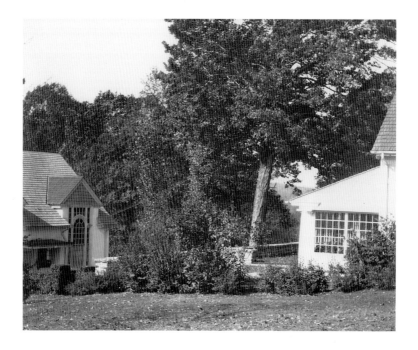

Cogslea, main house
and studio. Collection
of Jane and Ben
Eisenstat

Smith's easel in
the Cogslea studio.
Collection of Jane
and Ben Eisenstat

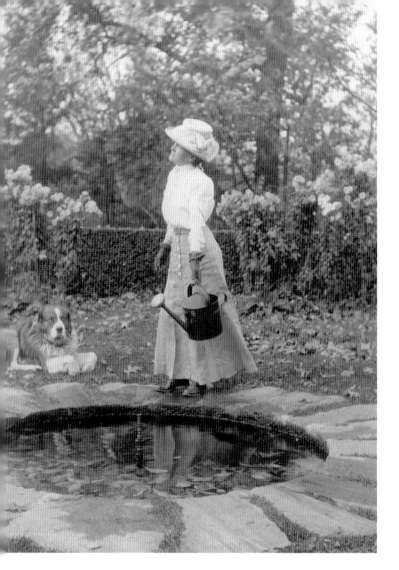 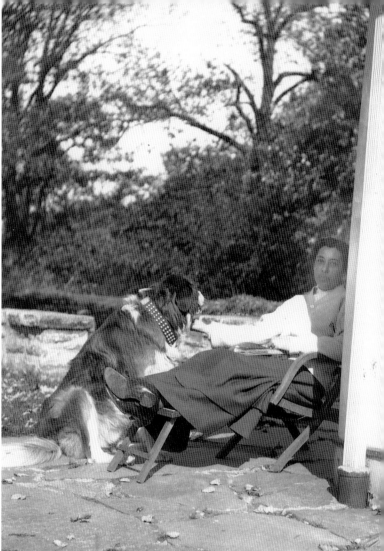

Above left:
Henrietta Cozens in the garden at
Cogslea. Archives of American Art

Above right:
Jessie Willcox Smith on the terrace at
Cogslea. Photograph by Elizabeth
Shippen Green

smaller than the vast acreage they enjoyed at the inn, was spacious enough to ensure both the privacy and bucolic English country atmosphere they cherished. Completely refurbished, the house lacked the inn's enchanting antiquity: the low-ceilings and archaic fixtures. Nevertheless, it offered considerable appeal. Open porches, flagstone terraces, and striking views of the Cresheim Valley lent a spacious feel to the first floor, which featured a dining room, pantry, kitchen, sitting room, central hallway, and a two-story library. On the second floor were four master bedrooms, two smaller servants bedrooms, and three baths. There were two additional large bedrooms and a bathroom under the eaves on the third floor—in sum, more than enough space to ensure privacy for every member of the extended family.

As soon their boxes were unpacked, Henrietta went to work in the garden, and the three artists, with not a moment to spare on inflexible deadlines, went back to their commissions in the renovated carriage house and barn that served as their studio. Violet claimed the largest area of the barn with no objections from her friends, who understood that she needed the space to accommo-

date her murals. Jessie and Elizabeth shared the smaller adjacent rooms. In 1908, illustrator and fellow Pyle student Olive Rush visited the Cogslea studio and described it in a letter to her mother.

> I thought I had written you about my trip to Violet Oakley's studio. It was most interesting and she was very helpful and inspiring. Her studio is a fine one—is large like a barn with no ceiling, showing the rafters, and with a great big north light . . . Violet Oakley lives in a beautiful home with two other artists . . . they built the place themselves—it is in the country out of Germantown. It is furnished with many beautiful old antiques.[110]

Their new residence did not exact any financial toll. In fact, George Woodward charged less for the rent than A. J. Drexel—about $117 a month. Green's bills were the highest, more than $200 a month for food, rent, and sundries for herself and her parents. Oakley, who was still supporting her mother, paid about $150 a month, Smith under $100, and Cozens about $70. The house was in easy walking distance of the Allen's Lane train station, and the three women took advantage of their proximity to convenient transportation and started going into Philadelphia frequently. Even Violet, who was making good progress on the Harrisburg panels and was pleased with the results, was ready to go out and have some fun.

When the great Alphonse Mucha, icon of the French Art Nouveau movement, was sponsored by the Plastic Club to speak at Witherspoon Hall in Philadelphia, they were in the audience. Mucha, who spoke no English, lectured with the aid of an interpreter. In high spirits, Violet commemorated the occasion to amuse Henrietta who, as usual, stayed home.

> Mr. Mucha says: Vat is Arrt? It is bewtee. The pairson who is onable to comprehend the mor-r-ral ar-rmonies is onable to comprehend feesicle ar-r-monies. The Amer-rican landscape is as r-rich if not r-richer than the Eur-r-ropean landscape. In composition everything should be in proportion of two to three. If not we say it is ogly—illustrates on blackboard—then it is bewtee. Vat is Bewtee? It is the manifestation of mor-ral ar-rmony (develops the 2 to 3 formula).

> Mr. Mucha has a pointed vest opening V. The interpreter has a square vest opening U. Frank Miles Day bored until he joins the girls. Mucha and interpreter look at their watches. "It is half past eleven o'clock— we have not begone our lecture!" At reception Violet asks whether he

Opposite:
Jessie Willcox Smith. *Mystic Wood*. From *McLure's* (December 1909). Photograph courtesy of the Archives of the American Illustrators Gallery, New York. © Copyright 1999, ASaP of Holderness, N.H.

measures his proportions to achieve the ideal 2 to 3. Oh no — he draws first and measures afterwards and it is always r-rright! They make the last train to Allen's Lane.[111]

In 1906, after four years of concentrated effort, Oakley finished the murals for the Governor's Reception Room. On November 23 the lights burned all night in the State Capitol building in Harrisburg as Violet, forfeiting any sleep at all, supervised the workmen hired to install the panels. They finished at 6 A.M., just as the crowds started to arrive for the ceremonies. Governor Samuel Pennypacker, who reached his office early in the morning, was surprised to see thousands already assembled at the Capitol. Although he had planned to attend to business before the start of the festivities, he was distracted by the noise and lively atmosphere and, in short order, abandoned his office and went out to shake hands with his constituency.

When the paintings were unveiled, Pennypacker was as pleased with the murals as any of the citizens. The critics were kind too, and Violet was elated with the subsequent acclaim, which secured her a place as an important member of the American Renaissance Revival movement. William McGrath and the American Catholic Historical Society continued to voice their objections to the narrative content of the paintings and to insist that they showed Catholics in a bad light, but their murmuring was muffled by the applause. Harrison Morris, former managing director of the Pennsylvania Academy of the Fine Arts, praised Violet's great achievement in both *The Century* and the *Philadelphia Public Ledger,* and Talcott Williams applauded her resoundingly in the *Philadelphia Press.*

> No American artist, and few artists anywhere have had a commission so precisely suited to their genius and their ability as Miss Oakley. The great wall picture is done so rarely and its difficulty is so great, that one can count on the fingers of one hand all who have been successful in this crucial task. Miss Oakley's work precisely resembles the better achievements of the Venetian School. . . . This great achievement will grow with every year it is seen and studied. In it there has been depicted what is unquestionably rare in modern art—a genuine spiritual conviction.[112]

The critical acclaim was absolutely essential to Oakley's career. She was out of money and needed another commission soon. While overseeing the installation at Harrisburg, reporters asked if she would divulge her fee for

Jessie Willcox Smith. Illustrations from *The Bed-Time Book* by Helen Hay Whitney (Dufield & Company, 1907)

Jessie Smith relied on the work of several other artists to provide inspiration for her paintings of children. She especially admired Abbott Thayer. "He is not modern," she once wrote. "He is eternal and his children have souls and minds and noble beauty."

Scales. The Kelly Collection of American Illustration

Noah's Ark. Photograph courtesy of Illustration House

the series. She was glad to comply with their request and to have the opportunity to suggest that she was vastly underpaid. "The sum paid for the entire series of decorations is $20,000. I do not think that it concerns the public that nearly all of this sum has of necessity been consumed in the four years required to produce the paintings."[113]

Violet need not have worried. Her reputation had been vastly enhanced, and she did not have to wait too long for her next large commission. Not only was she well known, but she now had influential friends. Once the artists were comfortably settled in Mt. Airy, the hospitable Woodwards often invited them to their nearby home, St. Martin's Green, where the three women were embraced into a lively and elite social circle. Frank Miles Day, the architect George Woodward had engaged to restore Cogslea, was also a frequent guest and soon became a friend of all three women, as well as an ardent admirer of Oakley's work. When Day was chosen to design an elaborate residence for prominent Philadelphian Charlton Yarnell, he probably had Oakley in mind when he designed the intricate central hall to include a Renaissance-inspired dome-shaped stained-glass window, three lunettes, four pendentives, and six octagonal murals for insets in the elaborately carved walnut paneling. At any rate, the commission was soon offered to her, once again alleviating her financial worries in the nick of time.

In the wake of Oakley's great critical triumph and subsequent fiscal liberation, the residents of Cogslea breathed a collective sigh of relief. With their moody and difficult sister once again placated and happy, the household seemed to revert to the pleasant camaraderie of the Red Rose days. Life was lively and convivial. Of necessity, work ended earlier in the winter months when the light faded; although drawings could be completed with gas or electric light, all three artists depended heavily on natural light to control the color of their paintings. Winter evenings were spent around the fire and the piano, talking, singing, reading aloud, and entertaining guests. Henrietta kept the house immaculate. Although the household was intensely suspicious of strangers, close friends had an open invitation. Always watchful of proper decorum, Jessie was careful that all invitations were reciprocated.

The Woodwards were frequent visitors and one day brought a new acquaintance with them. Huger (pronounced "U-gee") Elliott was a charming and erudite young architect who had recently been persuaded to entertain a select group of the doctor's friends with a series of lectures on architecture held at the Woodward estate.[114] Smith, Green, and Oakley were among this assemblage and enjoyed the talks. For some reason, George Woodward thought

Elliott would be an ideal beau for Violet. Violet was thirty-two years old at the time and, in the wake of all the positive national publicity that followed the completion of the Harrisburg murals, a most renowned young woman. Huger was anxious for an introduction. He was twenty-nine years old and had recently moved to Philadelphia to take his first job as an instructor of architecture at the University of Pennsylvania. Born October 5, 1877, in Sewanee, Tennessee, Elliott was a graduate of the Columbia University School of Architecture and subsequently—from 1903 to 1905— studied in Paris at the École des Beaux-Arts.

After he became acquainted with the household at Cogslea, it became apparent to Huger that he and Violet were not destined for a future together. One look at the drawings Violet was busy composing for the Yarnell commission should have been indication enough that her future was not going to be reorganized by any man. Powerful female allegorical figures were becoming a hallmark of her work. For the stained-glass panel in the center of the domed entryway, she designed a woman's head to exemplify wisdom. Around this central portrait, flying female figures, representing the four winds, ask, "Where shall wisdom be found?" Strength was an attribute she admired. She was proud of painting her murals with no assistants, a slim young woman in a long Victorian dress doing a man's job. She needed nothing from Huger Elliott.

Portrait of Huger Elliott on the lawn at Cogslea. Elliott's first name was pronounced "U-gee." Collection of Jane and Ben Eisenstat

Elizabeth, on the other hand, found the young architect charming. When the Woodwards told her they had arranged the introduction in the hope that Miss Oakley and Mr. Elliott would enjoy each other's company, she exclaimed, "Violet, nothing!"[115] Huger was a good-looking, dark-haired young man with a mustache and classically handsome features— and he began to turn up with regularity in Green's illustrations. He shared Elizabeth's lively wit, her love of nonsense verse, and her jovial personality. He became a fixture at gatherings at Cogslea and was a welcome guest—even after he asked Elizabeth to marry him. Jessie and Henrietta never dreamed she would ever accept his

Elizabeth Shippen Green. *Miguela Kneeling Still, Put it to Her Lip*. From "The Spanish Jade" by Maurice Hewlett, *Harper's Monthly Magazine* (September 1906). Collection of the Library of Congress

ELIZABETH SHIPPEN GREEN

offer. For ten years the four friends had harbored no secrets. They felt secure in Elizabeth's commitment to their family, an emotionally satisfying and professionally beneficial alignment that as yet had brought no censure. Publicly, they were known as "that group of very clever young women [who] live out their daily artistic lives under one roof in the gentle camaraderie of some Old World 'school,' a band of independent partners in talent who have no time for rivalries and who would admit none if they had."[116]

However, Violet must have been worried. Henrietta was forty-seven years old and Jessie, at forty-three, was already counting her gray hairs. The two were inseparable companions, and their intimacy did not always include the younger "sisters," Violet and Elizabeth. Upset and suddenly unsure of her future, Violet began to make some contingency plans. Hester Oakley's college roommate at Vassar, Louise Lawrence, had remained friendly with Violet after Hester's tragic death. The Lawrence family lived in Bronxville, New York, where Louise's father had founded Sarah Lawrence College. Violet visited the area, purchased some land, and began to entertain plans to build herself a house in case she ever needed a place of her own. She explained the purchase to her friends as an investment.

Elizabeth Shippen Green. *He Knew That He Was Not Dreaming*. From "The Love Match" by Justus Miles Forman, *Harper's Monthly Magazine* (August 1907). Collection of the Library of Congress

Green entered her four-color illustrations and several drawings for "The Love Match" in the Pennsylvania Academy of the Fine Arts "Fifth Annual Water Color Exhibition," where she was awarded the Beck prize for the best watercolor reproduced in color for the purpose of publication.

Elizabeth Green sketches in her studio at Cogslea. Behind her are the file folders in which she meticulously kept photographs and magazine clippings that she used as reference material for her illustrations. The contents of each folder were carefully numbered, and Elizabeth maintained a card catalogue to help her locate the proper subject matter in her extensive visual library. Collection of Jane and Ben Eisenstat

Although she did not fear any dramatic change in the composition of their household, the excitement in Elizabeth's life did have an effect on Jessie, who began to long for an adventure of her own. Her demanding, exhausting professional career had already consumed her youth. As appreciative as she was of her new home, she felt the need for a change of scenery. Like her friends, Jessie was an impassioned Anglophile brought up in the days when most American magazines, taking advantage of loopholes in international copyright law, were filled with the pirated works of English authors. In her youth, the novels of Dickens, Thackeray, George Elliot, and Trollope dominated popular literature. Yet she was the only one of the three artists who had never set foot on "England's green and pleasant land." She longed to see the country that inspired her dreams, and that spring she began to make plans to

travel abroad. When she asked Henrietta to accompany her, she was hurt and nonplussed by her friend's emphatic "no" and, notwithstanding impassioned entreaties, surprised when Henrietta would not budge. Increasingly reclusive, Heddy rarely left the house except to see relatives and resolutely refused to be persuaded to leave the country. A proud, stubborn woman with few financial resources, she also would not allow Jessie to bankroll the trip. Jessie rarely defied her friend and eventually gave up any further attempts to make her change her mind. However, she did not permit Heddy's intransigence to discourage her. Determined to see England, she was not about to be bullied into abandoning her plans. In a huff, she selected another companion to accompany her on her pilgrimage. Jessie Smith's friendship with her former housemate, Jessie Dodd, had remained constant over the years, and when she sent a letter suggesting that the two of them might tour England together, Jessie Dodd accepted the offer immediately. Dodd, who had abandoned her career in illustration in favor of an appointment as a teacher, had her summers free. The two women agreed to meet in London at the beginning of August 1907.

Huger Elliott posing for Elizabeth at Cogslea. Collection of Jane and Ben Eisenstat

Although Elizabeth's widening prospects troubled the household enough to send Violet to her real estate agent and Jessie to her travel agent, their fears soon appeared to be unfounded. Over thirty years old and by Victorian standards well ensconced in spinsterhood, reluctant Elizabeth stonewalled Huger's proposal. She was content with her life and her work, and the vow she had made to her friends must have weighed heavily on her conscience. Her official excuse for prolonging the engagement was the condition of her elderly parents. She told Huger she did not wish to burden him with the expense of their care. Since she was supporting them anyway, it is unclear why this excuse mollified young Elliott. Whatever his reason, he was willing to wait, and the problem was defused when he accepted a position to teach at Harvard. At the end of the summer he would be moving to Cambridge, and Elizabeth would be staying with her friends.

X.

"The Interstices between the Intersections"

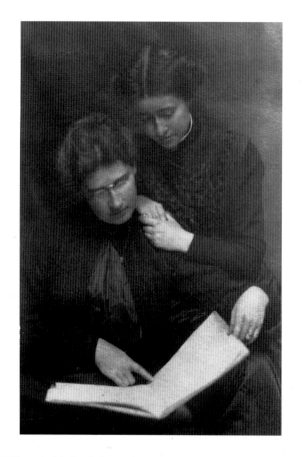

Jessie Willcox Smith (seated) and Elizabeth Shippen Green (standing) pose for a formal portrait, c. 1902. Photograph courtesy of the Bryn Mawr College Archives

FOLLOWING HUGER ELLIOTT'S DEPARTURE, LIFE AT Cogslea appeared to settle back into its familiar routine. But there were profound changes in American society as the twentieth century began—changes that would affect the lives of the three women as much as Huger's proposal. The first generation of educated American women was becoming successful in a variety of careers, and their achievements were beginning to attract considerable attention. A 1907 newspaper review of some of Smith's paintings at an exhibition in Boston was headlined, "Women Surpassing Men Illustrators . . . Jessie Wilcox [*sic*] Smith an Excellent Example." The author went on to note, "And by the way, the women seem to be doing notable work in illustration, better indeed than many of the men. I write this in fear and trembling."[117] Illustration was a lucrative career, and Jessie Smith was making a very good living. She was also exploiting a market that with few exceptions had been entirely dominated by men. In the nineteenth century, when a Boston marriage was considered an acceptable alternative for a spinster, it is doubtful that anyone imagined that women would form personal and professional alliances fortuitous enough to give them a viable financial alternative to marriage. However, by 1907, women were beginning to achieve considerable professional success. Their accomplishments began to be viewed as a threat to the American family, an institution that depended on ample career opportunities for men and the commitment of women to stay home and raise the children.

Jessie Willcox Smith. *Mother and Child.* Cover illustration from *Dream Blocks* by Aileen
Cleveland Higgins (Duffield & Company, 1908). Collection of Jane and Ben Eisenstat

*This painting, which appeared on the book's cover, was one of sixteen that Smith created to
illustrate Aileen Cleveland Higgins's sentimental collection of verse for children.*

Bedroom at Cogslea. Photograph by Elizabeth Shippen Green. Collection of Jane and Ben Eisenstat

That same year the New York Society of Illustrators, recognizing the excellence of women in the field, elected their first five female members. Jessie Willcox Smith, Elizabeth Shippen Green, and Violet Oakley joined Florence Schovel Shinn and May Wilson in the select group. The progressive Society organized an exhibition at the Waldorf-Astoria Hotel to encourage their new colleagues. Although the Plastic Club had been mounting exhibitions by its members for a decade, in New York a show featuring female artists was still something of a novelty. The exhibition attracted considerable attention from the press. Unfortunately, the reviews reflected the era's rising prejudice against working women.

In lieu of critical comment on the show, the *New York World* commissioned its caricaturist to make a drawing. He penned what he must have considered an amusing sketch: a group of smartly dressed women admiring a long gallery of portraits—all babies, all sucking their fingers. His jest at the expense of the young women artists was excused by a fellow critic who commented that the cartoon no doubt "was as much enjoyed by the artists as the perpetrator."[118] How much these five serious and talented illustrators enjoyed having their work ridiculed is open to debate. There is no doubt that Smith and Green possessed a lively sense of humor. Certainly Oakley could have used some levity

in her life, although it is hard to believe that the article could possibly have amused her.

The other changes that were taking place were most probably not noticed at all by the three artists. Psychoanalysts and sexologists, especially in Europe, were starting to take a closer look at romantic friendships and Boston marriages. What they discovered alarmed them enough that they began to revise their theories about female sexuality and ponder what women in long-term relationships might be doing aside from writing each other effusive letters. In the United States, where puritan morality and concern for the public decency were pervasive, these revelations were slower to manifest themselves. Lillian Faderman, a noted authority on lesbian history, points out that between 1740 and 1895, the *Index Catalogue of the Library of the Surgeon General's Office* showed only one scientific article on lesbian relationships.[119] In the subsequent twenty years, nearly 100 books and 566 articles on sexual "perversions" were listed in the same index. An article by Dr. Havelock Ellis that appeared in 1902 in the *Pacific Medical Journal* sounded a warning about the crushes that were such an integral part of the social life at women's colleges. When young girls are thrown together at college, Dr. Ellis warned, they become increasingly affectionate.

Jessie (facing camera) and Henrietta in the garden at Cogslea, 1907. Photograph by Elizabeth Shippen Green. Collection of Jane and Ben Eisenstat

> They kiss each other fondly on every occasion. They embrace each other with mutual satisfaction. It is most natural, in the interchange of visits, for them to sleep together. They learn the pleasure of direct contact, and in the course of their fondling they resort to cunnilinguistic practices. . . . After this a normal sex act fails to satisfy [them].[120]

This kind of specific information did not filter down to the general public or to the popular press. Although there was a growing body of opinion that close relationships between women were not entirely platonic, it is doubtful that the speculations of sexologists on the harmful consequences of physical intimacy between women infiltrated the flower-decked bedrooms of Cogslea, where life went on as usual. According to Faderman, "It was still possible in the early twentieth century for some women to vow great love for each other, sleep together, see themselves as life mates, perhaps even make love, and yet have no idea that their relationship was what sexologists were now considering, 'inverted' and abnormal."[121]

In August, Jessie sailed for England aboard the S.S. *Minnehaha*. She was so upset about leaving home that she called the day of her departure

"Black Friday." She missed Henrietta immediately and the first night out at sea took pen in hand and began a long letter. She described her cabin as neat and compact but, she pointedly assured Henrietta, too large. "I really love it but it is too *big* for one person. That is the only trouble. I rattle around and did I even suggest that the berth was a *trifle* small in any way? Absurd—quite as large as anyone needs." She ended her entry for the first day with considerable senti-ment. "Good night my dearest little Heddy, don't forget your Jeddy. I shall never be reconciled that you are not with me."[122]

Jessie was not lonely for long. In the early days of the century, women traveling first class did not journey unescorted. As much a part of maritime security as the lifeboat drill, "unprotected women"—any females traveling alone—were portioned out to reputable gentlemen making the voyage. In case of any shipboard emergency the men would be responsible for the safety of the women assigned to their care. Smith's distrust of strangers grew with every year, so she was relieved that one of her brother DeWitt's friends—Jessie referred to him only as "Bretzel"—was also on board and had been assigned as her protector. Jessie, who spent most of her days in her deck chair or in the ladies' writing salon penning page after page to Henrietta, did not have much time for her escort but assured Heddy that "Altogether Bretzel is really not bad, he hovers around but is not too oppressive."[123]

Her first three days at sea were perfect. Bare-headed in white linen she leaned out the porthole of her stateroom eating the fruit that Heddy's sister Delia sent for "bon voyage" and "consigning the stones and peels to the briny deep."[124] The twilight hours were beautiful, and for several nights Jessie could not bear to leave the deck and go down to dinner. Bretzel was her dining part-ner, so, as she gazed over the rail, he was obliged to linger with her. Jessie was growing more comfortable with him. He had a genuine interest in painting and was an avid collector with enough disposable income to purchase a picture from every exhibition he attended. He was obviously quite taken with Jessie, but she was not interested and made it clear to Henrietta that she need not fear a male rival. She explained that, although Bretzel was "very nice in the way of steamer chairs and rugs and books and wraps . . . when it comes to moonlight I kind of hanker for someone I have known longer!!"[125]

When she reached England, Jessie Dodd, who had arrived the week before, came out on the tender sent to unload the passengers. Jessie Smith was thrilled to be in England and her happiness was compounded by the sight of a familiar face among the crowd of people meeting the steamer. She disembarked hastily, embraced Jessie Dodd, and, with Bretzel in tow, went on to London by

train. After the oppressive heat of the Philadelphia summer, Jessie Smith was pleased to find the weather cool enough for a flannel petticoat, underwaist, and topcoat, but clear and sunny. The two women set themselves up in a small pension overlooking the British Museum. Their rooms had high ceilings, long windows with lace curtains, and cheerful window boxes filled with geraniums. From there, in high humor, they set out to see London. Jessie Smith was so thrilled she wrote home to Cogslea that she was afraid her "nervous system would become unstrung."[126] Notwithstanding, she and Jessie Dodd finally managed to catch their breath and tour the city and the galleries. Jessie Smith visited the National Gallery, the Tate Gallery, the Wallace Collection, and the Dulwich Gallery, and declared herself ready to commit any crime to carry away Sir Joshua Reynolds's *Age of Innocence*. She also admired Gainsborough's *Mrs. Siddons* and Sandro Botticelli's *Madonna and Child with Saint John and an Angel*.

Smith was in London for a week before she sent an answer to the letter from Henrietta that she found waiting when she arrived in London. Heddy missed her and admitted as much. "I miss you, I miss you, I miss you. Enough to satisfy you, I am sure. . . . Even the sponge in the rack in the tub looks lonely without its fat companion,"[127] she wrote plaintively. However, still irritated that Henrietta had refused to come along, Jessie was less demonstrative and wanted to make sure her friend heard in detail just what she was missing. "Oh if only I could come into the 'Corner Saloon' and tell you all about it," Smith wrote. "—But you probably would say—shut up— I don't want to hear, so in that way I have the advantage of you and will continue in the happy belief that you will read *all* I write."[128]

Henrietta was missing the time of her life. Smith and Dodd enjoyed the sights of London and even sampled the nightlife without any fear for their safety, courtesy of Bretzel, who escorted them around the city, took them to the theater, and invited them to his opulent hotel for dinner. Bretzel was evidently taken with Jessie Smith. He let at least one steamer leave for home without him, she informed Henrietta rather proudly. Even if she was still feeling the sting of Heddy's decision to remain at home, it is difficult to guess what could possibly have motivated her to add, "It is well that J. Dodd is here to chaperone this affair."[129] Presumably she was joking. Jessie Smith could be temperamental, but never ever cruel.

More than any of the other women, Henrietta was entirely dependent, both emotionally and financially, on her Cogslea family. She had no career and very few financial resources. Her limited funds were invested at the Girard

Trust Company and typically yielded about 5 percent. If the household were to ever dissolve she would become a burden for her relatives—the maiden aunt living on charity. Jessie understood this well. Before she left for Europe she hid a check in Henrietta's desk. "I don't think I said anything to you in my last letter about that other cheque I found in my desk," Henrietta wrote when she found Jessie's gift. "You were a naughty, naughty child to do that. It was taking an unfair advantage. You have plenty to do with your money besides wasting it on me and I have just been spending it on *riotous* living."[130] Much as Heddy appreciated Jessie's generous nature, she felt financially vulnerable. In her friend's absence, in a driving rainstorm, she took the opportunity to go into Philadelphia and check with her banker on the state of her finances.

By September Jessie Smith and Jessie Dodd, sunburned and freckled, were traveling through the English countryside, visiting Salisbury—where Bretzel reluctantly left them—and going on alone to the Lake Country. At the country house of a friend, the two women were assigned to separate rooms. Jessie Smith ingenuously informed Henrietta that she became so lonely in her room that she crawled into bed with Jessie Dodd. The bed was as broad as it was long, she explained, so there was no crowding. She celebrated her forty-fourth birthday in England and missed the festivities at home for Elizabeth's thirty-sixth. By the end of the month she was homesick and glad to be returning to Cogslea. All acrimony forgiven and forgotten, Jessie promised Henrietta that she would never go to Europe again without her.

Smith wasted no time getting back to her easel. Hailed as America's Kate Greenaway, there was a constant demand for her work. The comparison with Greenaway, the English illustrator whose charming images of impeccable children adorned British children's books at the end of the nineteenth century, pleased her. She never expressed any regret about her choice of subject matter or seemed to feel that children's book illustration was any less important than the illustrations Elizabeth sent to *Harper's* or the allegorical murals that Violet constructed. Nor did she make any self-deprecating remarks about the sentimental nature of her paintings. Despite her great financial success, Smith's work was driven by conviction, not by money. Although her even temper and noticeable lack of the sort of artistic zeal that drove Violet occasionally caused her to mention that perhaps she was not a "real" artist, she was dedicated to her profession and continued to work prodigiously even though it had been many years since there had been any pressing financial need. Her illustrations were tremendously popular, but a friend once wrote, "Only a few know what they represent—a steady devotion to work—a continuous effort, generously and

unselfishly poured out that others may rejoice and be glad."[131]

DREAM BLOCKS
BY
AILEEN CLEVELAND HIGGINS

After her return to Mt. Airy, Smith illustrated two critically acclaimed books in quick succession: *Dream Blocks*, published in 1908, and *The Seven Ages of Childhood*, published in 1909. Both were adorned with her subtle and sympathetic portraits of children and were widely circulated. Between them, the two books had twenty-three full-page color illustrations. She was also busy with magazine illustrations for *Collier's, Ladies' Home Journal, McClure's Magazine*, and *Woman's Home Companion*.

Green returned from a holiday of her own in time to pick up the September issue of *Harper's Monthly* and see four of her paintings for James Cabell's *The Navarrese* reproduced in full color. Notwithstanding constant worry over the precarious health of both her parents, she continued not only to be productive but to create landmark illustrations. That fall she produced a number of imaginative paintings for *Harper's*. Her illustrations for Justin Miles Forman's *The Dream*, Beatrix Demarest Lloyd's *The Empty House*, and *Endymion Uncut* by Arthur Stanwood Pier were among her best. She also illustrated *The Book of the Little Past* by Josephine Preston Peabody. Stylistically her work had moved further away from Jessie Smith's. In *The Book of the Child*, their techniques were nearly indistinguishable, but Green had since developed a more flowing line and an ethereal, almost abstract, quality that was all her own.

Jessie Willcox Smith. Illustrations from *Dream Blocks* by Aileen Cleveland Higgins (Duffield & Company, 1908)

Above:
Dream Blocks

Violet completely absorbed herself in designing the murals for the central hall of the Yarnell home. Never one to shy away from a difficult project, she decided to configure the panels to represent the entire progression of human civilization. She called the series (dominated by the female personification of wisdom in the stained-glass dome) *The Building of the House of Wisdom*. In keeping with the architectural metaphor, the four pendentives, which she christened *Builders of the Earth*, traced architectural progress from tents to skyscrapers. The lunettes showed the development of culture using the growth of a child to represent human progress, beginning with *The Child and Tradition*, in which a child is introduced to the luminaries of the past, and ending

Jessie Willcox Smith. *Stupid You*

Jessie Willcox Smith. *Doorsteps*

*"There a shining thread/ To-day in my rose-bed—/
A magic net the fairies have outspread/ To catch the
dewy sweet—and yet you said/ It was a cobweb
there instead!"*

Jessie Willcox Smith. *Summer's Passing*

Jessie Willcox Smith. *Punishment*

Elizabeth Shippen Green. Illustrations from "The
Navarrese" by James Branch Cabell, *Harper's
Monthly Magazine* (September 1907)

Above left:
All Misery, Antoine! And Now I Live Beneath a Sword

Above right:
Neither Could Be Quite Unhappy

Opposite:
So These Two at Montbrison, Hunted and Hawked

Elizabeth Shippen Green. *Rising Vigorously Out of the Earth Was a Little Rose Bush*. From "The Flowers" by Margarita Spalding Gerry, *Harper's Monthly Magazine* (August 1908). Collection of the Library of Congress

Opposite:
Elizabeth Shippen Green. *Gisele*. From "The Dream" by Justus Miles Forman, *Harper's Monthly Magazine* (October 1908). Collection of the Library of Congress

Violet Oakley's paintings in the central dome of the Yarnell House, Philadelphia, Pennsylvania. Archives of American Art

with *Man and Science*, which shows an amazed crowd watching a biplane sail across the skies of Florence. Oakley's designs reflected her own optimism, as well as the new century's distinctive confidence, that science would ultimately free man from the scourges of the past.

Solvency washed in and out of Oakley's life like waves on a beach, briefly erasing all vestige of debt. The Yarnell commission provided her with a clean slate. Imprudently, she booked another trip to Europe where she planned to travel extensively to study the Renaissance masters for the inspiration she deemed necessary to complete the project. Mrs. Oakley accompanied her, and they stayed for months. In August 1909, while in London and feeling homesick, she bought a piece of lavender from a street vendor and sent it home to Heddy, writing, "I sent you some [lavender] because it made me think of your garden."[132] December found the Oakleys lunching in grand style with the American consul at the picturesque hotel Reina Cristina at Gibraltar, in Alge-

ciras, Spain, and preparing to set out the following day to visit Violet's aunts Georgiana and Isabel at their villa in Tangier, Morocco. The stunning hotel Reina Cristina featured manicured gardens and terraces overflowing with flowers. From the deck the Oakleys admired a magnificent view of the Rock of Gibraltar. In the clear December air they could look out across the strait to the African coast. It was so splendid, Violet wrote, that it reminded her of a Spanish version of the Red Rose Inn. Perhaps her mind drifted back nostalgically to those idyllic years when the four friends were heady both with success and their love for one another. Realizing that their lives were now filled with many complications and that their time together might not last a lifetime, she penned Christmas greetings from herself and her mother. "We must take no more time in writing now. So this briefly, but none the less strongly carries you our loving thoughts for a happy Christmas and much hope for the unknown future of us all."[133]

Man and Science mural by Oakley for the Yarnell House. Archives of American Art

Violet's European trips, though costly and perhaps ill-advised, always inspired her. She came home overflowing with ideas and immersed in the glow of the Renaissance. Her work seemed rejuvenated, her paintings bold, and her stroke free. The Yarnell murals were going to be a great success. At night when the light was too dim to paint, Violet buried herself in her books and read extensively from the *Divine Comedy* of Dante Alighieri. In her opinion, it was the greatest single poem in Western literature—an invaluable guide to life and, if properly studied, a guide for humanity to climb out of the depths of mortal anguish and into the divine state of mind that moves the heavens. She studied the poem with the enthusiasm she had previously devoted to the ideas of William Penn. The luxury of time to read and relax in the evening was enjoyed by all three of the artists. While they attended to their careers, Henrietta attended to almost everything else.

Although she was rarely mentioned in any of the numerous articles lauding her famous housemates, Henrietta's assistance was a major factor in her friends' uninterrupted productivity and genteel lifestyle. The management of Cogslea was a demanding job, and she worked just as tirelessly as her three friends. Accustomed by her own meager income to making every penny count, she drove a hard bargain and was careful not only to procure the finest possible service for her household but also to obtain the best price. Groceries were delivered on schedule from the Centennial Market in Philadelphia. Vines were cut at the rate of seventy-five cents an hour by local Mt. Airy landscapers Thomas Meecham and Sons. Household repairs were made, washing and ironing attended to, pets cared for, windows washed, counters scrubbed, and three meals a day put on the table courtesy of her attentive management. The artists' interest in the house was aesthetic rather than pragmatic. One mild autumn when the rose tree flowered until November, the delighted artists rushed into the garden to photograph the late bloom. But, as Henrietta often reminded them, "Garden's are not made by Singing—'Oh how Beautiful', and sitting in the shade."[134] She was the one who weeded, pruned, and kept the household beautiful and orderly. For whatever their personal eccentricities, the four friends considered themselves to be ladies and were determined to live in style.

Although ardent about appearances and maintaining proper decorum at all costs, the Red Rose Girls were not vain women. But because they were often in the public eye, recognized by strangers, and photographed by the press, they were mindful of their attire and interested in fashion. Their clothing was conservative but elegant. Smith, who ordered her paints from Henry M. Taws in Philadelphia and knew the difference between rose madder and

alizarin crimson, also knew when to describe a dress as "plum." She was a capable seamstress, particular about tailoring. When a garment hung loosely she made the necessary tucks, fearing that an imperfect fit might make her look like a "market woman." Her fashion sense affected her illustrations, and she never painted children in what she referred to as ill-considered accessories. She chose her models carefully. They were usually the children of friends, people who knew that simplicity in clothing was a mark of gentility. "Children are like flowers," Jessie once said. "It seems to me inappropriate to dress them in bizarre colors or to paint them in a bizarre colors."[135] All four women watched their figures and rarely missed taking their morning constitutional, even when they traveled. Hairstyles were discussed at length. When humidity caused unwelcome curls or cold weather left locks limp and unmanageable, they fretted. Henrietta bit her nails, a habit that her friends tried unsuccessfully to cure by begging her repeatedly to take some time off, go into the city, visit relatives, or take a vacation.

Even with Heddy shouldering the bulk of the household responsibilities, in order to maintain their schedules, the artists helped each other with their projects. Jessie and Elizabeth were skilled with their cameras, having profited from Thomas Eakins's insistence that photography be part of the curriculum at the Academy. Both women photographed the models for their illustrations rather than having them sit for long poses. They spent hours working together to fashion elaborate costumes and to reconstruct the situations they would be illustrating. Many of their friends posed for them, and they willingly modeled for one another. Elizabeth was the librarian for the group, maintaining an extensive reference file of artwork and photographs clipped from magazines. They carefully saved reproductions of the work of other illustrators they admired: Howard Pyle; fellow Pyle students Sara Stillwell, Frank Schoonover, Stanley Arthurs, and N. C. Wyeth; as well as illustrations by Edwin Austin Abbey and Howard Chandler Christy. Smith and Green continued their artistic collaboration as well, combining their efforts once again to illustrate the 1909 Bryn Mawr calendar.

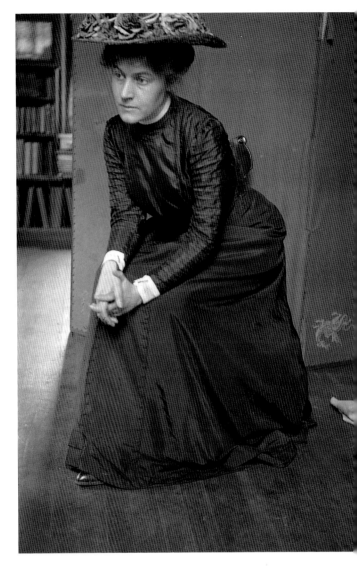

Violet posing for Elizabeth at Cogslea. Photograph by Elizabeth Shippen Green. Collection of Jane and Ben Eisenstat

The Honorable
Charles Evans Hughes,
Governor of New
York, and Violet Oak-
ley, Master of the
Pageant at the West-
chester County
historical pageant,
Bronxville, New York,
1909. Archives of
American Art

Opposite:
Elizabeth Shippen
Green. *The Folds of
Her Cloak Making Her
Seem Like a Kneeling
Marble*. From "Her
Eyes are Doves" by
Harriet Prescott Spof-
ford, *Harper's Monthly
Magazine* (January
1910). Collection of
the Library of Congress

Their home was charming, their careers flourishing, yet Cogslea was a transformed household. Letters arrived for Elizabeth from Huger Elliott with alarming regularity. Violet was increasingly involved with the Christian Science Church and her plans to build a home of her own. Jessie, still inspired by her European holiday, had stories to tell of her adventures that for the first time in many years were completely outside Henrietta's experience. The atmosphere in the Cogs family had shifted. In the Red Rose years, the four women shared everything. There had been no secrets. Now, some letters were private. Certain plans were simply not discussed. The changes at Cogslea were subtle and evidently did not affect the efficiency of the Cogs family, although Elizabeth called this period of their lives "the interstices between the intersections," sensing that it was a time of demarcation.[136]

In 1909 Elizabeth's mother, Elizabeth Shippen Boude Green, died. Jasper Green was failing. Violet began to harbor serious worries about the future, as the specter of Elizabeth's possible defection hung over the house like a dark cloud. At the end of 1909 Violet wrote a poem to Jessie voicing her fears, "To Our New Year 1910":

Coming events cast their shadows before
Oh may the substance prove unlike its shade

Grant us Some Light where but dark seemed in store
So may our New Year in joy, yet be made
Love is all Sunshine which knows naught night
Evil's negation—and night but Earth's Screen
After our nightmare—the Day dawns serene.[137]

The year 1910 did not "dawn serene." Jasper Green died on March 2, 1910. His obituary in the Philadelphia papers reduced his whole life and productive career as an engraver, illustrator, and Civil War artist/correspondent to the accomplishments of his only surviving child. On March 3, the Thursday morning edition of the *Philadelphia Public Ledger* acknowledged his death with the following brief notice:

> Jasper Green died yesterday morning at the home of his daughter, Elizabeth Shippen Green, the illustrator, Allen's Lane Mt. Airy. He was 82 years old. Mr. Green made his home with his daughter and her companions, Violet Oakley and Jessie Willcox Smith. The three illustrators live and work together in the one house which is known as one of the most beautiful spots in the Cresheim Valley.

Elizabeth characteristically dealt with her grief without reducing her workload. She also made no move to honor her promise to Huger, who was in Boston waiting for some indication that her mourning period was over and that they were finally free to plan their lives together. His patience did not last. Having accepted a job as director of the Rhode Island School of Design, he planned to make his home in Providence, Rhode Island, and required a definite answer from Elizabeth—one way or the other. So sometime in October 1910, nine months after the death of Jasper Green, Huger took the train to the Allen's Lane Station, walked down the road to Cogslea, and gave Elizabeth an ultimatum: marry him now or the engagement was over. Elizabeth was torn by indecision. She was thirty-nine years old and had been with her friends since she moved out of her parents' home at twenty-six. The four women had an agreement that she would violate if she left.

Elizabeth must have felt somewhat vindicated by the fact that her companions were financially secure. In 1910 the *Philadelphia Public Ledger* estimated Jessie's income at about $12,000 per year. She was so prosperous that her friends affectionately nicknamed her "the mint."[138] Violet had recently been awarded two important new commissions that seemed to ensure her solvency for many years. Her first assignment was for the home of Robert Collier of

Opposite:
Elizabeth Shippen Green. *Eyes of God, We Call Them in Italy*. From "The Treasure" by Frederick S. Isham, *Harper's Monthly Magazine* (October 1910). The Kelly Collection of American Illustration

Collier's Publishing Company. Collier was familiar with the work of all three women and had hired Violet to illustrate articles for *Collier's* magazine before she began her career as a muralist. Originally charged with creating a three-paneled window celebrating Boccaccio, Petrarch, and Dante, Oakley somehow convinced Collier that all three windows should be a tribute to Dante's *Divine Comedy*. The first panel was to represent Dante's *Inferno*, the second, the *Purgatorio*, and the third, the *Paradiso*. She was pleased with the assignment, as it gave her a chance to give visual representation to Dante's great work. With her studio once again filled with notes and sketches for the new project, Violet had no time to sit around and pine for Elizabeth Green. She was a proud woman who refused to be characterized as weak or wounded. When she was asked a few weeks later if she would be willing to paint a huge mural (fifteen by forty-one feet) for the Cuyahoga County Courthouse in Cleveland, Ohio, she accepted that assignment too, tackling the enormous task with eagerness, erecting scaffolding in her studio, arranging for props and costumes, and asking a succession of models to pose.

The prosperity of her friends was probably not the only factor that informed Elizabeth's decision. Huger was undeniably charming and fun. Jessie and Henrietta were an inseparable couple, close in age and similar in taste, and had an old-fashioned, unbending dedication to decorum that must have stifled exuberant Elizabeth. Violet was absorbed in her religion, her passionately held vision of a utopian society, and her desire to uplift the morals of the country through her paintings. Perhaps Elizabeth felt that she had grown away from her friends, or perhaps she was just tired of working so hard for so many years to achieve the fashionable lifestyle that had seemed so important. In one of her poems she wrote,

> Thus simple let one live and die
> Nor long for Midas' golden touch
> If heaven more generous gifts deny
> I shall not miss them much
> But thankful for the blessings sent
> Of simple tastes and minds content.[139]

She told Jessie and Violet first. Henrietta came in from her garden later, and Elizabeth confronted her with the news. She had accepted Huger's proposal. Henrietta said nothing, just turned her back and walked into the other room where Jessie and Violet were waiting. Blinking back her tears, Henrietta asked her friends, "How can she love anyone more than she loves us?"[140]

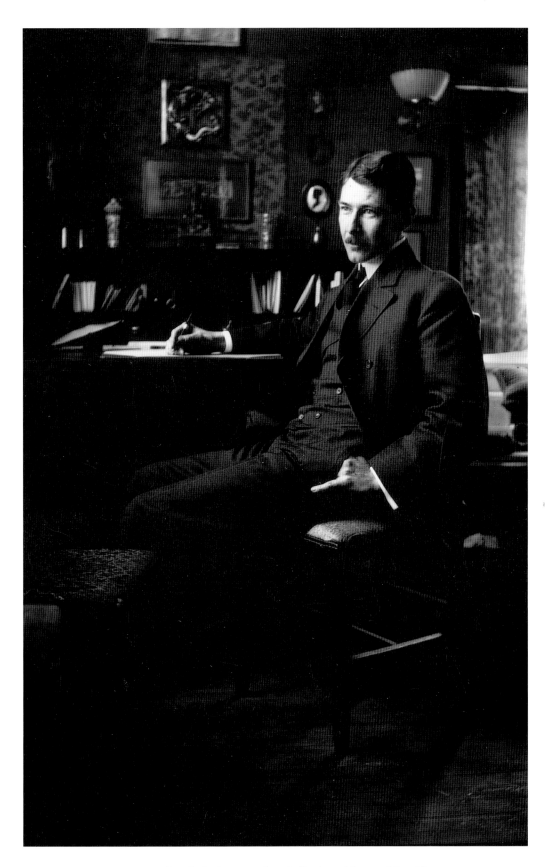

Huger posing for Elizabeth at Cogslea. Collection of Jane and Ben Eisenstat

XI.
Declaration of Independence

O N SATURDAY AFTERNOON, JUNE 3, 1911, ELIZABETH Shippen Green became Elizabeth Green Elliott. The late-afternoon wedding was a private function. Because the guest list consisted only of intimate friends, no formal invitations were sent out. Henrietta decorated the house with banks of flowers. The Reverend Jacob LaRoy of St. Martin's-in-the-Field performed the ceremony. Violet and Jessie attended the bride, who was given away in marriage by her uncle, Samuel Bethel Boude. The quiet service and modest dinner reception were conducted with the dignity and sense of propriety that characterized life at Cogslea.

Although the bride and groom left the house soon after the reception, they did not leave Philadelphia fast enough to miss the next morning's headline story on the front page of the *Philadelphia Press*. It ruined the occasion for Elizabeth, and worried her for many months. "Trio of Artist Friends Broken by Cupid," the *Press* announced. The story, which was accompanied by dolorous photographs of all three women, characterized Elizabeth's wedding as a bizarre and melancholy occasion.

TRIO OF ARTIST FRIENDS BROKEN BY CUPID
Artists Combine Fortune For Life: Miss Green, Noted Illustrator Becomes Bride of Institute Director.

After eight years of friendship rarely paralleled during which they studied art, lived together and each won distinction as artists, the trio of loving friends was depleted yesterday by the marriage of Miss Elizabeth Shippen Green to Mr. Huger Elliott, director of the Rhode Island School of Design. The ceremony was performed at "Cogslea," a quaint little chateau on the very edge of the Cresheim Valley in Mt. Airy where the three artists lived. Mr. and Mrs. Elliott left for Europe where they will spend the summer and there was a note of sorrow in the florally decked and art laden rooms of the cozy and beautiful little home of the trio last night, when Miss Green was separated from Miss Smith and Miss Oakley for the first time in their long friendship.[141]

The *Philadelphia Press* article went on to state, "a note of sadness was felt when the realization came that the trio of artists who had lived and worked

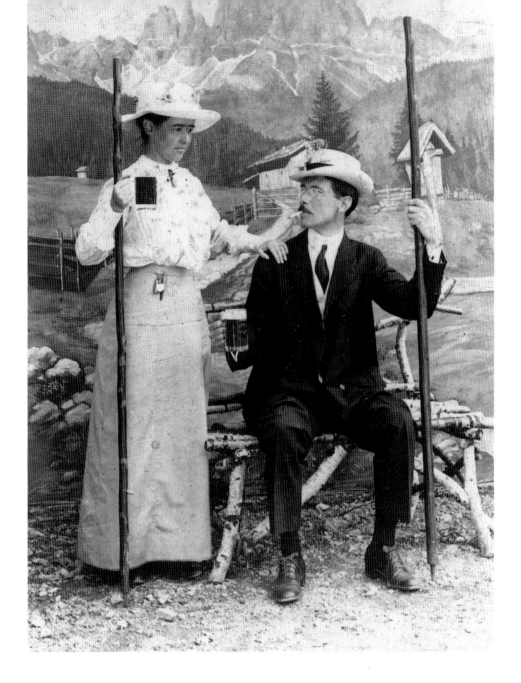

together so long would be depleted by the absence of Mrs. Elliott." Smith, Green, and Oakley, the *Press* reported, spent their last two hours "closeted" together, exchanging final farewells. *The Chestnut Hill Herald* also covered the event, less prominently but even more sensationally. A shattered Violet Oakley, the *Herald* reported, pleaded with Elizabeth Green to keep their compact and held out hope until the very last that Green would change her mind and stay. But when the day arrived, Oakley "broke down completely."[142] Whoever leaked the details of what was meant to be a very private occasion was obviously no friend of the Red Rose Girls.

Four days later Elizabeth wrote a note to her friends from the Red Lion Inn in Stockbridge, Massachusetts, where the couple was spending a few days before leaving for their European honeymoon. Elizabeth squandered her first

Huger Elliott and his new bride, Elizabeth Shippen Green Elliott, pose for a tourist photograph in Germany on their honeymoon, 1911. Photograph courtesy of the Bryn Mawr College Archives

161 ❧

day as Mrs. Huger Elliott worrying about the newspaper articles. Although benign by today's standards, the inferences seemed scandalous in 1911. "Sunday at the Belmont was spent pretty much as you did and trying to get over the two newspaper articles and deal with the chagrin and ending up finding it killingly funny," she wrote to Henrietta and Jessie. "The Press thing I must say wasn't. It's on the front page where everybody who knows us can see it. And those pictures. Neither do I see why we should be written up so commonly. But the Press is hopeless anyway and should be strangled."[143]

Elizabeth was especially worried about Violet, who was characterized in the newspapers as being completely grief-stricken. However biased the articles may have seemed, the reporters were correct to surmise that sadness clouded the festivities at Cogslea that day, and they were also correct when they said Violet was upset. Elizabeth's quarrel with the newspapers was not that they portrayed Violet as bereft, but that they failed to acknowledge the fact that, by the time the wedding day dawned, Violet had recovered her composure. Violet, Elizabeth recalled in her letter to Jessie and Henrietta, had been wonderful to her on those last two days—helping her with her shopping and packing her trunks. "As for the Herald's report of 'the sister's wails and the doleful music,'" Elizabeth claimed it was "just too funny." Unfortunately, Elizabeth was not amused for long. Even after the couple sailed for Europe, the new bride had trouble enjoying the trip. "I am truly sorry and enraged about those newspaper articles," she wrote. "I think the only redress is to sue for libel when we get back and heaven knows that is expensive. But libel it surely is to say nothing of defamation of character."

Elizabeth's failure to fully understand the implications of the articles is not surprising. Research on lesbian history supports the contention that women in the late nineteenth and early twentieth centuries could live as companions and lovers without consideration that their lifestyle constituted anything atypical in the view of mainstream society. Lillian Faderman explains that even if a relationship between two women was genital "they could have felt the same guilt over it that their contemporaries might have experienced over masturbation—it was sexual pleasure without the excuse of inescapable marital duties—but they would not necessarily have thought themselves to be abnormal."[144] Elizabeth obviously had an incomplete understanding of the nature of her alliance with her Cogslea sisters. And, although she seethed that the press was unjust, her letters home reveal their reports did not fall too far from the truth.

The newspaper articles were not the only thing upsetting the Elliotts' honeymoon. Elizabeth Green Elliott was a greatly confused bride. She was

filled with longing but evidently not for Huger, who, she informed her friends, behaved like a perfect gentleman. Her marriage was not yet a week old when she wrote, "We feel quite at home save for a horrid old ache in my heart whenever I think of Cogslea." Later that same week she assured her sisters that her feelings for them had not changed:

> I must say and I want to pour out my heart to you, you lovely dear people to work and slave for me to give me such a beautiful happy wedding day when I had troubled and feared that it would be the saddest day almost for me. I may be married and I'm very happy on the married side of the situation but I'll never be any less to you—not any different in the real me toward you and Jessie and Violet and Mrs. Oakley. I'm just not that kind. I don't know about what the future has in store but it has not in store any change or forgetting in me, only addition— not division. I'll be double but not half. . . . I hope this letter does not sound unhappy for I'm not. I'm very happy in the way I've been all along only I can't help feeling other things too. I find Huger a perfectly satisfactory person. He really is unusually nice and that is putting it mild. But then again, so is everybody else.[145]

Two weeks later, still on her European honeymoon, she continued to have a difficult time accepting her new position in life and wrote, "Well I love you just as hard as ever—I think a good deal harder. I certainly never did appreciate my own home before. I said to my husband, Oh if I only had our comfortable easy sisters with us!"[146]

Elizabeth may have been bewildered, but she did have the advantage of distance between herself and Philadelphia. The other three women had to live with the press notices, and it is doubtful, hearing the gossip that they must have engendered, that they could have remained unaffected by the implications raised by the articles. The respectable life they had fashioned for themselves in the nineteenth century was not going to be completely creditable in the twentieth. For although the Red Rose Girls had not changed, the world had. Their intimate relationship—considered charming, even noble when they began their life together—was now regarded with derision and suspicion. The humiliating public censure made it impossible for the three women remaining at Cogslea to return to a life that was the same as the one they had known before the wedding.

What actually occurred in the bedrooms at 1523 Chestnut Street, the Red Rose Inn, or Cogslea will never be known. A friend who knew the artists

Jessie enjoys a summer day with Cogs the cat and Prince the dog on the terrace at Cogslea. Archives of American Art

in later years dodged the question with a polite yet evasive answer. "What does it matter if they were orgasmic? The point is that they loved each other." They did love each other. That much is clear, even though biographers of all three women have chosen to ignore their sexuality, attributing their affectionate letters to Victorian hyperbole and their asexual lifestyle to some sort of nineteenth-century naïveté that evidently vanished in the twentieth century. To deny them a relationship with each other is to assign to four fit, healthy, and energetic young women fourteen years of complete celibacy—an idea that would seem preposterous if the four were male.

At Cogslea, Henrietta, Jessie, and Violet pieced their lives back together. They divided up the bills with Jessie assuming the bulk of the extra financial burden left in the wake of Elizabeth's departure. Prior to the wedding, Jessie's monthly charges for rent, food, and sundries came to $88.75. In June, her expenses increased to $148.32. Henrietta and Violet also owed slightly more. However, the added costs did not seem to cause any hardship for either Violet, who with her two new assignments was temporarily financially solvent, or for Henrietta, who, still subsidized by her friends, paid only $14.58 a month

for rent. With finances settled, they all went back to their work and the annual preparations for their elaborate fourth of July celebration.

All four women were all extremely patriotic. During their years together, Independence Day provided them with a chance to celebrate that patriotism. It was their custom each year to don Revolutionary-era costumes, invite guests, serve dinner, and listen to Henrietta read from the Declaration of Independence. After the reading, the women would rise and, reaffirming their personal faith in the doctrines of the American democracy, sign their own names between the signatures of the founding fathers. Except for the absence of Elizabeth, July 4, 1911, was to be no different. For the occasion, Jessie and Violet were fitted out as Revolutionary soldiers. Both carried swords and wore elaborate costumes: knickers, long vests, brocade topcoats, and hats. The guests assembled, and Violet opened the entertainment. Standing at the top of the terrace steps, she began to read from a document she had been preparing for some time. The guests sat in silence as in a loud clear voice with just a trace of an English accent—an affectation that would grow stronger with each ensuing year—she stunned her audience with "A Declaration." Beginning with three

Henrietta and Prince at Cogslea. Collection of Jane and Ben Eisenstat

165

pages of quotes from Dante, which doubtless were met with polite but confused silence, she finally got to the point after stating, "The master of all says: 'Light and Darkness cannot live together.'"

By the end of the year 1911 the house I am building will be finished—and with 1912 I feel called upon to make a great change in my life. Just what this change will consist in I do not yet know. But this one thing I do know. I am called to "come out from among them and be separate." That is, I feel no longer suffered to live in a home with other individuals (with the exception of my mother) who are unready to receive the light of Divine Science which I of necessity have entered.

Between now and the beginning of the New Year be six months—during this time it is possible for anyone so desiring to enter upon a tentative investigation of study of this most beautiful and beneficent Philosophy. Copies of the text book are here for anyone to borrow and read. Also copies of the Journal and Sentinel—and the free reading room in the Perry Building (Room 504), with its peace and quiet [and] secluded opportunity for investigation, is open to all.

Desire to know for one's own self the truth regarding this subject is always able to create and supply the time necessary for such investigation—

Twelve years ago this autumn I began this study. And I am now made ready for this demonstration when it is demanded of me after such a long period of privileged training to make my own home a place where anyone may freely come to inquire concerning the subject of this teaching, and to be gladly and openly welcomed and so informed. I must be able to soon ask to my table "all those who are discouraged and will do me the honor to come" if they desire to "eat of the bread and drink of the wine" which Wisdom has so freely mingled for me and commanded me to feed to others.

Whether others are still unready to begin this investigation and unprejudiced study, or not is not my concern. I can neither make anyone else ready nor prevent (through any error of my own) their readiness—nor delay it in any way. The Mother of this Divine Science said of His teaching: "No man can come to me except the Father draw him." That is [what] each one must recognize, that it is the Father which is drawing him up to this house of light and understanding and peace, and not the will power of any other personality.

Whether my home is to be here near Philadelphia or to be there near New York, I do not know—or whether it is to be divided between two places.

But it can no longer be made a compromise with the quality of thought which is either prejudiced against this Science, or content to be tolerant but still ignorant of it—Neither can it be a compromise with that state of mind which is prejudiced or ignorant concerning the life and purpose of the work of the Discoverer and Founder of this great Truth.[147]

Violet held forth for several more pages, ending as she began, with a quote from Dante. Her audience was dumbfounded—taken completely by surprise. Her friends had never underestimated Violet's commitment to her religion; they had also heard her expound many times about Penn's enlightened views on religious tolerance. But certainly they never dreamed she would attempt to force them to embrace her religion by issuing an ultimatum. Henrietta and Jessie were neither atheists nor agnostics. They both attended church, usually the Episcopal Church that George Woodward's father-in-law, Henry Howard Houston, built at the corner of Willow Grove Avenue and St. Martin's Lane. Years before, under the influence of Howard Pyle, who admired the doctrines of the Swedish scientist and theologian Emanuel Swedenborg, Jessie had joined the Swedenborgian church. However, she only rarely made the long trip to Center City Philadelphia where the Swedenborgians held their services, preferring to attend church in her neighborhood at St. Martin's-in-the-Fields.

In all probability, Violet's "Declaration" was not exclusively a matter of religious conviction. It was very likely made in sadness over the loss of her closest friend and out of embarrassment, a desperate

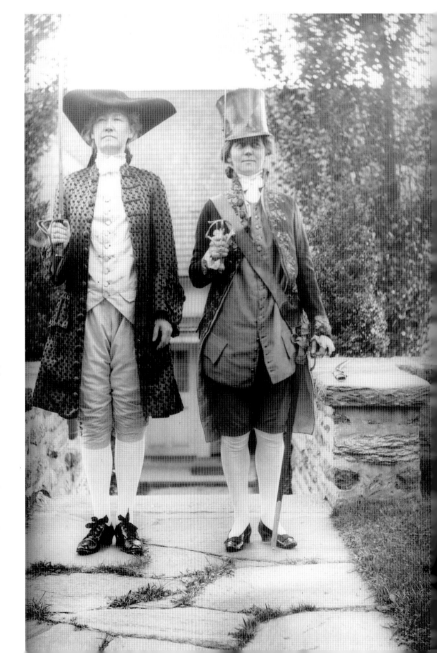

July 4, 1911. Jessie (left) and Violet on the terrace at Cogslea. Violet is just about to deliver her startling "Declaration of Independence." Archives of American Art

Violet Oakley at work on *The Constitutional Convention* mural for the Cuyahoga Courthouse in Cleveland, Ohio, in 1911. John Brown is posing for the portrait of George Washington. The mural measures 15 x 41'. Archives of American Art

attempt to distance herself from the close-knit family at Cogslea and the sly remarks that surely followed in the wake of the newspaper articles that characterized her as the injured party. Whatever Violet's motivations, circumstances intervened that made it impossible for her to consider making any kind of a move, regardless of the extent of her mortification or the religious preferences of her housemates.

On August 1, 1911, the great painter Edwin Austin Abbey died at home in England. His last days were spent in his studio where his bed had been carried so that he might gaze at the murals nearing completion for the House of Representatives in the State Capitol half a world away in Harrisburg, Pennsylvania. He had already completed his famous compositions for the dome and was about to embark on the balance of the assignment. Abbey was only fifty-nine years old, and the illness that ended his life came on swiftly. Violet attributed his sudden death to the difficulty of the Harrisburg contract, remarking, "it was perhaps the most colossal commission that had been given to one painter—and it was too heavy for him."[148] In fact, Abbey died of cancer, while his involvement in his Harrisburg work as well as numerous other projects was at its height.

In the autumn of 1911, Oakley was awarded the portion of Abbey's contract that he had not yet started, a series of murals for the Senate Chamber

and the Supreme Court Room in the Capitol at Harrisburg. Advised that with so much work from Pennsylvania she should remain in the state, Violet temporarily abandoned any plans to move to New York. This was to be her great life's work; she would spend the next sixteen years completing the project.

It was widely reported that Oakley's paintings for the Senate and Supreme Court were based on Abbey's designs. This was not the case. Abbey's widow was very protective of his reputation. Fearing that some unknown artist might destroy the harmony of the final panel in Abbey's series, she was insistent that the painting be completed in Abbey's studio by his former assistant, Ernest Board. Abbey's great friend and fellow expatriate artist John Singer Sargent supervised the work, smoothing out the rendering with his own brush, when necessary.

The reports that Violet's assignment for Harrisburg was the completion of Abbey's designs infuriated her. Many years later she still felt the sting of that misconception, which came at a time when her personal life was in shambles and her confidence was at its lowest ebb.

It was erroneously stated in the papers that I was to finish Abbey's paintings, and never have I been able to see that falsehood corrected. They still say I finished Abbey's paintings—some people. I didn't have a single painting of Abbey's to touch nor a single idea of his to embody. The paintings were finished by his assistant in England and also by his friend John Sargent with whom he'd worked on paintings for the Boston Public Library. These were put up under the auspices of his widow, Mrs. Abbey, a most able and wonderful helpmate. And I asked her if anything had been left that she would care to have me develop of his ideas. She said "nothing." Whether that was true or not doesn't matter. It was a relief to me—and that was what she said. "Nothing." So I wasn't hampered by trying to develop the ideas of someone else.[149]

Late that summer, Elizabeth and Huger Elliott returned from their honeymoon. Huger immediately went to Providence for the start of the academic year. Elizabeth did not accompany him. Instead, she took the train to Mt. Airy for a bittersweet reunion with her Cogslea family. Presumably no one mentioned Violet's "Declaration." Elizabeth stayed several days before going to New York to inform *Harper's* that she would need one more month to organize her new studio before she could accept any additional assignments. *Harper's* was agreeable, and Elizabeth was feeling optimistic about her future. Yet,

as she left New York and boarded the train to Providence, the consequences of her decision to leave Cogslea forever suddenly hit her with full force. "I cannot describe my feelings between New York and Providence," she wrote to Jessie and Henrietta. "It was a kind of loneliness and homesickness that was an actual physical ache, and it grew worse as time went on."[150] Once settled in Providence, Elizabeth tried to embrace her new role as Mrs. Huger Elliott but found herself unable to break the ties that bound her life to her sisters in Mt. Airy.

On November 9, 1911, sad news came to the residents of Cogslea. Their beloved teacher Howard Pyle had succumbed to Bright's disease in Florence, Italy. The next day Jessie and Henrietta called Elizabeth in Providence to report the tragedy. The news of Pyle's untimely death and the sound of her sister's voices so far away only compounded Elizabeth's loneliness, which, despite his best intentions, Huger could not seem to assuage. "I went all to pieces over the phone this morning," Elizabeth wrote to Henrietta.

> I was feeling pretty bad about Mr. Pyle and the moment I heard yours and Jessie's voices over the phone I burst into tears—it just seemed as if I could not bear it another moment without you. So please come to me just as soon as you can. I know it's hard to make plans. Do what you can. Come right away—really come as soon as you can. If I only knew you're coming I don't mind waiting a few days—it's putting it off indefinitely I can't stand. . . . I'm perfectly well only just homesick for you. I'm really too busy to be lonely and yet I feel lonely doing all these things all alone.[151]

Henrietta and Jessie could not come visit, and evidently Violet had not been invited. Elizabeth had finally been told about Violet's "Declaration" and, like her friends, was distressed and confused about its implications. In spite of her decisive rhetoric, Violet seemed to be making no plans to move. Instead, she became more entrenched in her studio than ever. Amid the scaffolding, costumes, and props for the Cuyahoga County Courthouse in Cleveland, Ohio, she began her research for the Senate Chamber series at Harrisburg—setting to work with her typical determination and the strong conviction that art was meant to teach and inspire. "I believe," she once wrote, "that the keeping of one's mental balance in the decisions as to what is or is not suitable for paintings on great permanent wall spaces is as difficult and delicate a matter of adjustment and equilibrium as is for example that dangerous achievement—the walking upon a tight rope, the slightest deviation—as fatal."[152]

Because Oakley was awarded the new contract on the basis of the success of her designs for the Governor's Reception Room, it is hardly surprising that she decided to "pick up the threads" of her original assignment as her theme for the new project. Since the narrative for the Governor's Reception Room ended with Penn arriving in the New World, Violet formulated the new series to begin with the philosophy of the Quakers—moral precepts on which the State was founded. To illustrate this theme she designed two panels representing famous Quaker legends. "The Legend of the Latch-String" told of unarmed Friends spared from attack by Native Americans by virtue of their unlocked door. "The Legend of the Slave Ship" concerned an entire vessel purchased by a wealthy Quaker for the sole purpose of setting free the captives. Satisfied with these designs, Violet moved on effortlessly to create conceptual sketches for the main wall. Revolutionary troops, Civil War soldiers, George Washington at the Constitutional Convention, a solemn Abraham Lincoln delivering his famous address at Gettysburg: all found a place in her grand scheme. However, much to her dismay, a theme for the largest panel—nine feet high and forty-four feet long—eluded her.

The Harrisburg commission was lucrative. Violet was offered the almost unheard of sum of $100,000, which, as usual, did not prove to be nearly enough. Eventually she spent all of it—and more. But at the outset the fee seemed generous, more than enough to purchase her escape from the dissension at Cogslea. In the fall of 1912, when troubles in the Balkans were already threatening the stability of Europe, she sailed for London on a research trip in preparation for the project. She was ill-prepared for the journey, emotionally upset and exhausted. News from home reporting the death of their adored St. Bernard, Prince, must have compounded her anguish. She took what comfort she could from her steadfast religious beliefs and wrote to Smith, "Blessed be Christian Science, which affirms that 'all creatures of God are harmless—useful—indestructible moving in the harmony of science.'"[153]

When Violet reached London she found that the political unrest in Europe had a profound effect on her. Inspired by a diplomatic conference at nearby St. James Place, she finally conceived a theme for the central Harrisburg panel that she hoped would convey a powerful appeal for disarmament. The main compositional element of the work was to be an immense and powerful-looking female allegorical figure representing the unity of all life. She would paint the panel in shades of blue, a color that she felt symbolized wisdom. In the midst of this inspired vision Violet, lonely and taxed to her emotional limits, suddenly lost all confidence in her ability.

She remembered:

And when I thought of that central figure of Unity, I was appalled and tried to make another composition, and it wouldn't come. And I had to go back to that, because there had to be that great, strong, enormous figure as a keystone to hold all the different parts of the thing in the room together. And I remember being quite dashed and one day going round—it was a rainy windy day—and I went round, and I thought that the Thames River looked like a rather good place to jump when you knew you couldn't carry out what you'd been asked to do. And I went to the exhibition of the Society of Watercolorists, to which one of my English uncles had belonged (great uncles). And that exhibition rather depressed me. There were some very good things but a lot of very poor things, very weak

things, very sentimental things, and that didn't help. I stumbled out of that, and I stumbled down to the National Gallery. And my hair was coming down. And the wind was blowing, and the rain was falling, and I was very miserable indeed. And I, with difficulty, climbed up all those steps of the National Gallery and got into the central hall and dropped upon a bench in the center. And I looked up and saw a beautiful Italian painting. An early painting by Orcagna. And I suddenly realized that time had nothing to do with art. It was a question of whether it was good enough at any time or age. That art was not for time, not for an

Opposite and above: Oakley in front of the *Unity* panel that she painted for the Senate Chamber in the Pennsylvania State Capitol building. Archives of American Art

173

age but for all time —that it was the expression of eternal qualities of beauty and harmony. And I was immediately healed. So I always think of that room in the National Gallery as where I was healed and where I was then to take up the theme and develop it.[154]

That day in the bleak London rain, when Violet (who never did learn to swim) decided not to throw herself into the Thames, became a turning point—a line of demarcation between her fourteen-year association with the Cogs family and a new independent life. For although she would later characterize her grief as an artistic crisis of confidence, her anguish was personal as well. After Elizabeth's marriage she no longer felt part of a loving sisterhood. She was a lonely middle-aged woman living with an established loving couple who did not entirely approve of her. She returned to Philadelphia determined to rectify her situation by severing her ties with Cogslea and forming new artistic and personal alliances. Although she had more than enough work to occupy her time, Oakley accepted an offer to teach a class in mural decoration at the Pennsylvania Academy of the Fine Arts. She was only the second woman (Cecilia Beaux was the first) to be invited to teach at the prestigious institution.

One of her best students was Edith Emerson, a promising twenty-two-year-old artist. She was small and slim with an uncanny resemblance to Elizabeth Green Elliott. She also shared Elizabeth's high spirits and sense of fun. Edith was an intelligent young woman who grew up in the academic environment that Violet felt had been denied to her so many years before when her father refused to send her to Vassar. Emerson's father was an archaeologist and classical scholar who taught at Cornell, and Edith claimed as one of her earliest memories sitting astride the wolf in a statue of Romulus and Remus in the Cornell Museum. Edith's mother was an accomplished pianist and taught first at Wellesley and later at the Ithaca Conservatory of Music. Like Elizabeth, Edith began her art education at a young age studying with Olaf Branner from the Cornell Department of Architecture when she was only twelve years old. By the age of fifteen she was enrolled in classes at the Art Institute of Chicago. An intrepid adventurer, she lived for a year in Japan with her grandfather and spent seven months sketching in Mexico before beginning her education at the Academy.

Violet was captivated by this accomplished young woman and began to spend a considerable amount of time with her new friend, showing a personal interest in her work and even buying her art supplies. Edith was in awe of Violet and found her class "electrifying." "It was especially exciting to women

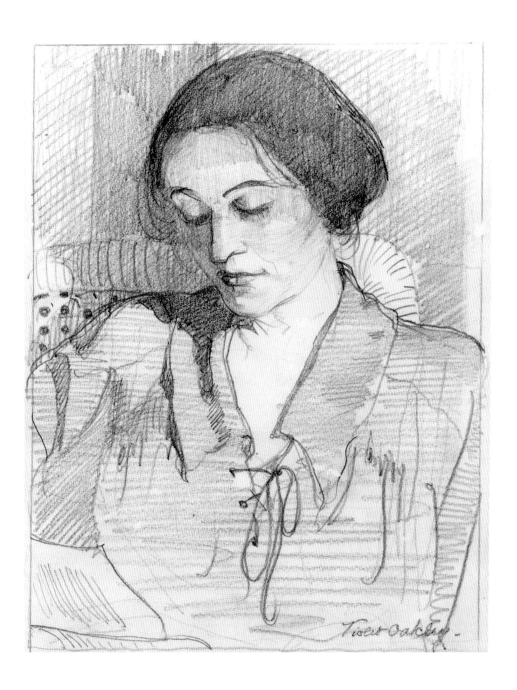

artists," Edith Emerson wrote. "It abolished any sense of inferiority. Was not this woman artist the recipient of many medals and honors? She was an honorable member of the American Institute of Architects since 1909. . . . Her students looked up to her as a brilliantly successful person, little realizing that inside she still felt like a small child."[155]

By the end of 1912, Huger Elliott had accepted a new job and Elizabeth was once again faced with the formidable task of moving her household and studio. For the next eight years Huger was employed by the Museum of Fine

Violet Oakley. *Portrait of Edith Emerson.* c. 1918. Collection of Jane and Ben Eisenstat

175

Greeting from 24 Concord Avenue Cambridge Massachusetts

Elizabeth Shippen Green Elliott. *Greetings from 24 Concord Avenue, Cambridge Massachusetts.* 1913 Christmas card from Elizabeth Shippen Green Elliott and Huger Elliott

Elizabeth made this drawing of herself and her husband to send as a holiday greeting. The first few years of married life were intensely lonely for Elizabeth, who missed the close companionship she had shared with her "sisters." The empty chair pulled out from the table was meant as an invitation for her friends to come and visit.

Arts, Boston, as supervisor of the institution's educational work and director of the museum school's department of design. The Elliotts lived nearby, in Cambridge, Massachusetts. Compounding the stress of yet another move was the fact that Elizabeth was still pining for her sisters at Cogslea. Huger often worked late, and Elizabeth was bitterly lonely, as well as overwhelmed with the task of running a household, a vocation entirely new to her. "Please come," she wrote to her friends. "I'm asking you with tears in my eyes, and please write and tell me you love me. I'm feeling terribly sad, and as if you did not love me and I can't stand that."[156] Following her marriage, she tried to strike a balance between her conflicting loyalties. She continued to be a productive illustrator. Although she made an effort to attend to her responsibilities as Mrs. Huger Elliott, she also tried hard to continue her collaboration with her friends. Jessie was beginning one of her most celebrated commissions, *The Jessie Willcox Smith Mother Goose*, a volume that has remained in print since it was first published in 1914. The book was to have a painted cover and twelve full-color illustrations, as well as black-and-white drawings throughout. Elizabeth wanted to feel as connected to the project as she would have been in the past, helping with models, photography, and reference. Late one night she wrote to Jessie.

I'm nearly dropping with fatigue but must add—that I sent off a package of geese to Jeddy and one of ducks—just to warn her not to use

ducks for they really are different. Geese have longer legs and necks and have that queer horny formation round the beak.[157]

Back at Cogslea, Henrietta tended the house. Jessie illustrated two classic children's books, *Dickens's Children* and *'Twas the Night Before Christmas*. Violet worked on her murals; models and friends came and went. But the shaky alliance between the remaining women was unraveling. In July 1913 Huger agreed that he and Elizabeth should spend some time in Mt. Airy. Finally reunited after two painful years, the four women enjoyed what was to be their last time together as a family. The visit was a resounding success. When the Elliotts were leaving to return to Cambridge, Elizabeth extracted a promise from her three friends that they would come for an extended visit. Jessie and Henrietta were to come in September, but serious problems at Cogslea intervened and the visit was canceled.

Although desperate for a place of her own, Violet was having trouble finding a studio large enough to accommodate her enormous murals. There are two versions of what happened next. According to Violet, she was obliged to sell all her assets and purchase Cogslea in order to enlarge the studio. It is also conceivable that she wanted to stay in her home because she was apprehensive about moving her aging mother. Jessie, Violet always contended, was supportive of this new arrangement and happily agreed to buy a quarter of the land and build an adjacent home on the property. Violet later assured her biographers that, when the new house was built, Jessie and Henrietta willingly moved out of Cogslea and into their charming new home. Violet outlived the other two women by many years. Jessie and Henrietta, who could not abide another scandal, never mentioned the subject, so Violet had the advantage of the last word. The story of their harmonious separation after so many years as a family was one that Violet repeated often. However, a letter from Elizabeth to Jessie and Henrietta tells a very different story.

I don't believe you realize what it has meant to me not to have you here through September. We went away from Cogslea in July confidently looking forward to it—and as for it seeming that I did not realize that you had left Cogslea and giving you my interest and sympathy—why it has never been out of my mind. If I have not said much about it in my letters it's because I can't write about what I feel so intensely—all the disagreeablenesses which brought it about and I don't suppose I know half of them for you never write about them. I'd like to talk to you about it—writing at length about it is too harrowing. Dear

Jessie Willcox Smith. Illustrations from *The Jessie Willcox Smith Mother Goose* (Dodd, Mead & Company, 1914)

Above:
Peter, Peter, Pumpkin-Eater. Collection of Jane and Ben Eisenstat

Opposite above:
Hush-a-Bye, Baby

Opposite below:
Rain, Rain, Go Away

Jeddy—please don't think me unsympathetic, for I'm not. I feel sometimes as if I'd burst about it. Violet is a strange person—she wrote me the most intense letter after I wrote that we would not spend Christmas at Cogslea—but that you were coming to us. I'd like you to see it. One of those intense Christian Science letters implying that I had let myself be pressured by the thought that she wanted you two to leave Cogslea but she had tried with all her might that you would stay and she would build. . . . I really feared that when she opened up the subject it would lead to a row for I would in all probability have told her how I felt about her attitude about not making the slightest suggestion that you stay with her during building—and also mention that extraordinary Declaration [of] Independence which was the beginning of the thing and all the disagreeableness in a nutshell. . . . Violet is certainly a remarkable person and certainly has a dual personality. How can I feel as I do toward her uncanny inhuman side . . . and yet enjoy her and find her disarming and likeable too? You know how it is, for she's always been that way.[158]

Below:
Preliminary drawing for *The Jessie Willcox Smith Mother Goose*. Collection of Jane and Ben Eisenstat

Opposite:
Jessie Willcox Smith. *Pip and Joe Gargery*. From *Dickens's Children* by Samuel McChord Crothers (Chaner's Sons, 1912). The Kelly Collection of American Illustration

XII.
Old Friends and
True Blue

ESSIE SMITH AND HENRIETTA COZENS MOVED INTO Cogshill, their new home, in 1914, thus ending what had been an outstandingly successful artistic collaboration. Although the Red Rose Girls eventually reestablished their friendship and were generous enough to embrace Violet's new companion, Edith Emerson, into their tightly knit circle, the guidance and inspiration they derived from one another ended. When their alliance was severed, their work did not so much decline as fail to move forward. Revolutionary changes, which they refused to acknowledge, were taking place in the art world. Although they were aware that their work was considered old-fashioned, there was still a market for it. In a letter written to Jessie from London in 1927, Violet addressed the subject and outlined the philosophy that

sustained her for the rest of her life: hold steadfastly to your beliefs. Ostensibly, she wrote with news of the death of a mutual friend, Isabel Spackman, an elderly expatriate who had been bedridden for years.

> I asked Mr. Roth what was his explanation of her [Mrs. Spackman] going to bed and staying there and he said she had no illness (except that which came from being in bed so long) and that it was her disgust at the present generation and their way of clothing themselves!!! upon which subject she evidently went quite mad—and believed that she could no longer get clothes for herself which she could possibly wear! and so she took to nightgowns!!! Did you ever hear of anything so colossal as this pathetic attempt to assert disapproval of the rising generation and the vanity of fashion by this magnificently beautiful old lady of the Dowager Duchess school? She would have been even more strikingly handsome and contrastingly distinguished had she continued to ride through the streets of London or Paris or Philadelphia in an open Victoria (as the skirts of the women on the sidewalks and in the motor cars grew shorter and skimpier each year!) with her massive and flowing garments pouring over her mountainous figure covering her feet completely. . . . Ah Isabel Spackman you should not have given up the fight you should have continued to wage it by your own splendid impressiveness.[159]

Jessie Willcox Smith, Elizabeth Shippen Green Elliott, and Violet Oakley did not give up the fight. Although they all lived well into the twentieth century, they never cut their hair, shortened their skirts, learned to drive, or embraced any of the changes taking place in the art world or in society. Artist Edna Andrade remembers being a member of the receiving line at one of the Academy Fellowship shows in the early 1950s. Looking down the line at the other artists, one of the group noticed that they were a shabby lot. "Don't worry," someone remarked, "we'll all look a lot better when Violet gets here." Indeed, Violet was majestic. Artist and historian Ben Eisenstat also remembers Oakley at the Academy openings cutting an impressive swath through the crowd in her long Victorian-style gown, looking like she was "dressed in the living room curtains."[160]

The Red Rose Girls embraced the nineteenth-century aesthetic of sentiment and narrative and never understood the twentieth-century's preoccupation with stream of consciousness or abstraction. Smith, Elliott, Oakley, and Emerson all admired the Pre-Raphaelites, as well as Abbot, Thayer, George

Opposite:
View of Cogshill, the home that Jessie built for herself and Henrietta after their exodus from Cogslea in 1914. Photograph courtesy of the Bryn Mawr College Archives

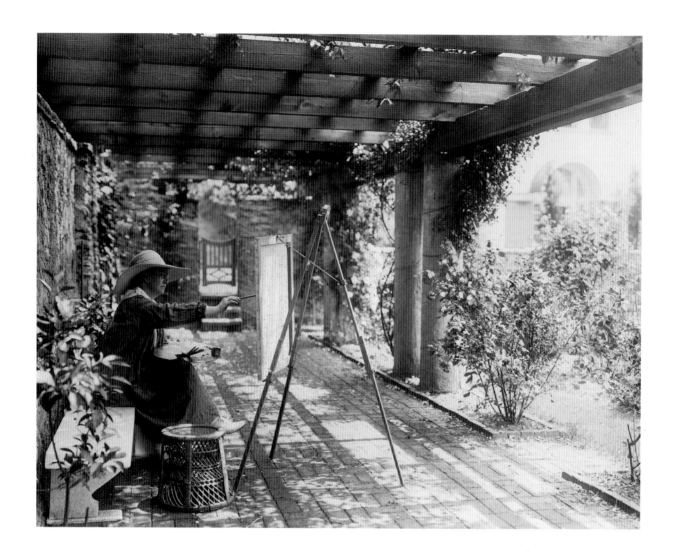

Jessie painting at
Cogshill, 1916. Archives
of American Art

Inness, James McNeill Whistler, the landscapes of John Twachtman, the stylized murals of Elihu Vedder, the works of John La Farge and Edwin Austin Abbey, and the writings of Shakespeare, Henry James, Dickens, and the Romantic poets. The Realist school, initiated by Eakins and carried on by painters William Glackens, Everett Shinn, George Luks, Robert Henri, Ernest Lawson, Maurice Pendergast, and John Sloan, although more palatable to them than modernism, celebrated American life as it was and scoffed at the idealized images of the previous century. The Red Rose Girls had built their lives around romance not realism.

After they severed their collaboration the friends each maintained another partnership: Jessie Smith and Henrietta Cozens, Elizabeth and Huger Elliott, and Violet Oakley and Edith Emerson. Although these alliances did not enrich their work, on a personal level they evidently all chose well. Their relationships proved to be stable and permanent. However, on a professional level

the inequality of the new unions made the artists less successful. At Cogshill, Jessie was the only artist. Henrietta continued to manage all the domestic chores, but her support, however helpful, did not inspire artistic development. In the Elliott home, Huger's career came first. Although Elizabeth proceeded with her work, her schedule was no longer her own. A full business and social calendar allowed little leeway for the reflection and collaboration needed by all artists for their work to evolve. Violet's relationship with Edith was always that of teacher and student. Even after they had been together for many years and Edith was a success in her own right, Violet's opinions were the ones that counted, and her opinions were adamant.

After the dissolution of the Cogslea family, Smith went on to illustrate many critically acclaimed books, including her favorite production, *The Water Babies* by Charles Kingsley, and a 1915 edition of Louisa May Allcott's *Little Women*. Henrietta was content to withdraw to the seclusion of her garden, where she worked hard to recreate the lost beauty of the Red Rose Inn. The new garden was banked by clipped hedges and once again featured a pergola and pool. Always a shadowy figure in the public lives of her famous sisters, Henrietta now rarely left the property except to visit relatives. Jessie also seemed determined to seek refuge at Cogshill, beginning a retreat from celebrity that would last for the rest of her life. Their new home was a pleasant sanctuary, a long low house tucked behind a high hedge broken by a peaked white gate and a brick walk. The studio was comfortable and airy, with great casement windows along one wall and tall arched bookshelves. There, Jessie felt safe and content. Once when a fan speculated on why Jessie had failed to respond to a request for a photograph, she answered,

> You are perfectly right—I sent no photograph because I had none. I have not had my photograph taken since I was a little girl many years

Henrietta stands by the gate at Cogshill. Photograph courtesy of the Bryn Mawr College Archives

185

Jessie Willcox Smith. Illustrations from *The Water Babies* by Charles Kingsley (Dodd Mead & Company, 1916). Collection of the Library of Congress

Charles Kingsley's social satire, The Water Babies, *provided Jessie Smith with the opportunity to create the kind of work she found most satisfying. The series of illustrations she created to augment this charming fable were among her favorite paintings and appealed to her vision of childhood as a magical time. Although her idealistic images were popular in 1916, at the time of her death nineteen years later, many critics considered her work mawkishly sentimental. Eulogizing her friend in 1938 Edith Emerson wrote hopefully, "Perhaps some citizens of the future, satiated with the morbid, the sensational, the grotesque and the horrible, may look back with nostalgia to those lovelier moments which she chose to record; the sunny mornings, the graceful awkwardness, the comic adventures and the groping wonder of young creatures in a strange world."*

Above:
He Looked Up at the Broad Yellow Moon . . . And Thought That She Looked at Him

He Felt the Net Very Heavy; and Lifted It Out Quickly, with Tom All Entangled in the Meshes

Opposite:
Portrait of Jessie Willcox
Smith. From "The Secret Was
About Covers," *Good House-
keeping* (November 1917)

*This photograph of Jessie Smith
appeared in the November 1917
issue of* Good Housekeeping
*along with this announcement:
"Beginning with the Christmas
number, Jessie Willcox Smith
will make our cover designs for
us—and for you. The very fact
itself carries with it so many
delightful possibilities that the
announcement scarcely needs any
garnishment of words. Certainly
no other artist is so fitted to
understand us, and to make for
us pictures so truly an index to
what we as a magazine are striv-
ing for—the holding up to our
readers of the highest ideals of
the American home, the home
with that certain sweet whole-
someness one associates with a
sunny living-room—and chil-
dren. We are sure our friends
will consider themselves privi-
leged among magazine readers to
look forward to cover designs
done each month by this famous
artist." Smith provided cover
illustrations for* Good House-
keeping *for more than fifteen
years until ill health forced her
retirement.*

ago—I find it much easier to put off newspaper requests for pho-
tographs by simply saying I have none than to hedge and say I don't
want to let them have it. That has been my defense for years.[161]

Jessie Smith was not a very good liar, and of course there were a great
many photographs. In the months and years following the publication of the
humiliating accounts of Elizabeth's nuptials, Jessie refused most requests for
interviews and developed an enduring mistrust of even the most benevolent
reporters. A letter from Louise Armstrong, who had been granted an interview
only to have Jessie renege on the agreement, shows the depth of her anxiety.
"Oh! Don't take it all too seriously," Ms. Armstrong cajoled.

[W]hether you will or no, you do belong to the public! Teachers and
mothers and children all over the country claim you as their own
and long to hear about you. . . . I was so anxious to correct your impres-
sion of journalists, to write a sympathetic—it was sympathetic?—and
informally readable article. Some reporters are ruthless as you evident-
ly have found out.[162]

In 1917 Smith was selected to be the cover artist for *Good Housekeeping*
magazine, a job she held until 1933. Announcing Smith's commission, *Good
Housekeeping* editorialized, "Certainly, no other artist is so fitted to understand
us, and to make for us pictures so truly an index to what we as a magazine are
striving for—the holding up to our readers of the highest ideals of the Amer-
ican home, the home with that certain sweet wholesomeness that one associates
with a sunny living room—and children."[163] If the editors at *Good Housekeep-
ing* had spent any time at Cogshill, they might have been surprised to learn that
the only children (aside from Jessie's models) who were regular visitors were
Henrietta's grandniece and grandnephew, who were invited, on occasion, for
tea. One Sunday the train schedule was changed and the children arrived a full
two hours before the appointed time. Jessie and Henrietta were scandalized and
confined the youngsters to the hallway where they were to sit and read maga-
zines until the assigned hour, at which time they were forgiven and finally
admitted to the parlor.[164] As they grew older, the two women developed the
petty quarrels and idiosyncratic behavior that often characterizes long-term
relationships. Henrietta's grandnephew remembers that she developed an
unusual aversion to passing anyone in the hall. When Jessie was irritated with
her, she would station herself there, trapping Henrietta on one side of the
house.

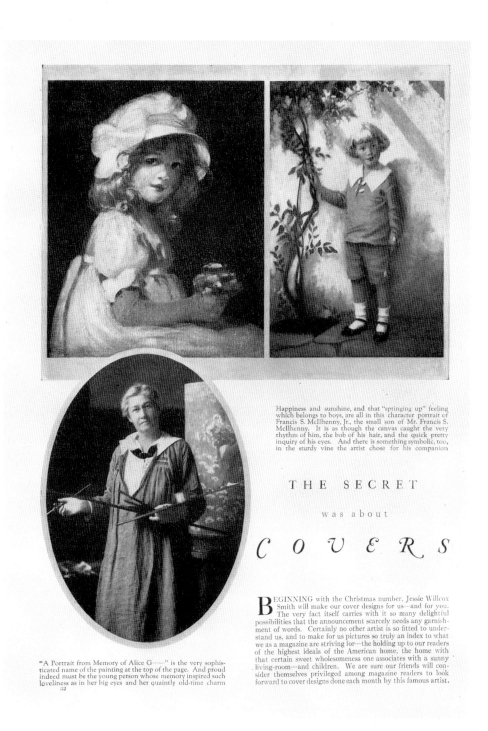

Happiness and sunshine, and that "springing up" feeling which belongs to boys, are all in this character portrait of Francis S. McIlhenny, Jr., the small son of Mr. Francis S. McIlhenny. It is as though the canvas caught the very rhythm of him, the bob of his hair, and the quick pretty inquiry of his eyes. And there is something symbolic, too, in the sturdy vine the artist chose for his companion

THE SECRET

was about

C O V E R S

"A Portrait from Memory of Alice G——" is the very sophisticated name of the painting at the top of the page. And proud indeed must be the young person whose memory inspired such loveliness as in her big eyes and her quaintly old-time charm

BEGINNING with the Christmas number, Jessie Willcox Smith will make our cover designs for us—and for you. The very fact itself carries with it so many delightful possibilities that the announcement scarcely needs any garnishment of words. Certainly no other artist is so fitted to understand us, and to make for us pictures so truly an index to what we as a magazine are striving for—the holding up to our readers of the highest ideals of the American home, the home with that certain sweet wholesomeness one associates with a sunny living-room—and children. We are sure our friends will consider themselves privileged among magazine readers to look forward to cover designs done each month by this famous artist.

Although Smith continued to be an active and popular illustrator, her isolation from her peers took its toll. She began to accept portrait commissions from wealthy Philadelphia families who wanted to see their own children depicted in Smith's idealized illustrative style. Had she still been living with Oakley and Green, they probably would have talked her out of changing her clientele. Violet had advised Jessie before. In 1904 she wrote to *Collier's* to tell

Henrietta and a child model in the garden. Photograph by Elizabeth Shippen Green. Collection of Jane and Ben Eisenstat

them that Smith's decision to sign a two-year contract with the magazine was "reprehensible." Her interference may have been unwelcome, but time proved her to be correct. The exclusive contract caused Jessie to have to turn away several lucrative assignments.

The private commissions presented several problems. Many of the young models were rambunctious children who had great difficulty holding a pose. Jessie was unaccustomed to painting from life, as she had always used photographs for reference. Her new clients would not have understood her use of photography and would almost certainly have considered any painting from photographic reference to be of less value than a portrait from life, so she was forced to change her way of working. To make matters worse, private clients were not much interested in aesthetic considerations. What they sought from Smith's brush was a likeness that flattered their child. As a result, the outcome was far too often an overly sentimental, lifeless image that did justice to neither the child nor Smith's prodigious talent. Nonetheless, as styles changed and her commercial clients dwindled, she began to rely more heavily on portrait work—although, as usual, she worked out of conviction and not for financial remuneration. Her income was secure. Limited-edition prints of her illustrations sold by the millions. Campbell Prints in New York offered these reproductions at affordable prices, from $2.00 to $3.50, unframed, and also extolled her talents in advertisements: "A rare soul is this artist who portrays childhood as it really is. With a gift that is genius, she gives us a glimpse, for a charmed moment, into the very soul of the child; and she catches in rich colors, the magic atmosphere that always surrounds lovely children."

In 1931, during the Depression, Smith's adjusted income was $31,450.18, more than enough to support her own household as well as a number of impoverished relatives. In spite of her sound finances, Jessie continued to work steadily until failing eyesight and illness forced her to stop accepting commissions in 1933. By 1935 Jessie Smith was bedridden and almost blind. On the night of May 5, Edith Emerson dreamed that she was visiting Smith's sickroom. Suddenly, despite frantic attempts by her nurse to stop her, Smith rose

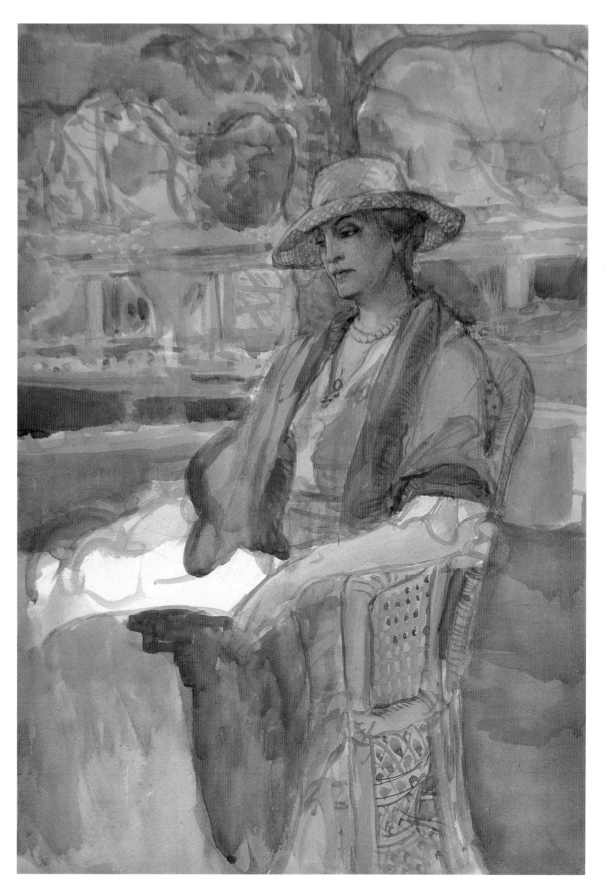

Violet Oakley. *Henrietta Cozens*. c. 1923. Courtesy of the Bryn Mawr College Collections

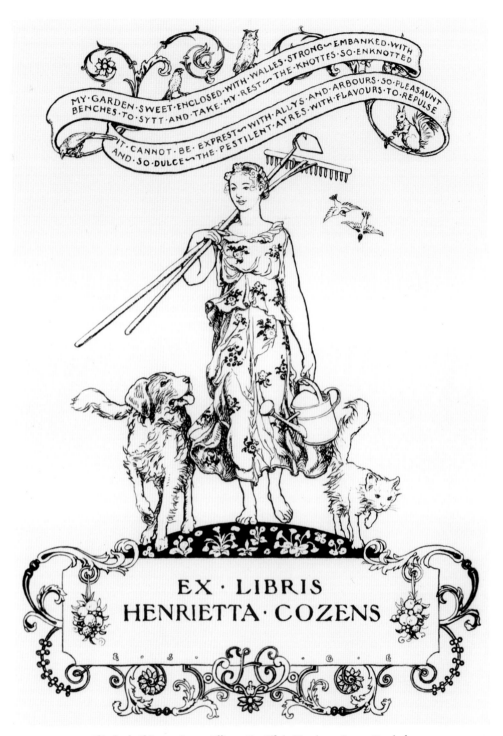

Elizabeth Shippen Green Elliott. *Ex Libris Henrietta Cozens.* Bookplate

Elizabeth created this bookplate for Henrietta. Recalling their days at the Red Rose Inn, she drew a portrait of Henrietta as she first knew her, flanked by the pets they acquired when Henrietta joined the trio of artists in 1902. The inscription reads: "My garden sweet enclosed with walles strong, embanked with benches to sytt and take my rest, the knottes so enknotted it cannot be exprest. With allys and arbours so pleasaunt and so dulce, the pestilent ayres with flavours to repulse."

from her bed, glided across the room, and opened the French doors to the garden. Crossing the threshold she turned, grinned mischievously at Edith, and disappeared into the night. Edith was not surprised when an hour later she received the news that Jessie was dead. Henrietta, who inherited the house and the bulk of her friend's $240,000 estate, lived at Cogshill for five more years and died in 1940 at the age of eighty-one.

Emerson, who by virtue of being the youngest member of what was now the extended Cogs family, inherited the unenviable job of eulogizing all three women. After Smith's death she approached the Pennsylvania Academy of the Fine Arts about the possibility of mounting a memorial show. Initially, still harboring their traditional objections to illustrative images, they were less than enthusiastic. "The Secretary of the Academy wasn't precisely thinking of having a memorial show for her [Jessie Smith]," recalled Emerson. "And I said to him 'you know, she did an awful lot of portraits besides all those magazine things'. And I said, 'prominent Philadelphia families all over Philadelphia had their children done.' And that kind of woke him up. So they borrowed them all around and had a huge show."[165] Edith wrote the foreword for the show's catalogue, honoring Smith with love and respect on behalf of her Cogslea family.

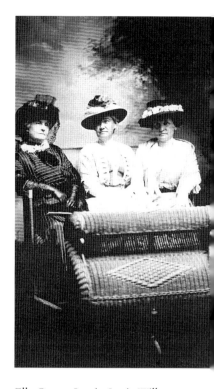

Ella Cozens Lewis, Jessie Willcox Smith, and Henrietta Cozens on the boardwalk at Atlantic City, New Jersey, 1913. Family collection of Clifford Lewis III

> Nothing morbid or bitter ever came from her brush. This is not because the difficulties of life left her untouched. She had her full share, but when they came she met and conquered them. She demanded nothing for herself but obeyed the simple injunction on the poster she designed for the Welfare Foundation—GIVE. She helped those in need, the aged, the helpless, the unfortunate. She gave honest and constructive advice to students who came to her for criticism. She rejoiced in the success of others and was modest about her own. Tall, handsome and straightforward, she carried herself well, with no trace of self-assertation. She always spoke directly and to the point. She lived quietly and loved natural unaffected things and people. Altogether hers was a brave and generous mind, comprehending life with a large simplicity, free from all pettiness and unfailingly kind.[166]

The exhibition was a great success as well as a fitting memorial and precipitated the final bit of poetry inspired by the art of Jessie Willcox Smith. Written by an admirer, Dorothy Spring, it ended with the lines, "Lord we thank thee for bestowing/ On an artist skilled and knowing/ Patience in such generous measures/ That she left us all these treasures."

Despite their difficult start, Elizabeth Green and Huger Elliott eventually established a viable relationship. Contrary to Howard Pyle's prediction, marriage did not ruin Elizabeth's career. She continued to be a productive illustrator and take great pleasure in her work. She fulfilled her social responsibilities as Mrs. Huger Elliott, maintained her contract with *Harper's*, and illustrated nineteen books, including *Tales from Shakespeare by Charles and Mary Lamb*, for which she wrote the following introduction:

> These Pictures and decorations have been designed with much joy in the making in the hope that there may be some who will follow with a like pleasure and amusement such play of fancy as therein the illuminator may have displayed—or half concealed—in an endeavor to link together the golden age of Elizabeth Tudor, the time of Charles Lamb, and this present year of our Lord MCMXXII when Elizabeth Elliott humbly presents her contributions to these tales.[167]

Although it would take several years for her to reestablish her friendship with Violet or to fully accept Edith, Elizabeth maintained her close alliance with Henrietta and Jessie, which Huger was sensitive enough to encourage. In July 1915, full of his emblematic humor and exuberance, he wrote to announce an impending visit.

> To—Miss Henrietta Cozens (called by the populace—"Heddy") and Miss Jessie Willcox Smith (Similarly hight "Jeddy")
>
> —Warning—!
>
> A Friend has learnt that a certain E.S.G.E. (otherwise "Liddy"—save to her enslaved spouse) having accomplished almost a miracle by making six figure drawings from models in eight days and now drawing the Backgrounds of the Four drawings wherein the said figures appear (the same to cozen from some unfortunate named Harper many bright shekels)—intends to finish the said drawings by August 1st—or a day

Elizabeth Shippen Green Elliott. *Out Came Their Sabers and They Was at Me Howlin' Wit Glee*. From "The Merle" by Henry C. Rowland, *Harper's Monthly Magazine* (June 1918). Collection of the Library of Congress

Elizabeth Shippen Green
Elliott. *Ariel: The Tempest*.
From *Lamb's Tales from
Shakespeare* by Charles and
Mary Lamb (David McKay
Company, 1922). The Kelly
Collection of American
Illustration

or two thereafter—and Then—has formed the Fell intention of Falling (and she is no Light Weight) upon your Helpless Domicile (for 2 days) and eating you out of house and home—thereafter—like the Locust—Hitting further. So Be Prepared! Announce a visit to a sick aunt in Siberia—hang out a Small-pox flag—burn down the house—And don't say you haven't been warned! (She brings her husband—the latter quite innocuous—)! LOOK OUT! The Elliotts are Coming!

The intimacy between the three women did not seem to trouble the erudite Elliott but instead evoked a detached amusement that continued unabated over the years. In 1920 he wrote again to Cogshill on behalf of his wife who was recovering from a minor illness. "Yitty One . . . Sends her YUV&YUV to Jed-Jed and Hen-Hen: I've told her that if she bursts forth into baby-talk while we are with you this summer I'll get a divorce and marry Mrs. Blackenburg!"[168]

In June 1920, Huger Elliott accepted the position of president of the Philadelphia Museum School of Industrial Arts. The appointment was greeted with jubilation by Elizabeth, as it brought with it the opportunity for a move back to the Philadelphia area. Elizabeth knew immediately where she wanted to live, and from the ever-benevolent Woodward family she was able to secure a house ready for renovation on Cresheim Road near Cogslea and Cogshill. The Elliotts constructed a handsome home on the property, which they named "Little Garth," meaning little garden. There Elizabeth occupied what Edith later called "her first perfect studio."[169] It was a large sunlit room with cabinets ample enough to store her extensive clipping files, which by that time occupied some thirty feet of space. Over the fireplace hung a huge copy of an Italian

fresco fashioned by Huger when he was an architectural student. Huger's office was set on a balcony overlooking the studio, and there he was agreeably ensconced with his books and his typewriter.

Elliott held his position as president of the Museum School for only five years. Although he was hired as an administrator, he enjoyed working with students. In 1924 he organized thirty-five young artists from the school to paint a background mural for the Philadelphia Orchestra, a project that was praised by everyone from season-ticket subscribers to conductor Leopold Stokowski. However, while the orchestra project was met with general acclaim, Elliott's involvement with the Museum School students was often the subject of considerable gossip. During his tenure at the institution, rumors abounded that Mr. Elliott showed too much interest in the male students, conducting an ill-advised study on the relative sizes of their biceps for which scientific method dictated he make extensive and careful measurements.[170] However, these reports were hearsay, and after so many years it is doubtful that they could be substantiated. Whatever the exact orientation of Huger's private life, the couple's personal relationship seemed solidly based on mutual affection. Elizabeth's letters indicate that eventually the intense grief that followed her separation from Cogslea abated and that the Elliotts' marriage was a happy and productive union.

In 1925 Huger Elliott resigned his position in Philadelphia when he was appointed head of the new Department of Education at the Metropolitan Museum of Art in New York. The couple rented their home in Mt. Airy, hoping someday to return, and moved to a small apartment in New York City. Returning to "first principles," as Edith Emerson remarked, Elizabeth once again produced her illustrations in a corner of the bedroom. When demand for her work diminished, she penned decorative ink drawings for the brochures and pamphlets issued by the museum for Huger's educational programs. She also designed patterned borders for Martex towels.

Huger retired in the early 1940s and the couple returned to Little Garth where they settled into a comfortable life. Although Jessie and Henrietta had both died, any quarrels with Violet were forgiven if not forgotten. Elizabeth felt that she was finally coming home. Violet and Edith welcomed the couple and became the Elliotts' most trusted friends. Elizabeth gained weight as she grew older. Her nephew and niece Charles Cunningham and Esther Shay remember her as short, plump, and jovial. She liked to compare herself to Helen Hokinson's proper "club" ladies who appeared regularly in cartoons in the *New Yorker*. As she aged, she never lost her keen eye for design or her technical skill in drawing. In her later years she was still able to impress her young

Opposite left:
"The Lady and Her Page." Edith Emerson and Violet Oakley in the costumes they wore at a 1917 dinner celebrating the completion of five panels for the Senate Chamber at the Pennsylvania State Capitol. Archives of American Art

Opposite right:
Edith, dressed as Giovanni the page, poses in front of the garden door of the pergola at Cogslea, 1917. Archives of American Art

niece and nephew with her ability to draw a perfect circle—freehand.[171] After Huger died of a heart attack on November 14, 1948, Elizabeth elected to remain at Little Garth near Violet and Edith. She died in 1954 at the age of eighty-two. When notified of her friend's death, Violet was disconsolate and for once could not find the strength for the task at hand. It was Edith who went through the Elliott household and packed up Elizabeth's belongings.

Shortly after Jessie and Henrietta moved out of Cogslea, Violet Oakley enlarged the studio to an expansive room fifty feet square and twenty-four feet high. Her young friend and protégé, Edith Emerson, often frequented the

Right:
Violet Oakley. (Left) *The Armies of the Earth Striving Together to Take the Kingdom of Unity by Violence;* (Center) *Unity;* (Right) *The Slaves of the Earth Driven Forward and Upward by Their Slave-drivers, Greed, and Ignorance and Fear.* Three panels from *The Creation and Preservation of the Union.* Series of paintings in the Senate Chamber, Pennsylvania State Capitol, Harrisburg, Pennsylvania. 1911–20. Left panel, 11' 4" x 13' 8"; central panel, 9' x 44'; right panel, 11' 4" x 13' 8". Photograph by Brian Hunt

After the death of Edwin Austin Abbey in 1911, Oakley was asked to complete the part of his commission that he had not yet started. Unity *was unveiled on Lincoln's birthday in 1917 along with four other panels. The remaining paintings were finished over the next three years.*

newly renovated space. Like her mentor Howard Pyle, Oakley believed that the opportunity to work professionally could be a valuable experience for students. When she heard that Philadelphia's Little Theater needed refurbishing, she encouraged her class at the Academy to compete for the assignment of designing the mural decorations, assuring the theater's board that she would personally supervise the work. Emerson won the job. One day in 1916, designs in hand, she stopped at Cogslea unexpectedly to show her drawings to Violet. In the front hall she came upon an odd tableau. Cornelia Oakley, resplendent in an elaborate hat and veil, was stationed on a chair in the hall, posing for the painter John McLure Hamilton, who busily assigned her image to canvas, while Violet, off to one side, sketched an informal portrait. Not wanting to interrupt the concentration of the two noted artists, Edith quickly reported on her progress and turned to leave. Violet called her back and whispered, "When are you going to finish them so you can come and help me in the studio?"[172]

Emerson regarded this brief interchange as the turning point in her life. It was then that she officially became Oakley's assistant, spending many weeks working diligently on the Harrisburg murals project. The Cogslea studio must have provided an inspirational atmosphere for the young apprentice. Violet's magnum opus, the huge "Unity" painting, dominated one wall of the studio, counterbalanced by iron weights. One day, in an effort to lower the great canvas, Emerson removed the weights, causing the end of the painting to collapse on the floor. Horrified, she confessed to Violet, sure that her teacher's infamous temper would be unleashed. Instead, showing the solicitude with which she would always treat her new companion, Violet responded with concern. "I am so glad you were not hurt! It might have fallen on you!"[173]

HAT·GREAT·CITY · AND·HE·SHEWED·ME·A·PURE·RIVER·OF·WATER·OF·LIFE · UNITY · CLEAR·AS·CRYSTAL·PROCEEDING·OUT·OF·THE·THRONE · THE · LEAVES OF·THE · TREE · WERE·FOR·THE·HEALING·OF·THE·NATIONS·

TY · AND·HE·SHEWED·ME·A·PURE·RIVER·OF·WATER·OF·LIFE · UNITY · CLEAR·AS·CRYSTAL·PROCEEDING·OUT·OF·THE·THRONE · + · THE · LEA

In 1917 Oakley completed seven of the nine panels for the Senate Chamber. The gigantic central panel that had caused her so much concern five years earlier now struck her as a great success—a timely and fervent plea for world peace. The heroic central figure of Unity dominated the canvas. From her flowed the water of life. On the left side of the panel, gallant men beat swords into plowshares; on the right side, a crowd of slaves reached out to Unity as their manacles were removed. Across the bottom of the panel Oakley

had carefully lettered an inspirational message from the Book of Revelations. "He carried me away to a great and high mountain and shewed me that Great City, and he shewed me a pure river of water of life—UNITY—clear as crystal proceeding out of the throne and the leaves of the tree were for the healing of the nations."

The paintings were to be unveiled on Lincoln's birthday, February 12, 1917. While Violet was at the Capitol to help with the installation, an incident occurred that caused her to wonder if the world was ready for William Penn's message of world peace and disarmament.

> Weeks before the United States entered into the World War at the time these [paintings] were placed, we were still hoping that our country might be the mediator to bring peace to the belligerent nations. And I remember one terrible shock when I was here one day superintending the placing of those panels on the wall. A very charming Harrisburg lady came in among others to look at what was being done. And I heard her call out to her friend, "Did you see the rumors of peace this morning in the papers? Isn't it terrible? My steel stocks will go down!"[174]

The chance remark shocked Violet, though she came to understand it the following day when the paintings were unveiled. After pulling the drapery from the smaller murals, Governor Martin Brumbaugh with great ceremony yanked so vigorously on the drapery cords covering the huge central panel that they broke. Amid gasps from the crowd, a workman climbed up on a ladder and crawled along a two-foot wide cornice forty feet above the assembled audience, peeling back the drapery inch by inch. Violet, who saw many events as portents, took this one as a sign that the world as it was—concerned with the price of steel—was not ready for Unity to be revealed.

Aside from the problems with the drapery, the day was a great triumph for Violet. Cornelia Oakley, who Violet had feared might be too frail to attend the festivities, was at

Edith and Violet on the terrace at Cogslea, 1919. Archives of American Art

her daughter's side to witness the culmination of so many years of hard work. However, Cornelia's health was failing, and she died shortly afterward, in her eighty-fourth year. It was her mother who over the years placated what friends referred to as Violet's "rebellious fire," and her loss left Violet bereft and completely alone for the first time in her life. Her Christian Science practitioner, Kathryn Brownell, stood by her in her bereavement, encouraging her to be strong and resolute. Edith also rushed to her friend's side, staying at Cogslea so Violet would have company. Violet asked her not to leave—ever. So on March 13, 1918, at the age of thirty, Edith moved to Cogslea. Comforted by her friend, Violet finished the two remaining panels for the Senate Chamber, completing the narrative of Penn's "Holy Experiment." Late one evening when the paintings were finally packed up and rolled in drums to be loaded on a truck bound for Harrisburg, Violet, sitting alone in her empty studio, had the distinct feeling that a gray-coated William Penn picked up his hat, bowed a final farewell, and went out the door.[175]

Edith pours tea for Violet, 1919. Archives of American Art

The exit of Violet's patron saint after so many years did not dim her enthusiasm for the Capitol decorations. For the next ten years, with Edith assisting, she worked on the last portion of her task. On May 23, 1927, Oakley completed the sixteen panels for the Supreme Court Chambers, which she called *The Opening of the Book of the Law*. That same year she published a limited-edition folio, *The Holy Experiment*, which contained reproductions of her murals for the Governor's Reception Room and the Senate Chamber. Emerson once told a friend that when Oakley dispatched all her obligations to the State of Pennsylvania, dismantled the scaffolding, and straightened her studio after the completion of the monumental assignment, she surveyed the clean, empty space and declared, "this makes me feel like working!"[176]

Oakley may have felt like working, but she needed a commission. The seemingly inexhaustible sum received in payment for her murals at the Capitol had all been spent. For the first time in her professional career, no assignment

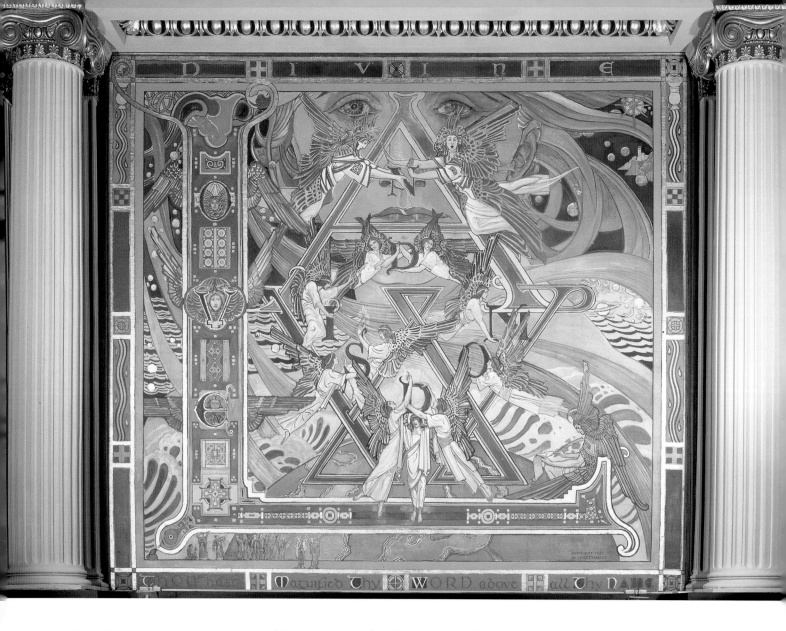

Violet Oakley. *Divine Law: Love and Wisdom*. From *The Opening of the Book of Law*. Series of Paintings in the Supreme Court Room, Pennsylvania State Capitol, Harrisburg, Pennsylvania. 1917–27. 10 x 11'. Photograph by Brian Hunt

Oakley's final series of paintings for the Pennsylvania State Capitol were unveiled on May 23, 1927, twenty-five years after she started working on the project.

arrived in time to save her from serious financial problems. Although her panels garnered praise even her staunchest supporter, Dr. George Woodward, wondered if the extent of her accomplishment could be fully appreciated. "The ambitious architect of the Capitol," Woodward wrote, "never learned the value of empty spaces; he has none. Every architectural detail from Noah's ark, the Taj Mahal, the Medici Chapel, St. Peter's, Rome, St. Pauls, London, can be found right here in Harrisburg. Against this gluttony of architectural surfeit Violet Oakley's distinguished mural paintings, also Edwin Abbey's, had to compete."[177]

Oakley's beautifully crafted work was invariably strongly tied to content. As the twentieth-century art establishment became concerned with self-expression and abstraction, she found it difficult to garner important assignments. Emerson was more of a disciple than a colleague and never advised her to experiment or change her way of working. She fervently

believed in Violet's aesthetic, which she embraced tenaciously for the rest of her life despite the relentless assault of modernism. Years later, mincing no words, Edith voiced her opinion on Abstract Expressionism. "Some painters have discovered an easy way of avoiding work by discarding all human interest in favor of an abstraction that can be designed in half an hour or less and executed by a corps of house painters. No research, no thought, just 'feeling' readily stimulated by a few cocktails. The marvel is that the dispensers of the commissions are so readily hypnotized!"[178] A friend recalls noticing a crumpled painting by the early mechanistic modernist Morton Schamberg in a wastebasket at the Cogslea studio. "Better save that," he advised Edith, "it's worth a lot of money."[179] Edith rescued the artwork, but not because she recognized its genius.

With no forthcoming assignments, Violet, who once confessed to Edith that if deprived of her art materials she would draw on the roof of her mouth with the tip of her tongue, was not about to be thwarted.[180] She immediately found a new project to interest her, in spite of the fact that she had no patron for the work. That same year, she and Edith rented Cogslea and traveled to Geneva, Switzerland, to document the beginning of the League of Nations and draw portraits of the delegates. Violet was bitterly disappointed when the United States failed to join the League, for she felt the organization represented the culmination of William Penn's dreams, as well as her own. While they were in Geneva, Henrietta wrote with bad news about Cogslea. The renters were not keeping up the house and it was in need of expensive repairs. "In all probability she [Violet] ought to sell Cogslea if she can get a good price for it," Edith wrote back.

Violet in front of *The Weavers of New Hope*. Archives of American Art

> I wouldn't advise her to sacrifice it. She could then get on well with the studio and living abroad where it is so much cheaper and you don't have to drain yourself dry to get a little domestic service. . . . If I were a millionaire I'd finance her here for three years and she would come home with an international reputation. Everyone is crazy about her and her work but things like that take time and social contacts.

Violet Oakley. *Henrietta Cozens, Jessie Willcox Smith, Marg Nixon, and Edith Emerson at Cogshill.* c. 1918. The Pennsylvania Academy of the Fine Arts, Philadelphia

Instead of my financing her she has to finance me at present, as my own wealth only covered the summer. Don't imagine we are trying to break away from Philadelphia—we would just like to be back and forth frequently. Old friends and true blue ones like yourselves can never be displaced.[181]

Violet eventually did put her home up for sale, but not in time to take advantage of the prosperity of the 1920s. She also found no commercial outlet for the Geneva drawings. In 1933 she published them along with reproductions of the Harrisburg project in a privately printed book, *The Law Triumphant.* Unfortunately, the revenues generated from the project failed to cover the production costs. Over the next twenty-seven years, Violet published several books, accepted various mural commissions, completed a number of portrait commissions, and to help pay expenses started an art school, The Cogslea Academy of Arts and Letters, in her studio. The school's lecture series brought some notable artists to Mt. Airy. Letitia Harris, a well-known pianist, composer, and soloist with the Philadelphia Orchestra, was a guest artist as well as tenor Lawerence Haynes, dancer Ruth St. Dennis, and the poet Rabindranath Tagore.

The Depression, World War II, and the changing aesthetics of the twentieth century destroyed Violet's hopes for financial recovery. Money was

a constant problem. Eventually, Oakley and Emerson were forced to rent the house and move into the studio, which they bravely named "Lower Cogslea." They kept the main house leased while attempting unsuccessfully to sell it for ten years. Jessie helped where she could, paying for a new roof and other repairs, but Violet's financial woes were overwhelming. Eventually the bank foreclosed on the mortgage of the entire property. Violet and Edith, facing the mortification of eviction, were saved one last time by Mrs. George Woodward, who bought Lower Cogslea and rented it back to the two artists at a price they could afford.

Amid trouble and crisis, changing manners and mores, Violet Oakley and Edith Emerson remained devoted companions and helpmates. Edith was not an idle partner and helped financially as much as possible. She was an accomplished and prolific painter of some note and also designed murals, stained glass, illustrations, and bookplates. She taught in the Philadelphia area at the Agnes Irwin School, The Museum School of Industrial Arts, and at Chestnut Hill College. Beginning in 1940 she was successively vice president, president, and curator of the Woodmere Art Gallery in Chestnut Hill.

This author remembers both women: Violet Oakley in the 1950s as a magnificent but frightening figure evidently much respected at the Academy openings. Her obvious impatience with small children made me loath to linger anywhere near her. I much preferred to sit on a bench opposite Benjamin West's sublime canvas *Death on a Pale Horse*, spellbound by its enthralling violence. I remember Edith Emerson better, as she outlived Oakley by twenty years. She was a contemporary of my grandfather, born in the same year, and had a quick wit. Her relationship with Oakley was the subject of the long silences and raised brows that immediately alert children that something of great interest is being withheld. Emerson's loyalty to Oakley was the subject of some speculation, although by the time such things were openly discussed, Violet's majestic dowager status quelled most comment.

Whatever people may have thought, forty-seven years after she met Violet at the Academy, Edith's fidelity was undiminished. On the occasion of Violet's eighty-fifth birthday, Edith wrote the following poem.

This many a year	Oh Lady Fair
Oh Violet—dear	With genius rare
To meet your need	No moment is dull
In thought and deed	Each day to the full
I strive	We live.[182]

THIS EDITION IS LIMITED TO ONE THOUSAND COPIES OF WHICH THIS IS NUMBER

364

Violet Oakley. Personal Logotype

Oakley used this imprint as her logotype on many occasions. The image symbolizes her name as well as what she recognized as the two opposing sides of her character: the fragile violet and the mighty oak.

205

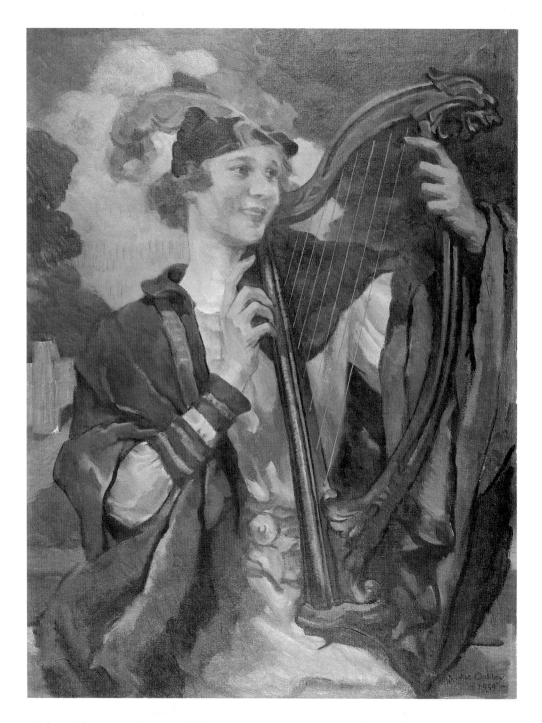

Violet Oakley. *Quita Woodward*. 1939. Courtesy of the Bryn Mawr College Collections

Gertrude "Quita" Woodward was in the Bryn Mawr College class of 1932. The fifth child and only daughter of George and Gertrude Woodward, she died tragically of Hodgkin's disease at the age of twenty-five. Two years after her death her parents donated a wing to the Bryn Mawr College library in her memory. Oakley painted this portrait of Quita dressed as a wandering minstrel (her Bryn Mawr College May Day costume).

After Oakley's death in 1961, Emerson found it impossible to abandon her close connection to the ethics of her beloved comrade. In order to disseminate Violet's message, she established the Violet Oakley Memorial Foundation, an organization dedicated to keeping her friend's memory and ideals alive. The elderly membership consisted mainly of longtime friends, former students of the Cogslea Academy, and amateur painters who were upset by Abstract Expressionism and found solace in Oakley's didactic work. Artists who lectured for the Foundation remember that many of the members regarded the meetings as an opportunity to socialize and dozed off during the presentations.[183] Several years after Edith died on November 21, 1981, at the age of ninety-three, the Violet Oakley Foundation was dissolved, and Lower Cogslea sold. Although the hedges grew tall, the clematis bloomed in September, and roses still opened in the bright Mt. Airy summer, the last beneficiary of the Red Rose legacy was gone.

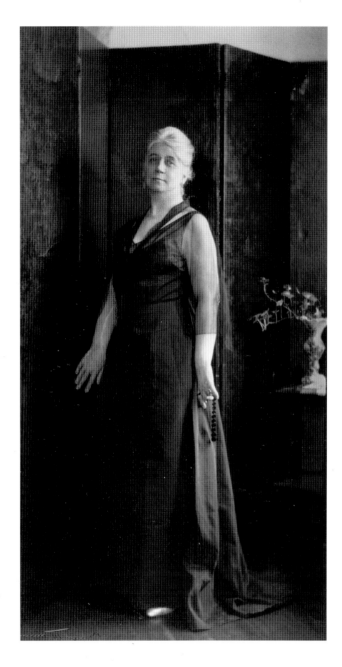

Violet Oakley, December 1937. Archives of American Art

The date is Thursday, February 23, 1905. The excitement of the centennial banquet has ebbed. The lights go out at the Red Rose Inn, and the household retires for the night. It is so quiet, not even the sound of the future disturbs the peace of the evening. The Fauves who will present their work at the Paris salon that same year will not cast their brilliance over the careers of the three women. The Red Rose Girls will never change their painting styles, and the modern revolution that rocks the art world will pass them by. Yet they will leave their message for each new generation of artists—both men and women—who increasingly isolate themselves in home studios, connected to the larger world remotely and electronically. Jessie Willcox Smith, Elizabeth Shippen Green, and Violet Oakley knew the value of an artistic community, of honest and informed criticism by their peers, and of the company of compatible friends. By the close of the twentieth century, 106 eminent artists were honored with inclusion into the Society of Illustrators Hall of Fame: ninety-seven men and nine women. Perhaps it is no coincidence that of the nine, three have just blown out the candles and gone to bed.

Notes

1. "Lovers of Fine Art at Banquet Board," *Evening Bulletin*, Feb. 23, 1905.

2. "The Academy Dinner," *Philadelphia Press*, Feb. 26, 1905.

3. Jessie Willcox Smith, "What Type of Children I Seek as Models," handwritten account in response to a request for an article, 1927, Henrietta Cozens Papers, Bryn Mawr College Library, Bryn Mawr, Pa.

4. Undated clipping, Jessie Willcox Smith Papers, Archives of American Art, Smithsonian Institution, Washington, D.C.

5. Smith, "What Type of Children I Seek as Models."

6. Ibid.

7. Typewritten copy of the first draft of an article, possibly by Louise Hillyer Armstrong, mailed to Jessie Willcox Smith, Jan. 31, 1927, Jessie Willcox Smith Papers.

8. Theodore C. Knauff, *An Experiment in Training for the Useful and the Beautiful* (Philadelphia, 1922), 5.

9. Christine Jones Huber, *The Pennsylvania Academy and Its Women, 1850–1920* (Philadelphia, 1974), 12.

10. Nancy Mowll Mathews, *Mary Cassatt: A Life* (New York, 1994), 26.

11. Thomas J. Schlereth, *Victorian America: Transformations in Everyday Life 1876–1915* (New York, 1991), 71.

12. Ibid., 72.

13. Knauff, 15.

14. Ibid., 31.

15. Adam Gopnik, "Eakins in the Wilderness," *The New Yorker* (Dec. 26, 1994; Jan. 2, 1995): 85.

16. William Innes Homers, *Thomas Eakins—His Life and Art* (New York and London, 1992).

17. Kathleen A. Foster and Cheryl Leibold, *Writing about Eakins* (Philadelphia, 1989), 236.

18. Louise Hillyer Armstrong article, Jessie Willcox Smith Papers.

19. *Report of the Private View of the Exhibition of the Works of Howard Pyle at the Art Alliance: Philadelphia, January 22, 1923* (Philadelphia, 1923), 18.

20. Edith Emerson, taped interview with Catherine Connell Stryker, 1975, Delaware Art Museum, Wilmington, Del.

21. The Shippen family was included in a satirical rhyme called the Philadelphia Rosary that names the city's "first" families. "Morris, Norris, Rush, and Chew / Drinker, Dallas, Coxe, and Pugh / Wharton, Pepper, Pennypacker / Willing, Shippen, and Markoe." Nathaniel Burt, *The Perennial Philadelphians: The Anatomy of an American Aristocracy* (Boston and Toronto, 1963), 44.

22. Christine Anne Hahler, *Illustrated by Darley* (Wilmington, Del., 1978), 10.

23. Algeron Tassin, *The Magazine in America* (New York, 1916), 251, 252.

24. *The Philadelphia Times*, Sept. 8, 1889.

25. Regina Armstrong, "Representative Women Illustrators: The Decorative Workers," *The Critic* 36, no. 6 (June 1900): 520.

26. Violet Oakley, handwritten text from a family scrapbook, Violet Oakley Papers, Archives of American Art, Smithsonian Institution, Washington, D.C.

27. Violet Oakley, handwritten autobiography, Violet Oakley Papers.

28. Undated clipping, *Christian Science Monitor*, Violet Oakley Papers.

29. "Violet Oakley's New Porfolio of Reproductions," *Philadelphia Public Ledger*, June 9, 1922.

30. Hester Oakley, *As Having Nothing* (New York and London, 1898), 28.

31. Ibid., 16.

32. Edith Emerson, "Violet Oakley, 1874–1961," undated typed manuscript, Violet Oakley Papers, Archives of American Art, Smithsonian Institution, Washington, D.C.

33. *Circular of Committee on Instruction: Schools of the Pennsylvania Academy of the Fine Arts*, season of 1895–1896, 4, 9.

34. Emerson, "Violet Oakley, 1874–1961."

35. Ibid.

36. Ibid.

37. Edna Andrade, telephone interview with author, Jan. 27, 1997.

38. Handwritten inscription on a copy of Howard Pyle's book, *Otto of the Silver Hand*, Collection of Ben and Jane Eisenstat.

39. Henry C. Pitz, *Howard Pyle: Writer, Illustrator, and Founder of the Brandywine School* (New York, 1975), 132.

40. Jane Allen Gregory, in Gregory, et al., *Howard Pyle: Diversity in Depth* (Wilmington, Del., 1973), 5.

41. Henry C. Pitz, "Pyle the Teacher," in Gregory, et al., *Howard Pyle: Diversity in Depth*, 41.

42. Mary Tracy Earle, "The Red Rose," *The Lamp* 26, no. 4 (May 1903) 227, 278.

43. Jean Henry, "Drexel's Great School of Illustration," *Drexel's Great School of American Illustration: Violet Oakley and her Contemporaries* (Philadelphia, 1985), 7.

44. *Report of the Private View of the Exhibition of Works by Howard Pyle at the Art Alliance*, 12.

45. Charles De Foe, "Personal Reminiscences of Howard Pyle," in Gregory, et al., *Howard Pyle: Diversity in Depth*, 17.

46. *Report of the Private View of the Exhibition of Works by Howard Pyle at the Art Alliance*, 19, 20.

47. Ibid., 12.

48. Pitz, *Howard Pyle: Writer, Illustrator, and Founder of the Brandywine School*, 135.

49. Ibid., 128.

50. Emerson, taped interview with Catherine Stryker, 1975, Delaware Art Museum, Wilmington, Del.

51. Henry Wadsworth Longfellow, *Evangeline: A Tale of Acadie* (Boston, 1897), xv.

52. Sarah F. Crumb, "The House that Jill Built," typewritten document, 1972, Archives of the Plastic Club, Philadelphia, Pa, 2.

53. Blanche Dillaye, "Annual Address of the President," *The Plastic Club of Philadelphia, Second Annual Report and Announcement, Seasons 1898, 1899*, Archives of the Plastic Club.

54. Ibid.

55. Michael S. Schnessel, *Jessie Willcox Smith* (New York, 1977), 35.

56. Lillian Faderman, *Odd Girls and Twilight Lovers: A History of Lesbian Life in Twentieth-Century America* (New York and London, 1991), 20.

57. Harriet C. Seele, "Festivals in American Colleges for Women," *The Century Magazine* (Jan. 1895): 433.

58. Henry James, "The Bostonians," *The American Novels and Stories of Henry James* (New York, 1964), 492.

59. Faderman, 48, 49.

60. Louise Hillyer Armstrong enclosure, Jessie Willcox Smith Papers.

61. Charles Holme, *Modern Pen Drawings: European and American* (London, 1901), 104.

62. Violet Oakley, "Art as a Stimulus to Civic Righteousness," *The Philadelphia Forum Magazine* (Aug. 1922): 11.

63. Emerson, taped interview with Catherine Stryker, 1975, Delaware Art Museum, Wilmington, Del.

64. Emerson, "Violet Oakley, 1874–1961."

65. Agnes Repplier, *Philadelphia: The Place and the People* (New York and London, 1898), 370.

66. Earle, 282.

67. Violet Oakley, "The Romance of the Red Rose," handwritten undated autobiography, Violet Oakley Papers.

68. Burt, ix.

69. P. W. Humphreys, "The Old Red Rose of 'Stoke Pogis' at Villa Nova, Penna.," undated unidentified magazine article, Violet Oakley Papers.

70. Violet Oakley, "The Romance of the Red Rose."

71. Violet Oakley, handwritten memories dictated to Edith Emerson, July 20, 1920, Violet Oakley Papers.

72. Ibid.

73. Ibid.

74. Ibid.

75. Violet Oakley, "The Romance of the Red Rose."

76. "Anthony Drexel Buys Red Rose Inn," *Philadelphia Press*, Oct. 24, 1901.

77. Violet Oakley, "The Romance of the Red Rose."

78. Anna Lea Merritt, "A Letter to Artists: Especially Women Artists," *Lippincott's Monthly Magazine* 65 (1900): 467–68.

79. Clifford Lewis III, interview with author, Feb. 18, 1997.

80. James, 149.

81. Letter from an admirer to Henrietta Cozens, Oct. 28, 1888, Henrietta Cozens Papers.

82. Smith, undated letter to Henrietta Cozens, Henrietta Cozens Papers.

83. Anna Barton Brown, *Alice Barber Stephens: A Pioneer Woman Illustrator* (Chadds Ford, Pa., 1984), 19. Praising Stephens's work in a 1906 letter to her, Howard Pyle commented, "It is less affected and far more serious than this later, flat, semi-decorative work that the Red Rose Girls (Elizabeth Shippen Green, Jessie Willcox Smith, and Violet Oakley) seemed to be drifting into."

84. Smith, undated letter, Archives of the Plastic Club.

85. Undated unidentified newspaper clipping, Archives of the Plastic Club.

86. Patricia Likos, "Violet Oakley," *Bulletin of the Philadelphia Museum of Art* (Philadelphia, 1979), 12.

87. Violet Oakley, "Dear Red Roses," Sept. 14, 1903, Henrietta Cozens Papers.

88. Norma K. Bright, "Art in Illustration: The Achievements of a Group of Popular American Artists," *Book News* (July 1905).

89. Smith, "What Type of Children I Seek as Models."

90. Smith, letter to Henrietta Cozens, June 19, 1906, Henrietta Cozens Papers.

91. Emerson, taped interview with Catherine Stryker, 1975.

92. Earle, 282.

93. "Violet Oakley on Visit Here Talks of Work," *Baltimore Sun*, Aug. 22, 1922.

94. Smith, letter to Henrietta Cozens, Aug. 20, 1904, Henrietta Cozens Papers.

95. Ibid.

96. Newspaper clipping, Jan. 10, 1905, Elizabeth Shippen Green Elliott Papers, Archives of American Art, Smithsonian Institution, Washington, D.C.

97. Harrison S. Morris, "Philadelphia's Contribution to American Art," *The Century Magazine* 69 (Mar. 1905): 714–33.

98. Smith, letter to Henrietta Cozens, Apr. 2, 1906, Henrietta Cozens Papers.

99. Smith, letter to Henrietta Cozens, Monday morning, 8:45, [undated], 1906, Henrietta Cozens Papers.

100. Smith, letter to Henrietta Cozens, Monday afternoon, 1:30, [undated], 1906, Henrietta Cozens Papers.

101. Elizabeth Shippen Green Elliott Papers.

102. "The Latest News in Art Circles," *Philadelphia Inquirer*, Mar. 5, 1905.

103. Maxfield Parrish, letter to Jessie Willcox Smith, May 11, 1905, Jessie Willcox Smith Papers.

104. Violet Oakley, taped speech at the Pennsylvania State Capitol, Harrisburg, May 21, 1955.

105. "Miss Oakley Defends Capital Pictures: Declares Completed Pictures Will Be Unobjectionable—Catholics Will Push Protest," undated newspaper clipping, Violet Oakley Papers.

106. Ibid.

107. "Art in Old Red Rose Inn," *The Philadelphia Record*, Violet Oakley Papers.

108. Emerson, taped interview with Catherine Stryker, 1975.

109. David R. Contosta, *A Philadelphia Family: The Houstons and Woodwards of Chestnut Hill* (Philadelphia, 1988), 72.

110. Olive Rush, letter to mother, Mar. 3, 1908, Olive Rush Papers, Archives of American Art, Smithsonian Institution, Washington, D.C.

111. Violet Oakley Papers.

112. Talcott Williams, *Philadelphia Press*, Oct. 25, 1906.

113. Undated, unidentified newspaper clipping, Violet Oakley Papers.

114. Huger Elliott pronounced his name "Hugh-gee," a corruption of the French pronunciation.

115. Emerson, taped interview with Catherine Stryker, 1975.

116. Catherine Connell Stryker, *The Studios at Cogslea* (Wilmington, Del., 1976), 10. Quoted from Armstrong, "Representative Women Illustrators," 520.

117. Philip L. Hale, unidentified newspaper article, 1907, Jessie Willcox Smith Papers.

118. "Five Clever Women of Philadelphia's Artist Colony Display Their Work to New Yorkers and Score a Success, " *Philadelphia Press*, Nov. 3, 1907, Archives of the Plastic Club.

119. Faderman, 49.

120. Ibid., 49.

121. Ibid., 48.

122. Smith, letter to Henrietta Cozens, Aug. 9, 1907, Henrietta Cozens Papers.

123. Smith, "Sunday Morning at Sea, 500 miles out," undated letter to Henrietta Cozens, Henrietta Cozens Papers.

124. Ibid.

125. Ibid.

126. Smith, letter to Henrietta Cozens, Aug. 28, 1907, Henrietta Cozens Papers.

127. Cozens, letter to Jessie Willcox Smith, Aug. 23, 1907, Henrietta Cozens Papers.

128. Smith, letter to Henrietta Cozens, Aug. 28, 1907.

129. Ibid.

130. Cozens, letter to Jessie Willcox Smith, Aug. 23, 1907.

131. Emerson, "The Age of Innocence: Portraits by Jessie Willcox Smith," *The American Magazine of Art* 16, no. 7 (July 1925): 342.

132. Violet Oakley, letter to Henrietta Cozens, Aug. 19, 1909, Henrietta Cozens Papers.

133. Violet Oakley, letter to Henrietta Cozens, Dec. 13, 1909, Henrietta Cozens Papers.

134. Cozens, Dec. 1912, Henrietta Cozens Papers.

135. Emerson, "The Age of Innocence: Portraits by Jessie Willcox Smith," 345.

136. Emerson, "Violet Oakley, 1874–1961."

137. Violet Oakley Papers.

138. Stryker, 19.

139. Henrietta Cozens Papers.

140. This story has been handed down in the family of Henrietta Cozens and comes from an interview by the author with Clifford Lewis III, Feb. 18, 1997.

141. "Trio of Artists Broken by Cupid: Artists Combine Fortunes for Life," *Philadelphia Press*, June 4, 1911.

142. *Chestnut Hill Herald*, date unrecorded.

143. Green, letter to Henrietta Cozens, June 7, 1911, Henrietta Cozens Papers.

144. Faderman, 50.

145. Green, letter to Henrietta Cozens, June 9, 1911, Henrietta Cozens Papers.

146. Green, letter to Henrietta Cozens, June 27, 1911, Henrietta Cozens Papers.

147. Violet Oakley, "A Declaration: To Be Read July 4, 1911," handwritten document, July 3, 1911, Violet Oakley Papers.

148. Violet Oakley, taped speech at the Pennsylvania State Capitol, Harrisburg, May 21, 1955.

149. Ibid.

150. Green, letter to Henrietta Cozens, Sept. 18, 1911, Henrietta Cozens Papers.

151. Green, letter to Henrietta Cozens, Nov. 10, 1911, Henrietta Cozens Papers.

152. Violet Oakley, undated article, *Philadelphia Forum*, Edith Emerson Papers.

153. Violet Oakley, letter to Jessie Willcox Smith, 1912, Henrietta Cozens Papers.

154. Violet Oakley, taped speech at the Pennsylvania State Capitol, Harrisburg, May 21, 1955.

155. Emerson, "Violet Oakley, 1874–1961."

156. Green, "Dear Jeddy and Heddy," letter to Jessie Willcox Smith and Henrietta Cozens, Dec. 5, 1913, Henrietta Cozens Papers.

157. Ibid.

158. Ibid.

159. Violet Oakley, letter to Jessie Willcox Smith and Henrietta Cozens, Oct. 26, 1927, Henrietta Cozens Papers.

160. Ben Eisenstat, interview with author, Mar. 6, 1997.

161. Smith, rough draft of undated letter, Jessie Willcox Smith Papers.

162. Louise Hillyer Armstrong, letter to Jessie Willcox Smith, Feb. 9, year unknown, Jessie Willcox Smith Papers.

163. *Good Housekeeping* (Nov. 1917): 32.

164. Clifford Lewis III, interview with author, Feb. 18, 1997.

165. Emerson, taped interview with Catherine Stryker, 1975.

166. Emerson, "Jessie Willcox Smith: An Appreciation," foreword to the catalogue of the memorial exhibition at the Pennsylvania Academy of the Fine Arts, 1936.

167. Elizabeth Elliott, *Tales from Shakespeare by Charles and Mary Lamb*, 1922.

168. Huger Elliott, letter to Henrietta Cozens and Jessie Willcox Smith, May 25, 1920, Henrietta Cozens Papers.

169. Emerson, taped interview with Catherine Stryker, 1975.

170. Ben Eisenstat remembers artist Maurice Bower's tales of Huger Elliott's eccentric behavior at the Museum School. Interview with author, Aug. 15, 1998.

171. Charles Cunningham, letter to author, Feb. 18, 1997.

172. Emerson, "Violet Oakley, 1874–1961."

173. Ibid.

174. Violet Oakley, taped speech at the Pennsylvania State Capitol, Harrisburg, May 21, 1955.

175. Emerson, "Violet Oakley, 1874–1961."

176. Brian Zahn, telephone interview with author, May 16, 1997.

177. George Woodward, *Family Letters and Proletarian Essays* (Philadelphia, 1937), 107.

178. Emerson, "Violet Oakley, 1874–1961."

179. Ben Eisenstat, interview with author, Mar. 6, 1997.

180. Emerson, "Violet Oakley, 1874–1961."

181. Emerson, letter to Henrietta Cozens, Nov. 9, 1927, Henrietta Cozens Papers.

182. Emerson, June 10, 1959, Violet Oakley Papers.

183. Ben Eisenstat, interview with author, Apr. 12, 1997.

Bibliography

"The Academy Dinner." *Philadelphia Press*, Feb. 26, 1905.

Armstrong, Regina. "Representative Women Illustrators: The Decorative Workers." *The Critic* 36, no. 6 (June 1900).

"Art and Artists." *Philadelphia Press*, Jan. 24, 1901.

Beyer, Rita. "'Portraits of Cogslea' On Display at CHHS and Woodmere." *Chestnut Hill Local*, Apr. 6, 1995, 31.

Bright, Norma K. "Art in Illustration: The Achievements of a Group of Popular Artists." *Book News* (July 1905): 848–55.

Bronner, Edwin B. *William Penn's "Holy Experiment": The Founding of Pennsylvania 1681–1701*. New York and London: Temple University Publications, 1962.

Brown, Anna Barton. *Alice Barber Stephens: A Pioneer Woman Illustrator*. Ex. cat. Chadds Ford, Pa.: Brandywine River Museum, 1984.

Burt, Nathaniel. *The Perennial Philadelphians: The Anatomy of an American Aristocracy*. Boston and Toronto: Little Brown & Co., 1963.

Carter, Alice, A. "The Cogs Of Red Rose Inn." *Print* (Jan./Feb. 1997): 43–51.

Cather, Willa, and Georgine Milmine. *The Life of Mary Baker G. Eddy and the History of Christian Science*. 1909. Reprint, Lincoln, Neb., and London: University of Nebraska Press, 1993.

Chadwick, Whitney. *Women Art and Society*. London: Thames and Hudson, 1992.

Circular of Committee on Instruction: Schools of The Pennsylvania Academy of the Fine Arts. Season of 1895–1896.

Contosta, David R. *A Philadelphia Family: The Houstons and Woodwards of Chestnut Hill*. Philadelphia: University of Pennsylvania Press, 1988.

_____. *Suburb in the City: Chestnut Hill, Philadelphia, 1850–1990*. Columbus, Ohio: Ohio State University Press, 1992.

Cozens, Henrietta. Henrietta Cozens Papers. Emma C. Brown Collection. Bryn Mawr College Library, Bryn Mawr, Pa.

_____. Henrietta Cozens Papers. Robert DeMento Collection. Bryn Mawr College Library, Bryn Mawr, Pa.

Crumb, Sarah F. "The House that Jill Built." 1972. Archives of the Plastic Club, Philadelphia, Pa.

Design for Women: A History of the Moore College of Art. Wynnewood, Pa.: Livingston Publishing Co., 1968.

Dillaye, Blanche. "Annual Address of the President." *The Plastic Club of Philadelphia, Second Annual Report and Announcement, Seasons 1898, 1899*. Archives of the Plastic Club, Philadelphia, Pa.

Earle, Mary Tracy. "The Red Rose." *The Lamp* 26, no. 4 (May 1903).

Elliott, Elizabeth Shippen Green. Elizabeth Shippen Green Elliott Papers, 1848–1947. Archives of American Art, Smithsonian Institution, Washington, D.C.

Emerson, Edith. "The Age of Innocence: Portraits by Jessie Willcox Smith." *The American Magazine of Art* 16, no. 7 (July 1925): 342–47.

_____. Edith Emerson Papers, 1839–1981. Archives of American Art, Smithsonian Institution, Washington, D.C.

_____. "Jessie Willcox Smith: An Appreciation." Foreword to the catalogue of the Memorial Exhibition at the Pennsylvania Academy of the Fine Arts, 1936.

Faderman, Lillian. *Odd Girls and Twilight Lovers: A History of Lesbian Life in Twentieth-Century America*. New York and London: Penguin Books, 1991.

"Famous Red Rose Inn Is Sold For $200,000." *North American*, Aug. 26, 1905.

"Five Clever Women of Philadelphia's Artist Colony Display Their Work to New Yorkers and Score a Success." Newspaper unknown, Nov. 3, 1907. Plastic Club Archives, Philadelphia.

Foster, Kathleen A., and Cheryl Leibold. *Writing about Eakins*. Philadelphia: University of Pennsylvania Press for the Pennsylvania Academy of the Fine Arts, 1989.

Goodman, Helen. "Woman Illustrators of the Golden Age of American Illustration." *Woman's Art Journal* 8, no. 1 (spring/summer 1987): 13–20.

Gopnik, Adam. "Eakins in the Wilderness." *The New Yorker* (Dec. 26, 1994; Jan. 2, 1995).

Gregory, Jane Allen, Charles De Foe, and Henry Pitz. *Howard Pyle: Diversity in Depth*. Ex. cat. Wilmington, Del.: Delaware Art Museum, 1973.

Hahler, Christine Anne. *Illustrated by Darley*. Ex. cat. Wilmington, Del.: Delaware Art Museum, 1978.

Hale, Helen. "Hints to Young but Ambitious Artists from Some of the Most Famous Women Illustrators." *Chicago Examiner*, Jan. 22, 1906.

Hawthorne, Nathaniel. *The Marble Faun: Or, the Romance of Monte Beni*. 1860. Reprint, New York: Penguin Books, 1990.

Henry, Jean. *Drexel's Great School of American Illustration: Violet Oakley and Her Contemporaries*. Ex. cat. Philadelphia: Drexel University Museum, 1985.

Holme, Charles. *Modern Pen Drawings: European and American*. London: The Studio, 1901.

Homers, William Innes. *Thomas Eakins—His Life and Art*. New York and London: Abbeville Press, 1992.

Huber, Christine Jones. *The Pennsylvania Academy and Its Women, 1850–1920*. Ex. cat. Philadelphia: Pennsylvania Academy of the Fine Arts, 1974.

Humphreys, P. W. "The Old Red Rose of 'Stoke Pogis' at Villa Nova, Penna." Undated, from unidentified magazine. Violet Oakley Papers. Archives of American Art, Smithsonian Institution, Washington, D.C.

James, Henry. "The Bostonians." *The American Novels and Stories of Henry James*. New York: Alfred A. Knopf, 1964.

Knauff, Theodore C. *An Experiment in Training for the Useful and the Beautiful*. Philadelphia: Philadelphia School of Design for Women, 1922.

"The Latest News in Art Circles." *Philadelphia Inquirer*, Mar. 5, 1905.

Levy, Florence N., ed. "Last Week of Academy's Centennial." *Art Bulletin*, Mar. 4, 1905.

Likos, Patricia. "For Myself, for My Sisters." *Arts Exchange* (Nov./Dec. 1978): 6–9, 56–57.

———. "Violet Oakley." *Bulletin of the Philadelphia Museum of Art*. Philadelphia: Philadelphia Museum of Art, 1979.

———. "Violet Oakley, Lady Mural Painter." *Pennsylvania Heritage* (fall 1988): 14–21.

Lippincott, Horace Mather. *Philadelphia*. Port Washington, N.Y.: Kennikat Press, 1926.

Longfellow, Henry Wadsworth. *Evangeline: A Tale of Acadie*. Boston: Houghton Mifflin, 1897.

"Lovers of Fine Art at Banquet Board." *Evening Bulletin*, Feb. 23, 1905.

Mather, Frank Jewett Jr., James Rufus Morey, and William James Henderson. *The American Spirit in Art*. New Haven: Yale University Press, 1927.

Mathews, Nancy Mowll. *Mary Cassatt: A Life*. New York: Villard Books, 1994.

Merritt, Anna Lea. "A Letter to Artists: Especially Women Artists." *Lippincott's Monthly Magazine* 65 (1900): 463–69.

Morgan, Jessica. "Violet Oakley and Cogslea: Art Colony Flourished Here." *Times Express*, Mt. Airy, Pa., Mar. 1, 1995, 1–2.

Morley, Christopher. *Travels in Philadelphia*. Philadelphia and New York: J. B. Lippincott and Co., 1937.

Morris, Harrison S. "Miss Violet Oakley's Mural Decorations." *The Century Magazine* (June 1905): 265.

———. "Philadelphia's Contribution to American Art." *The Century Magazine* 69 (Mar. 1905): 714–33.

"Naughty Lady Jane." *Philadelphia Times*, Sept. 8, 1899.

"Notable Company at Academy of Fine Arts Banquet Observes Institution's Centennial in Fitting Setting." *Philadelphia Press*, Feb. 24, 1905.

Nudelman, Edward D. *Jessie Willcox Smith : A Bibliography*. Gretna, La.: Pelican Publishing Co., 1989.

———. *Jessie Willcox Smith: American Illustrator*. Gretna, La.: Pelican Publishing Co., 1990.

Oakley, Hester. *As Having Nothing*. New York and London: G. P. Putnam's Sons, 1898.

Oakley, Violet. "Art as a Stimulus to Civic Righteousness." *The Philadelphia Forum Magazine* (Aug. 1922).

———. *The Holy Experiment: Our Heritage from William Penn*. 1922. Reprint, Philadelphia: Cogslea Studios Publications, 1950.

———. *The Law Triumphant*. Philadelphia: Privately printed, 1933.

———. Undated article. *Philadelphia Forum*. Edith Emerson Papers. Archives of American Art, Smithsonian Institution, Washington, D.C.

———. Violet Oakley Papers, 1841–1981. Archives of American Art, Smithsonian Institution, Washington, D.C.

Pennell, Elizabeth Robbins, and Joseph Pennell. *The Adventures of an American Illustrator*. Boston: Little, Brown & Co., 1925.

———. *Joseph Pennell's Pictures of Philadelphia*. 1914. Reprint, Philadelphia and London: J. B. Lippincott Co., 1924.

Perlman, Bennard B. *The Immortal Eight*. Westport, Conn.: Northlight Publishers, 1979.

Pitz, Henry C. *Howard Pyle: Writer, Illustrator, and Founder of the Brandywine School*. New York: Clarkson N. Potter, Inc., 1975.

———. *Two Hundred Years of American Illustration*. New York: Random House, 1977.

"Redfield's 'Hillside Farm' Takes Sesnan Gold Medal: Final Awards of Prizes at Academy of the Fine Arts' Centennial Exhibition. Mary Smith Honor Captured by Miss Green." *Philadelphia Inquirer*, Mar. 8, 1905.

Report of the Private View of the Exhibition of the Works of Howard Pyle at the Art Alliance: Philadelphia, January 22, 1923. Philadelphia: Ad Service Printing Company, 1923.

Repplier, Agnes. *Philadelphia: The Place and the People*. New York and London: Macmillan, 1898.

Rush, Olive. Olive Rush Papers. Archives of American Art, Smithsonian Institution, Washington, D.C.

Schlereth, Thomas J. *Victorian America: Transformations in Everyday Life 1876–1915*. New York: HarperPerennial, 1991.

Schnessel, Michael S. *Jessie Willcox Smith*. New York: Thomas Y. Crowell, 1977.

"The Secret About Our Covers." *Good Housekeeping* (Nov. 1917): 32–33

Seele, Harriet C. "Festivals in American Colleges for Women." *The Century Magazine* (Jan. 1895): 433.

Smith, Jessie Willcox. "Humorous Experiences in Painting Children." Henrietta Cozens Papers. Emma C. Brown Collection. Bryn Mawr College Library, Bryn Mawr, Pa.

———. Jessie Willcox Smith Papers, 1901–1931. Archives of American Art, Smithsonian Institution, Washington, D.C.

———. "What Type of Children I Seek as Models." Henrietta Cozens Papers. Emma C. Brown Collection. Bryn Mawr College Library, Bryn Mawr, Pa.

Stryker, Catherine Connell. *The Studios at Cogslea*. Ex. cat. Wilmington, Del.: Delaware Art Museum, 1976.

Tassin, Algeron. *The Magazine in America*. New York: Dodd, Mead & Co., 1916.

Taylor, Frank H., ed. *The Book of Philadelphia: The City of Philadelphia As It Appears in the Year 1893*. Philadelphia: Geo. S. Harris & Sons, 1893.

"Trio of Artists Broken by Cupid: Artists Combine Fortune for Life." *Philadelphia Press*, June 4, 1911.

"Violet Oakley, 86, Portraitist, Dead: Also Illustrator and Painter of Mural—Was Worker For International Peace." *New York Times*, Feb. 26, 1961.

"Violet Oakley's New Portfolio of Reproductions." *Philadelphia Public Ledger*, June 9, 1922.

"Violet Oakley on Visit Here Talks of Work," *Baltimore Sun*, Aug. 22, 1922.

"Woman Artist's Will Is Filed: Jessie Willcox Smith Bequeaths Her 'Water Babies' Drawings to Congressional Library." *Evening Bulletin*, May 10, 1935.

Woodward, George. *Family Letters and Proletarian Essays*. Philadelphia: Harris & Partridge, Inc., 1937.

Index

Italicized pages numbers refer to illustrations.

A

Abbey, Edwin Austin, 52, 78, 168–69, *198*, 202

Admiral Penn Denouncing and Turning His Son from Home Because of His Sympathy with the Despised Sect of Quakers (Oakley), *110*

Afternoon Tea (Green), *102*

Ahrens, Ellen W., *58*, *61*

Alighieri, Dante, 152, 158

All Misery, Antoine! And Now I Live Beneath a Sword (Green), *146*

Are You Ill, Dear North Wind? (Smith), *2*

Ariel: The Tempest (Elliott), *195*

Armies of the Earth Striving Together to Take the Kingdom of Unity by Violence, The (Oakley), *198*

Attempt to Stop the New Learning: The Burning of the Books at Oxford, 1526 (Oakley), *106*

B

Book of the Child, The, 79–85, *80–85*

Boston marriages, 136, 139

Boude, Elizabeth Shippen, *see* Green, Elizabeth Shippen Boude

Bretzel, 140, 141

Bryn Mawr College, *56*, 57–60, *206*
calendar for, *7*, 57–60, *58–62*

C

Cassatt, Mary, 15–16

Charter of Pennsylvania Receives the King's Signature, The (Oakley), *114*

Child's Garden of Verses, A (Stevenson), 85–86, *86*, *87*, *97*, 97–99, *98*

Christian Science, 55, 166–68, 171, 180

Cogshill, 182, *182*, 185

Cogslea, *120*, 121, 122–27, *124*, *138*, 153–54, 164–65, 177–80, 197–98, 203–04, 205

Collier's Magazine, *97*, *97*, *98*, 189–90

Come Play With Me (Smith), *85*

Complete Translation Set Forth with the King's Most Gracious License, The (Oakley), *107*

Cozens, Henrietta, 9, *9*, *54*, 68, 70–73, *74–75*, 91, 94, 96–97, *124–25*, 133, 135,

139, 141–42, 152, *165*, 177–80, 182, 185, *185*, 188, *190*, *192*, 193, *193*

D

Darley, Felix Octavius Carr, 25, *25*

Divine Law: Love and Wisdom (Oakley), *202*

Dodd, Jessie, 46–47, 50–51, 135, 140–41, 142

Dolly's Nap (Smith), *80*

Doorsteps (Smith), *144*

Dream Blocks (Smith), *143*

Drexel Institute, 35, 41

E

Eakins, Thomas, 15, *19*, 19–20, 21, 41

Elizabeth Shippen Green (Oakley), *51*

Elliott, Elizabeth Green, *see* Green, Elizabeth Shippen

Elliott, Huger, 130–33, *131*, *135*, 154, *159*, *161*, 175–76, 194–95, 197

Emerson, Edith, 56, 174–75, 185, *186*, 190–93, *196–97*, 197–98, *200*, 201, *201*, 202–03, 205–07

Evangeline (Longfellow), *42*, *43*, 45, 47–48

Ex Libris Henrietta Cozens (Elliott), *192*

Eyes of God, We Call Them in Italy (Green), *156*

F

Faderman, Lillian, 139, 162

Fair in Sooth Was the Maiden (Smith), *43*

Five Little Pigs, The (Green), *102*

Folds of Her Cloak Making Her Seem Like a Kneeling Marble, The (Green), *155*

Founding of the State of Liberty Spiritual, The (Oakley), *106–14*

G

Gentle Shadow Had Fallen Upon Him, A (Green), *93*

George Fox on the Mount of Vision: The Voice of One Crying in the Wilderness (Oakley), *108*

Girl on Sailboat (Green), *62*

Gisele (Green), *149*

Good Housekeeping, 188, *188*, *189*

Governor's Reception Room murals, Pennsylvania State Capitol, 76–79, 92, 103–15, *106*, *107*, *108*, *109*, *110*, *111*, *112*, *113*, *114*, 116–18, 128–30

Graduation Hats (Green), *60*

Graduation (Smith), *59*

Green, Elizabeth Shippen, *1*, 6, 8, 9, *9*, 22, *22*, *54*, *74–75*, *79*, *89*, 119, *122–23*, *134*, *136*, *161*, *192*; *see also* specific works of art
art education of, 24, 28, 29
childhood of, 23–24
death of, 197
engagement to Elliott, 131–33, 135, 157, 158
family of, 22–23, *119*, 154, 196–97; *see also* specific family members
as illustrator, 7, 27–29, 38, 48–49, 52–53, 60, *62*, *71*, *77*, *82*, *83*, *84*, *90*, 91, *93*, *94*, *100*, *101*, *102*, 103, *104*, *105*, *132*, *133*, 143, *146*, *147*, *148*, *149*, *155*, *156*, *194*, *195*
at Little Garth, 195–96
at Love Building, 46–47
marriage of, 160–63, 169–70, 176–77, 185, 194–96
and 19th-century sensibilities, 182–84
on Oakley, 177–80
poetry by, 27, 158
in Pyle's class, 38, 44, 45
receives Mary Smith Award, 115
social life of, 56, 95

Green, Elizabeth Shippen Boude, 23, *119*, 154

Green, Jasper, *23*, 23–24, 25, 26, 27, *119*, 154, 157

Greetings from 24 Concord Avenue, Cambridge Massachusetts (Elliott), *176*

H

Harper's Monthly Magazine, 91, *100–02*, 103

Having Been Liberated Through the Force of His Knowledge He Seeks to Free Other Friends Imprisoned (Oakley), *111*

Hayloft, The (Smith), *97*

He Felt the Net Very Heavy; and Lifted It Out Quickly, with Tom All Entangled in the Meshes (Smith), *187*

He Knew That He Was Not Dreaming (Green), *133*

He Looked Up at the Broad Yellow Moon... And Thought That She Looked at Him (Smith), *186*

Henrietta Cozens, Jessie Willcox Smith, Marg Nixon, and Edith Emerson at Cogshill (Oakley), *204*
Henrietta Cozens (Oakley), *191*
Hush-a-Bye, Baby (Smith), *179*

I

Illustration, as art, 24–26
I Myselfe and My Servannts (Green), *71*
Independence Day, celebrating, 165
Intolerance and Persecution Culminate in Civil War (Oakley), *107*

J

Jessie Willcox Smith Mother Goose, The, 176, *178*, *179*, *180*, *181*
Jingles (Smith), *80*
Journey, The (Green), *94*
June (Oakley), *48*

K

Kerbaugh, H. S., 118–19

L

Land of Counterpane, The (Smith), *87*
Lenten Cover (Oakley), *49*
Lesbian relationships, concern about, 139, 162, 163–64
Library, The (Green), *101*
Life Was Made for Love and Cheer (Green), *77*
Little Gardeners, The (Green), *82*
Little Garth, 195–96, 197
Little Officer Bending to the Saddle, The (Pyle), *40*
Looking Glass River (Smith), *86*
"Lord Open the King of England's Eyes" (Oakley), *106*
Love Building, 35, 46–47, 56–57

M

Man and Science (Oakley), *151*
Mary Smith Award, 115
Maypole (Smith), *58*
Miguela Kneeling Still, Put it to Her Lip (Green), *132*
Millais, John Everett, 28
"Mistress of the House, The" (Green), *100–02*, 103
Morley, Christopher, 97–99
Morris, Harrison S., 95–96
Mother and Child (Smith), *137*
Mucha, Alphonse, 127–28
Mystic Wood (Smith), *126*

N

Neither Could Be Quite Unhappy (Green), *146*

New York Society of Illustrators, 138–39
Noah's Ark (Smith), *129*

O

Oakley, Cornelia Swain, *31*, 116, 200–01
Oakley, Hester, *32*, 33, 34, 35–36, 46, 54, 55, 116
 daughter of, 103, *103*, 116
Oakley, Violet, 6, 8–9, *9*, *30*, *31*, *32*, *34*, *37*, *46*, *51*, *55*, *74–75*, 76, *92–93*, *153*, *154*, 154–57, *167*, *168*, *196–97*, *200*, *201*, *203*, 207, *207*; *see also* specific works of art
 art education of, 33, 34–35
 on changing fashions, 182–83
 childhood of, 31–33
 as Christian Scientist, 55, 166–68, 171, 180
 at Cogslea, 177–80, 197–98, 203–04, 205
 "Declaration of Independence" by, 166–68, 170
 drawings by, *175*, 203, 204
 and Emerson, 174–75, 185, 197–98, 205
 European travels of, 33, 78–79, 150–52, 171–74, 203
 family of, *30*, 30–31, 33–34, 35, 54–55, 103, *103*, 116; *see also* specific family members
 home built by, 133, 166–68
 as illustrator, *14*, 36, 42, 48, *48*, *49*
 logotype of, *205*
 at Love Building, 35
 on Mucha, 127–28
 as muralist, *54*, 76–79, 92, 103–15, *106*, *107*, *109*, *110*, *111*, *112*, *113*, *114*, 116–18, 128–29, 130, 143–50, *150*, *151*, 158, 168–69, 170–74, *172*, *173*, 198, *198–99*, 199–202, *202*
 and 19th-century sensibilities, 182–84
 paintings by, *191*, *204*, *206*
 in Pyle's class, 35, 38, 45
 at Red Rose Inn, 60, 64–66, 67–68
 and Smith, 45
 as stained-glass artist, *53*, 53–54, 131, 157–58
 as teacher, 174
Out Came Their Sabers and They Was at Me Howlin' Wit Glee (Elliott), *194*

P

Penn, William, 63, 92, *109*, *110*, *111*, *112*
Penn Examined by the Lieutenant of the Tower of London, Condemned to Imprisonment in Newgate (Oakley), *111*
Penn Meets Quaker-thought in the Field—Preaching at Oxford (Oakley), *110*
Penn's Vision (Oakley), *112*
Pennsylvania Academy of the Fine Arts, 6–9, *8*
 Green and, 24, 27, 115

Oakley and, 34, 35, 174
 Smith and, 18–19, 20–21, 193
 watercolor show at, 115–16
 women's education at, 14–15
Pennsylvania State Capitol murals:
 Abbey's commission for, 78, 168–69
 Governor's Reception Room, *see* Governor's Reception Room murals, Pennsylvania State Capitol
 Senate Chamber and Supreme Court Room, *see* Senate Chamber and Supreme Court Room murals, Pennsylvania State Capitol
Pennypacker, Governor Samuel, 118, 128
Peter, Peter, Pumpkin-Eater (Smith), *178*
Peter, Sarah, 17
Philadelphia, 10, 11–12, 60–63
Philadelphia Museum School of Industrial Arts, 195, 196
Philadelphia School of Design for Women, 17–19, *18*, *39*
Picture Books in Winter (Smith), 98
Pip and Joe Gargery (Smith), *181*
Plastic Club, 49–50, 73–74, 95, 127–28
Portrait of Beth Romney (Smith), *73*
Portrait of Edith Emerson (Oakley), *175*
Portrait of Jessie Willcox Smith (Oakley), *14*
Punishment (Smith), *145*
Pyle, Howard, 35, 38, 39–44, *40*, *41*, *42*, 45, 47–48, 52, 170

Q

Quakers, *110*, 171
Quita Woodward (Oakley), *206*

R

Rain, Rain, Go Away (Smith), *179*
Rainy Day, A (Green), *83*
"Rather Deathe Than False to Faythe" (Oakley), *107*
Real Santa Claus, A (Smith), *81*
Rebecca Mary (Donnell), 103, *104*, *105*
Rebecca Mary Was Going Away (Green), *104*
Red Rose Inn, *56–57*, 60, 63–69, *66*, *67*, *69*, 74, 91–92, 95–96, 118–19, 120–21
Rising Vigorously Out of the Earth Was a Little Rose Bush (Green), *148*
Romantic friendships, 51–52, 139
Rose Garden, The (Green), *101*

S

Scales (Smith), *129*
Self-Portrait: The Artist in Mourning for Her Father (Oakley), *55*
Senate Chamber and Supreme Court Room murals, Pennsylvania State Capitol, 168, 170–71, *172*, 173, *173*, 198, *198–99*, 199–201, *202*

Sewing Room, The (Green), *100*

She Bent Her Head and I Stood Over Her (Smith), *72*

She Read One of the Annuals, or Gazed through the Window (Smith), *50*

Slaves of the Earth Driven Forward and Upward by Their Slave-drivers, Greed, and Ignorance and Fear, The (Oakley), *199*

Sleigh Ride (Green), *60*

Smith, Jessie Willcox, 6, 8, 9, *9, 10, 14, 21, 54, 74–75, 79, 88, 89, 122–23, 125, 136, 139, 164, 167, 184, 189, 193; see also specific works of art*

 art education of, 13, 18–19, 20–21

 childhood of, 10–12

 on children, 88–91

 at Cogshill, 182, 185

 and Cozens, 73, 96–97, 133, 135, 185, 188

 family of, 11

 fashion sense of, 152–53

 as illustrator, 38, *43*, 48, *50*, 53, 57–60, *58, 59, 61, 72, 73, 80, 81,* 85, *85, 86, 87, 97,* 97–99, *98, 126, 129, 137,* 142–43, *143, 144, 145,* 176, *178, 179, 180, 181, 186, 187,* 190

 leaving Cogslea, 177–80

 at Love Building, 46

 and 19th-century sensibilities, 182–84

 and Oakley, 45, 92–94

 on Plastic Club show, 73–74

 as portrait artist, 189–90, 193

 in Pyle's class, 38, 44, 45

 sculpture of, 13

 as teacher, 12–13

 and visit to England, 134–35, 139–42

Smith, Walter George, 118

Smuggling the New Testament into England, 1526 (Oakley), *106*

Soccer (Smith), *59*

So Haunted at Moonlight with Bat and Owl and Ghostly Moth (Green), *71*

So These Two at Montbrison, Hunted and Hawked (Green), *147*

Student and Teacher on Horseback (Green), *62*

Students on a Street Car (Smith), *61*

Stupid You (Smith), *144*

Summer's Passing (Smith), *145*

Summer Sun, The (Green), *83*

T

They Were in Each Other's Arms (Green), *105*

Thousand Quilt, The (Green), *90*

Thy God Bringeth Thee into a Good Land (Oakley), *113*

Toasting (Green), *7*

U

Unity (Oakley), *172,* 173, *173,* 198, *198–99*

V

Violet Oakley Memorial Foundation, 207

W

Ward, Hester Oakley, *see* Oakley, Hester

Water-lilies in Myriads Rocked on the Slight Undulations (Oakley), *42*

"Well Bless the Boy, He Don't Even Know How to Plant Potatoes!" (Oakley), *36*

Why Don't You Just End It? (Pyle), *41*

William Penn at Christ Church, Oxford, 1660 (Oakley), *109*

Williams, Talcott, 128

William Tyndale Printing His Translation of the Bible into English, at Cologne, A.D. 1525 (Oakley), *106*

Women:

 art education for, 13–15, 19–21

 as artists, 16, 41–44, 52

 Boston marriages of, 136, 139

 as decorative artists, 17

 employment of, 16–17

 in lesbian relationships, 139, 162, 163–64

 professional success of, 136

 romantic friendships of, 51–52, 139

Woodward, Dr. George, 121–22, 123, 130–31, 195, 202

Woodward, Gertrude "Quita," *206*

Woodward, Mrs. George, 205

Y

Yarnell House murals, 130, 143–50, *150, 151*

Acknowledgments

JESSIE WILLCOX SMITH, ELIZABETH SHIPPEN GREEN, Violet Oakley, and Henrietta Cozens wrote very little about their lives and were often vague and uncooperative with journalists interested in their history. Uncovering their fascinating story required years of research and the help of many generous and knowledgeable people. I am grateful to the following scholars and historians: Cheryl Leibold at the Pennsylvania Academy of the Fine Arts, Leo M. Dolenski and Kathleen Whalen at the Bryn Mawr College Library, Walt and Roger Reed at Illustration House, Richard Kelly and Elizabeth Marecki at the Kelly Collection of American Illustration, Harriet B. Memeger at the Delaware Museum of Art, Sherron R. Biddle at the State Museum of Pennsylvania, Judy Goffman Cutler and Jennifer Goffman at the American Illustrators Gallery, Judy Throm at the Archives of American Art, and Terry Brown at the New York Society of Illustrators.

To the friends and family members of these remarkable women, Edna Andrade, Charles Cunningham, Clifford and Molly Lewis, and Brian Zahn, thank you for sharing your time, your unique perspective, and your fascinating memories. This story could not have been written without your help.

I also owe a debt of gratitude to everyone who facilitated the production of the book. Linda Paulson helped me begin and read every draft of the manuscript. Julie Lasky helped me finish by finding the right words to bring closure to the story. My agent, John Campbell, championed the book from beginning to end and offered continuous encouragement. Designer Darilyn Carnes put up with my many suggestions with tolerance and good humor. My editor, Elisa Urbanelli, worked tirelessly and creatively on this project and somehow managed to keep us all on task.

To my husband, Dennis, and my children, Amanda, Todd, and especially Robert (who can't remember a time when this story was not part of the fabric of our household), thank you for your patience and support. Finally, my most sincere appreciation and heartfelt thanks go to my parents, Jane and Ben Eisenstat, who not only shared their memories, their photographic collection, and their paintings but also introduced me at a very young age to the Red Rose Girls.